Still Lifes of the Golden Age

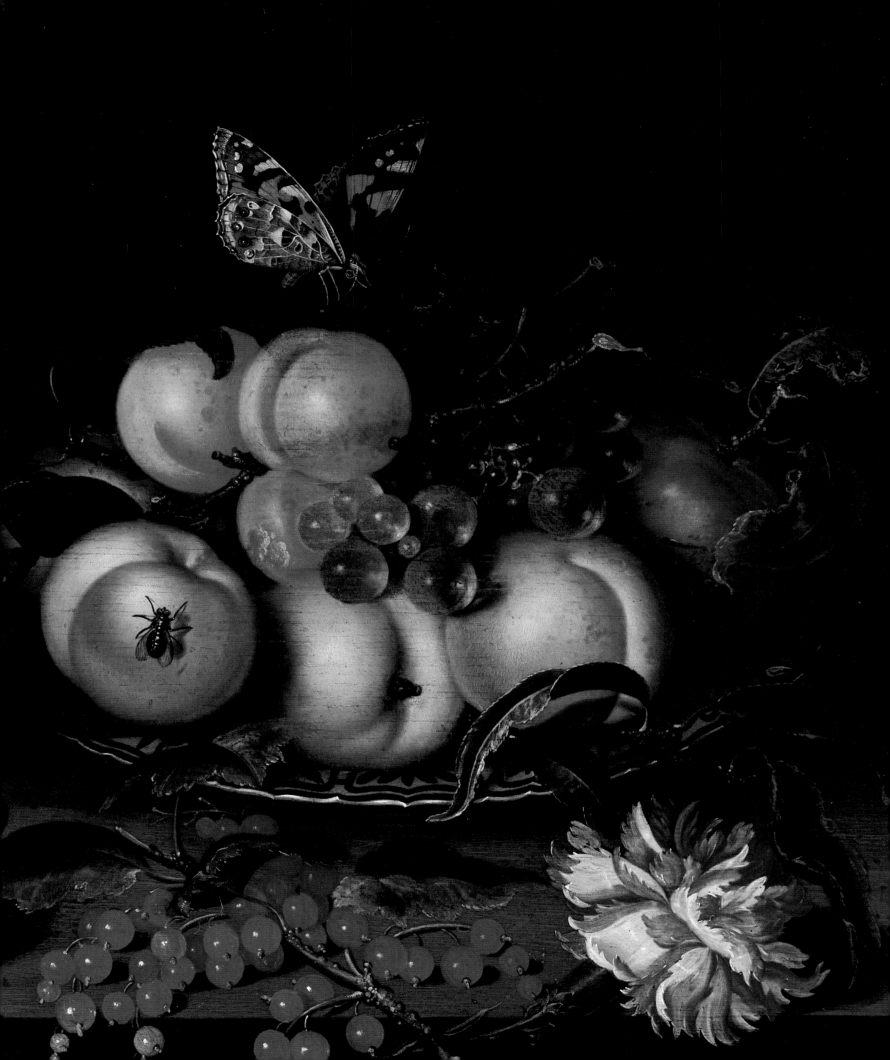

Still Lifes of the Golden Age

NORTHERN EUROPEAN PAINTINGS FROM THE HEINZ FAMILY COLLECTION

Catalogue Entries by INGVAR BERGSTRÖM

Edited by ARTHUR K. WHEELOCK, JR.

National Gallery of Art, Washington

National Gallery of Art, Washington
14 May–4 September 1989

Museum of Fine Arts, Boston
18 October–31 December 1989

Produced by the Editors Office, National Gallery of Art, Washington
Designed by Susan Lehmann, Washington
Typeset in Meridien by VIP Systems, Inc., Alexandria, Virginia
Printed on 80 lb. Centura paper by Schneidereith & Sons, Baltimore, Maryland
All color photographs by Dirk Bakker except for cats. 9 and 42 by Edward Owen and cat. 17 by Richard C. Amt.

Library of Congress Cataloging-in-Publication Data

Bergström, Ingvar.
Still lifes of the golden age: northern European paintings from the Heinz family collection/ catalogue by Ingvar Bergström: edited by Arthur K. Wheelock, Jr.
p. cm.
Catalog of an exhibition.
Bibliography: p.
ISBN 0-89468-129-X
1. Still-life painting, Dutch—Exhibitions. 2. Still-life painting—17th century—Netherlands—Exhibitions. 3. Still-life painting, Flemish—Exhibitions. 4. Still-life painting—17th century—Flanders—Exhibitions. 5. Heinz family—Art collections—Exhibitions. 6. Still-life painting—Private collections—Exhibitions. I. Wheelock, Arthur K. II. National Gallery of Art (U.S.) III. Title.
ND1393.N43S834 1989 89-3180
758'.4'094920740153—dc19 CIP

cover: detail, cat. 28
frontispiece: detail, cat. 7

Contents

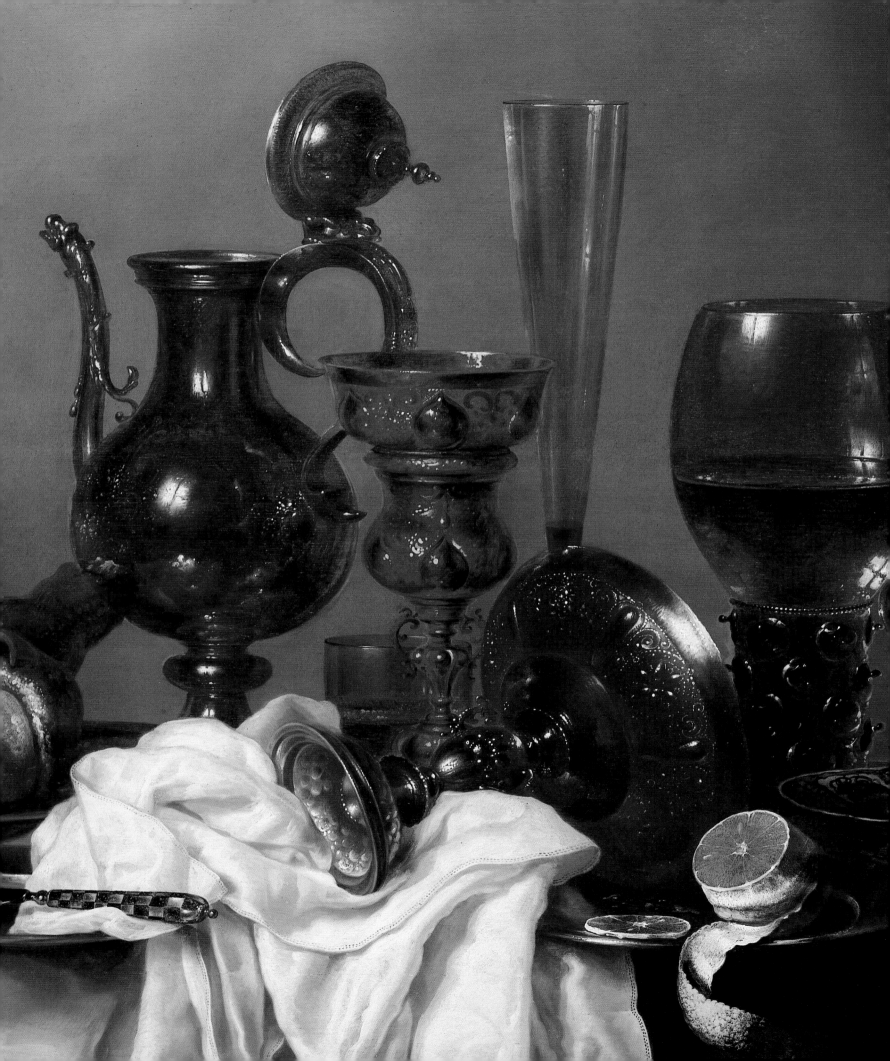

Foreword

Dutch and Flemish still-life paintings have always had a special appeal to American taste. Because artists such as Raphaelle Peale and William Harnett were inspired by the realism and illusionism of these works, and because connoisseurs and collectors admired their technical virtuosity, Dutch and Flemish still lifes have become incorporated into our cultural heritage. This fundamental connection between Dutch and American pictorial traditions was one of the incentives that led the Heinz family to bring together an outstanding collection of late sixteenth- to early eighteenth-century northern European still lifes.

We are very grateful to the Heinz family for allowing us to present a selection from their remarkable collection. *Still Lifes from the Golden Age: Northern European Paintings from the Heinz Family Collection* contains many paintings that are little known to a broad public, since they have come from private holdings and have never been exhibited. Moreover, this group also brings to the National Gallery of Art in Washington and the Museum of Fine Arts, Boston, many works of a kind and by artists not represented in our respective collections.

Limitations of space at the National Gallery mandated that only a portion of this extraordinary collection could be exhibited. The selection of paintings was made in close consultation with the Heinz family by Arthur K. Wheelock, Jr., from the National Gallery of Art and Peter C. Sutton and Theodore E. Stebbins, Jr., from the Museum of Fine Arts. This selection also benefited from the recommendations of Peter Tillou and Ingvar Bergström, as well as from Charles S. Moffett at the National Gallery.

The catalogue has been the work of many scholars. We have been very fortunate that the Heinz family decided to ask Ingvar Bergström, one of the foremost authorities in the field, to write the entries on the individual paintings. The essays were written by Arthur Wheelock, Elisabeth Blair MacDougall, and Lawrence O. Goedde, and the biographies and bibliography by Anke A. van Wagenberg-ter Hoeven.

J. Carter Brown
Director, National Gallery of Art

Alan Shestack
Director, Museum of Fine Arts, Boston

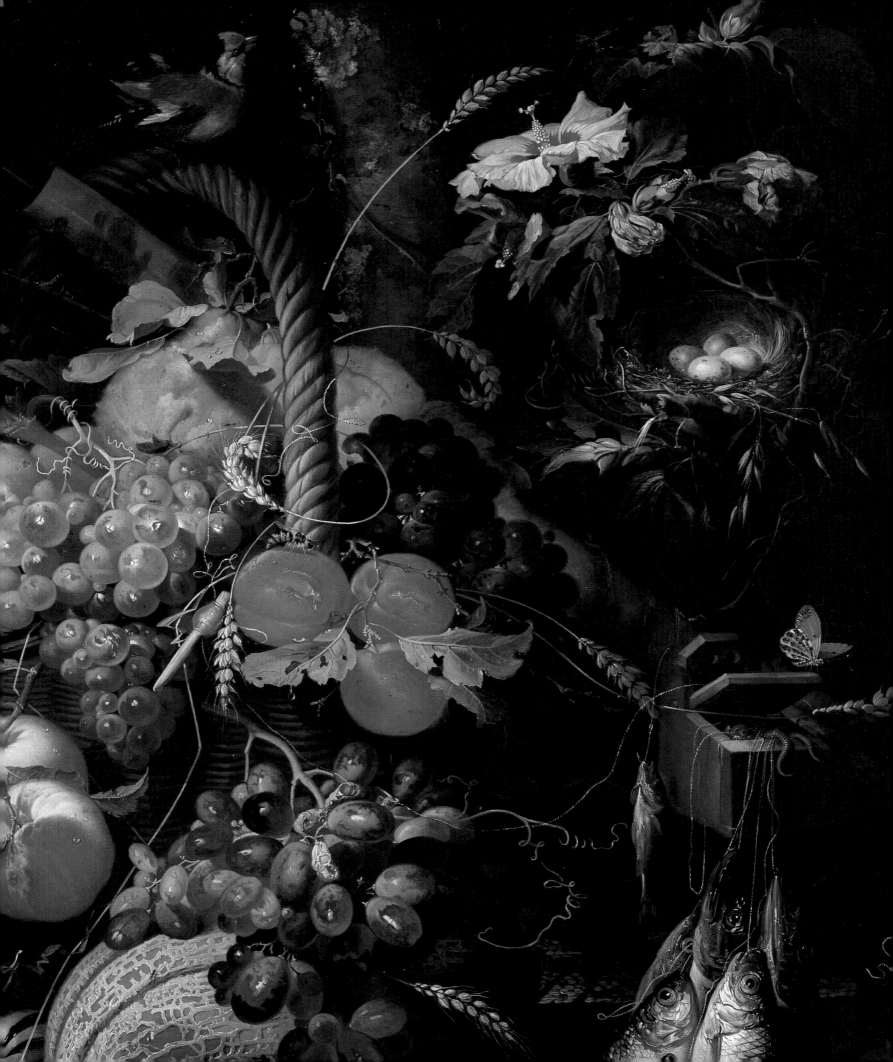

Acknowledgments

This exhibition consists of forty-four still-life paintings from the Heinz family collection, which numbers more than seventy works and is the largest of its kind in private hands. The selection attempts to represent the full scope of the collection. Within its chronological range, from the late sixteenth to the early eighteenth centuries, one finds a wide variety of types of still lifes, from fruit pieces to depictions of smoking implements, from breakfast scenes to images of skulls intended to remind the viewer of man's mortality.

The collection is especially noteworthy because it contains paintings by a number of artists for whom little documentation and only a few paintings have survived. Hence, the Heinz collection reminds us of the high level of quality that existed in Dutch and Flemish art of this period, even among artists who are not well-known to twentieth-century audiences. Special acknowledgment is due to Peter Tillou, who has assisted the Heinz family over the years in locating many of these rare and unique examples, without which the richness and extensiveness of the collection would have been impossible.

The exhibition at the Gallery was ably designed by Gaillard Ravenel and his staff in the department of installation and design, and the administrative details were coordinated by Sarah B. Tanguy and Ann B. Robertson of the department of exhibitions. Anne Halpern and Mary Suzor in the registrar's office organized the transportation of the works. In Boston, Tom Wong is responsible for the handsome installation and Patricia Loiko ably dealt with logistical matters.

The format of the catalogue derived from discussions with Ingvar Bergström, Peter Sutton, who also helped edit essays, and especially Jane Sweeney, who, with careful editing of the text, ushered the catalogue through the press. Sarah McStravick graciously helped prepare manuscripts. For the excellent color photography we are indebted to Dirk Bakker, Edward Owen, and Richard C. Amt. The design is due to the sensitive eye and hand of Susan Lehmann.

Arthur K. Wheelock, Jr.

Detail, cat. 28

Still Life:
Its Visual Appeal and
Theoretical Status in the
Seventeenth Century

ARTHUR K. WHEELOCK, JR.

The sense of awe elicited by a Dutch or Flemish still-life painting is not accidental. The artists who created these works wanted to convey the delicacy of a rose petal, the sheen of a silver urn, the rich textural surface of a lemon, and the shimmer of a satin drapery because they felt that the essence of a still-life painting is found in its illusion of reality. The realism of these paintings derives from the careful grouping of objects, from the play of light, but above all from the refined painting techniques used to convey the texture of the materials represented. Through the choice of support, whether copper, panel, or canvas, and through the care with which rich impastos and subtle glazes were applied, these artists made every effort to simulate the character of the objects before them.

This realistic ideal was not new to the seventeenth century, but had long been part of art theory. The story of Zeuxis' ability to depict fruit so realistically that he deceived birds into pecking at the painted image was by then a frequently cited standard of illusionistic skill. Even greater than Zeuxis' accomplishment, however, was that of his rival Parrhasius, with whom Zeuxis had entered into a competition to see who could paint the more realistic work. Zeuxis lost the wager when he tried to pull aside a curtain that apparently obscured Parrhasius' image only to discover that the curtain was not real, but painted. Visual references to the illusionistic conceits of these ancient masters abound in seventeenth-century still-life paintings: flies and other insects seem to light upon realistic objects (fig. 1), and curtains are drawn halfway across paintings to hide objects from view (fig. 2). Indeed, some Dutch artists following the lead of Parrhasius pushed trompe l'oeil painting to its extreme and sought to create totally illusionistic images to deceive the eye. The window frame in this exhibition is a wonderful example (fig. 3), but one thinks also of the perspective boxes that Dutch artists, in particular Samuel van Hoogstraeten, created in the second half of the century.[1]

Trompe l'oeil illusionism as an end unto itself is only one aspect of seventeenth-century Dutch and Flemish still-life painting. Most still

Detail, cat. 12

11

fig. 1. Detail, cat. 7

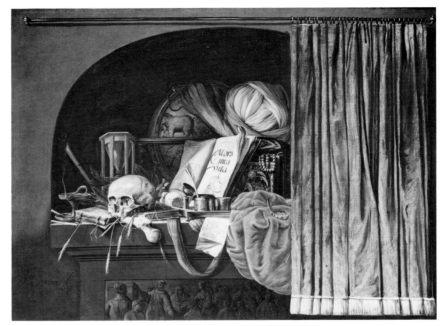

fig. 2. Cat. 12

lifes, however illusionistic in character, were intended to convey broader religious, moral, and theoretical issues than apparent to us at first glance. This short introduction to the exhibition will examine some of these ideas and place them in their artistic framework. Specific information about the paintings and the artists can be found in the Catalogue at the end of this volume.

There is a paradoxical quality about the position of still-life painting in seventeenth-century northern European artistic traditions. Though theorists ranked still lifes at the lowest echelon in the hierarchy of painting, collectors were willing to pay enormous prices for these delicately conceived works.[2] The difference between their theoretical position and market value raises interesting questions about contemporary attitudes toward still-life painting, questions that revolve around intellectual arguments concerning the position of the artist in seventeenth-century society.[3]

The theoretical issues that placed still-life painting at the low end of the scale of worthy subjects focused on the desire to demonstrate that painting belonged to the liberal arts. Primary to such arguments was that the role of the artist should be differentiated from that of the craftsman. The artist should deal with abstract ideas that draw upon his imagination and intuition. He should also demonstrate a thorough knowledge of the mathematical principles underlying the laws of perspective. The most elevated form of expression for an artist was history painting, in which he would represent stories drawn from the Bible and mythology that convey moral and ethical issues essential to human existence.[4]

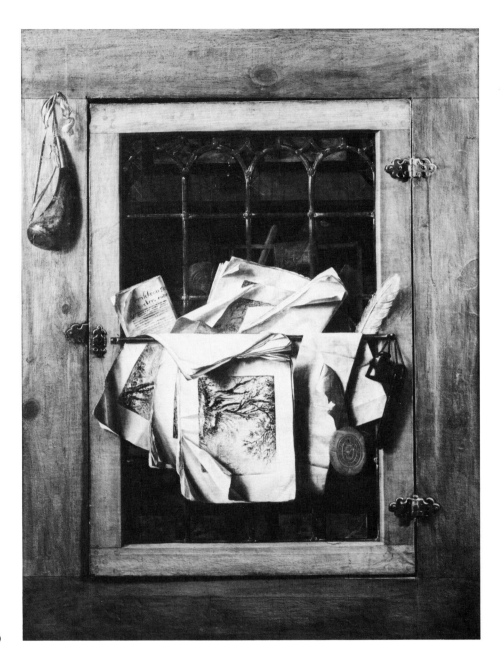

fig. 3. Cat. 17 (recto)

The implicit contrast between artist and craftsman was that the latter was unconcerned with such abstract principles. He knew his craft: how to prepare his support, grind his pigments, choose his medium, and apply his paints with a thorough knowledge of their optical qualities. His work, however, did not exhibit imagination and was not concerned with moral issues that could be represented through the depiction of the human figure. These ideas, which have their origins in sixteenth-century Italian humanistic traditions, were transported to the north in the writings of, among others, Karel van Mander, and became part of the framework of seventeenth-century art theory. However, the hierarchical distinctions among subject matters never accom-

13

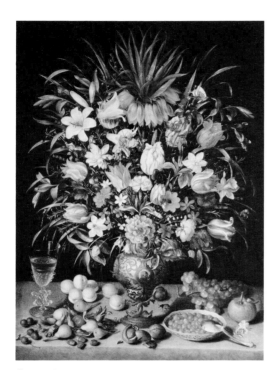

fig. 4. Cat. 15

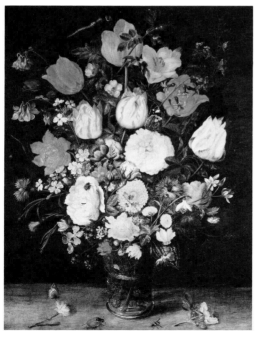

fig. 5. Cat. 8

modated artistic traditions, such as still life, that were more northern than Italian in origin. Moreover, since these concepts emphasized imagination over craftsmanship, still-life painting, whose realism depended upon precise observation and great technical skill, came to represent a genre of painting that was the antithesis of a successfully conceived history painting. When Samuel van Hoogstraeten, in his treatise on painting in 1678, described still-life painters as "the ordinary soldiers in the army of art" and placed still life at the lower end of the hierarchy of subject types for an artist, he did so because he considered the representation of flowers, fruit, and vegetables mere craftsmanlike virtues, relatively insignificant in those areas that identified the artist as a legitimate practitioner of the liberal arts.[5]

Artists were concerned about their social and economic status in the seventeenth century. They devised stricter guild regulations both to establish the predominance of their profession in relation to the other artisans and to control the influx of foreign competition. They were also careful to convey the notion that they were learned individuals. Artists frequently represented themselves playing a musical instrument and surrounded by scholarly books and globes, attributes associated with the liberal arts.[6] The story that Peter Paul Rubens, the preeminent learned artist, could paint while simultaneously dictating a letter and having Tacitus read to him similarly reinforced the ideal of the artist as an integral member of the learned community that practiced the liberal arts. Nevertheless, as is evident in this exhibition, the low status of still lifes in the hierarchy of painting did not prevent a large number of artists from becoming specialists in this area. Not only did a significant market for these works exist, but enormous prestige was granted to those artists who could depict flowers, fruits, insects, and animals as though they were real. One of the most admired masters in the court of Rudolf II in Prague at the end of the sixteenth century, for example, was Joris Hoefnagel, an artist whose microscopically detailed watercolor drawings of plants and animals recorded a wide range of natural phenomena.[7]

A number of ironies surround the low rank of still-life painting in art theory. Primary among these is that still-life painting had a strong scientific foundation. The scientific naturalism of the late sixteenth and early seventeenth century still-life masters working in the tradition of Joris Hoefnagel, including Georg Flegel (fig. 4) and Jan Brueghel the Elder (fig. 5), was allied to botany, precisely the area where some of the most exciting discoveries of the day were being made. These artists represented large numbers of flowers that had only recently been imported into Europe. Indeed, it seems likely that some of the earliest efforts at rendering flowers came in response to the requests of flower lovers to see what new wonders botanists had developed.[8] The care with which these artists worked is evident in a letter Jan Brueghel wrote to his patron Cardinal Federico Borromeo in 1606. In it he

stressed that he had begun his portrayal of a *Large Vase of Flowers* (Pinacoteca Ambrosiana, Milan) in the spring, when he had depicted the narcissi and snowdrops, and had added other flowers as they came into bloom. When he had completed the bouquet in the fall, he wrote that "I do not believe that so many rare and varied flowers have ever been painted, and with such diligence. They will look beautiful in the winter: some colours almost emulate nature."[9]

Brueghel's letter emphasizes the importance he attached to imitating nature in his careful observation and depiction of individual flowers. The finished painting, however, does not accurately reflect a bouquet that ever existed, since it contains flowers from different seasons of the year. Indeed, many Dutch and Flemish flower painters worked extensively from drawings of blossoms made from life and used these as a basis of their compositions. Thus identical flowers can be found in totally different paintings (cats. 3, 8). Their compositions, thus, while realistic in their specifics, are imaginative re-creations of reality rather than specific records of it. In this respect the still-life painter, while depending on his diligence and craftsmanship to convey the form, texture, and color of the objects in his painting, could be as imaginative as the history painter in composing his image.

The abstraction inherent in the image he created, moreover, was not merely in the arrangement of diverse compositional elements, but also in its implied meaning. Brueghel stated that his painting will "look beautiful in winter" when nature's flowers have withered and died. His statement seems self-evident: the painting will serve to remind Cardinal Borromeo of the beauties of nature that flourish during the other seasons of the year, but which he cannot enjoy during the winter. On another level, however, Brueghel alluded to one of the fundamental arguments for the value of art: it outlasts nature. That Cardinal Borromeo understood this concept is made clear from his own descriptions of the enjoyment he received from viewing Brueghel's still life the whole year through:

Then when winter encumbers and restricts everything with ice, I have enjoyed from sight—and even imagined odor, if not real—fake flowers . . . expressed in painting . . . and in these flowers I have wanted to see the variety of colors, not fleeting, as some of the flowers that are found [*in nature*], but stable and very endurable.[10]

The concept *Ars longa, vita brevis* is one that pervades much of seventeenth-century northern still-life painting. Constantijn Huygens, secretary to the prince of Orange in The Hague and one of the most articulate connoisseurs of the day, wrote admiringly of one of Daniel Seghers' paintings in much the same vein that Cardinal Borromeo wrote of Brueghel's still life: its beauty would far outlive the temporal beauty of the rose he had depicted.[11]

As a corollary to this glorification of the painted image was the reminder of the transitory nature of life implicit in these paintings. In-

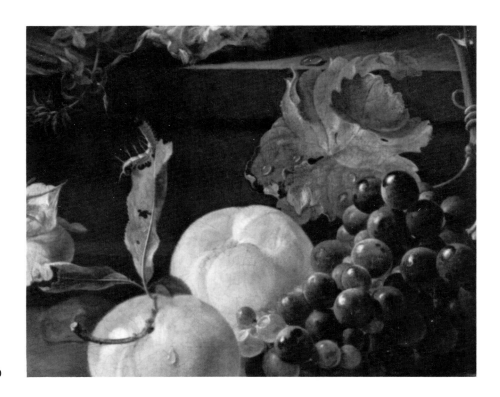

fig. 6. Detail, cat. 30

deed, still lifes became a favorite vehicle for reminding the viewer of the passage of time. Not only was the very existence of the painting a reminder of the temporal quality of the objects depicted within it; but artists also began to include explicit reminders of transience, from insects devouring leaves on plants (fig. 6) to rotten fruit, snuffed out candles, skulls (fig. 2), and watches hidden amidst exuberant displays of food and elegant objects made of gold and silver (fig. 7). In one particularly lush floral still life in this exhibition the artist inscribed *[moment] o mori* on the vase as a reminder that death comes to all living things, however beautiful they may be (fig. 4). Even Simon Luttichuys' *Allegory of the Arts*, which apparently celebrates human creative endeavors in painting, drawing, sculpture, astronomy, and topography, remains in essence a *vanitas* image (cat. 23).

The abstract principles contained in such *vanitas* symbolism are but one aspect of seventeenth-century still-life painting. By this time an extensive emblematic vocabulary had developed that gave abstract associations to fruits, flowers, and other objects from daily life. Flowers, for example, were considered an attribute of Flora. They could also symbolize the sense of smell or of sight in an allegorical representation of the five senses. A proliferation of fruit and flowers could be part of an allegorical representation of abundance. Still-life images were also important components in representations of the seasons (fig. 8), a concept represented in this exhibition by the imposing *Allegory of Summer*, a painting executed jointly by Georg Flegel and Lucas van Valcken-

16

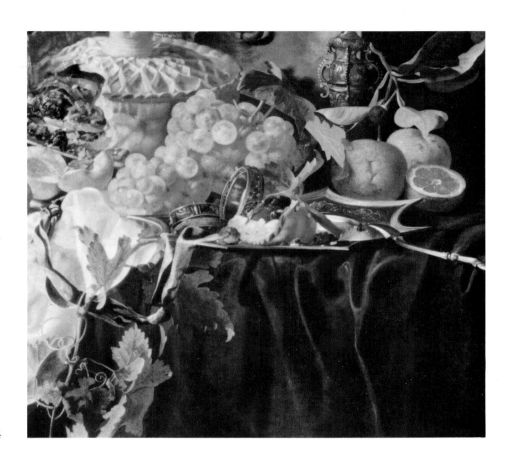

fig. 7. Detail, cat. 24

fig. 8. Detail, cat. 42

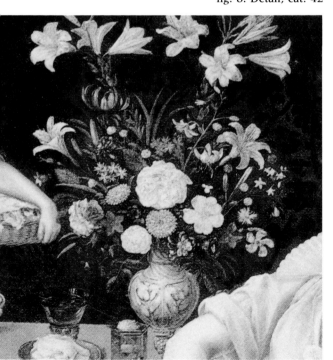

borch. A number of still-life objects were also imbued with religious symbolism. Certain flowers, in particular the white lily, were associated with the purity of the Virgin, while red grapes and stalks of wheat often are symbolic of the Eucharist. Many fruits, flowers, and nuts also stand for the passion of Christ and his all-embracing divinity; a butterfly or dragonfly, for redemption and resurrection.[12]

Given the overridingly realistic foundation of seventeenth-century northern still-life painting, one of the most complex problems facing the viewer is to understand the artist's intent when he included these and similar objects within his works. Important in this respect is to understand the context in which the object occurs.[13] It seems very unlikely, for example, that the prominent lilies in the vase of flowers in the *Allegory of Summer* have Marian imagery given that the painting is such an obvious allegory of one of the seasons.

The religious associations within still-life paintings, however, are more complex than just the question of which objects have which symbolic meaning. Both Catholics and Calvinists warned that sensual pleasures found in the beauty and variety of the natural world threatened to distract man from the message of Christ's sacrifice and from the overriding significance of God's word. In the mid-sixteenth century this message was conveyed by Pieter Aertsen and Joachim Beuckelaer

17

when they juxtaposed market scenes and tabletops filled with meats, vegetables, and other comestibles with religious scenes discreetly situated in the background.[14] No vehicle was more effective in conveying this message, however, than flower still-lifes. As a reminder of the temporal beauty of the flowers, artists often included depictions of blossoms that had already passed their prime, or whose leaves had been ravaged by insects (fig. 6). Jan Brueghel explicitly expressed these concerns when he inscribed the following text underneath a *Flower Still Life* that he executed at the beginning of the seventeenth century (fig. 9):

Look upon this flower which appears so fair, and fades so swiftly in the strong light of the sun. Mark God's word: only it flourishes eternally. For the rest, the world is naught.[15]

After mid-century, Jan Davidsz. de Heem expressed similar sentiments when he painted his *Flowers with Crucifix and Skull* in collaboration with Nicolaes van Veerendael (Alte Pinakothek, Munich, fig. 10). Here he included an admonition inscribed on a piece of paper directly under the crucifix: "But one does not turn to look at the most beautiful flower of all." The message is that one should not spend one's life searching for sensual pleasures, such as the smell and beauty of flowers, or the enjoyment of ripe fruit. As the watch, empty shell, and skull indicate, life is transitory. The most beautiful flower is Christ, and only by focusing on the meaning of his death and resurrection can one hope to achieve salvation.[16]

Not all religious associations with flower and fruit still lifes, however, reflect such sentiments. At this time there were two interrelated yet conflicting appraisals of the relationship of objects in the natural world to God and his divinity. On the one hand was this concern that man should not be distracted by sensual experiences. On the other hand, by the end of the sixteenth century theologians had begun to celebrate the blessings of God's creation that could be found in the extraordinary richness and beauty of the natural world. This religious strain of thought, which was essentially Catholic in origin, derived from the writings of people in the circle of Cardinal Borromeo. Instead of warning about the appeal of the flowers, exotic shells, and ripe fruits, these writers felt that God's goodness and wisdom could be found in contemplating the variety and beauty of the physical world.[17]

The tremendous influx of newly discovered plants, animals, and shells from the explorations of the Americas gave added substance to this theological approach, since these wonders demonstrated the extraordinary richness of God's creations. The newly found flora and fauna, moreover, which had not been known by the Church Fathers, helped broaden the approach humanists took toward nature. These new discoveries, however small and insignificant by themselves, were enthusiastically described and categorized by naturalists. To scientists

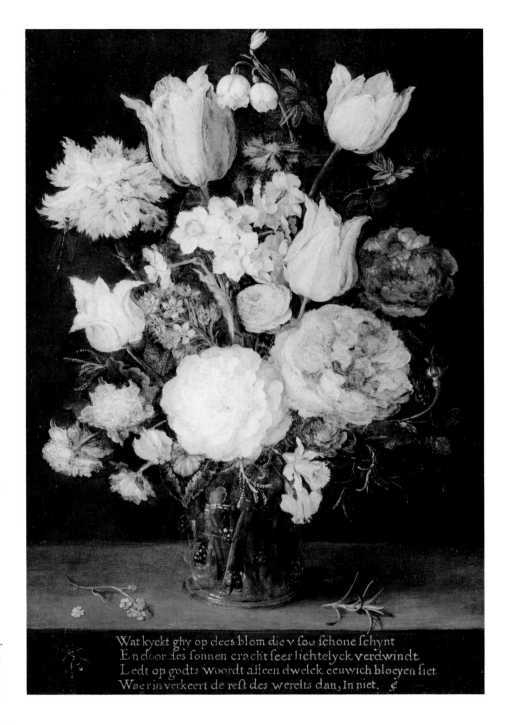

Wat kyckt ghy op dees blom die v foo fchone fchynt
En door des fonnen cracht feer lichtelyck verdwindt.
Ledt op godts woordt alleen dwelck eeuwich bloeyen fiet
Waerin verkeert de reft des werelts dan, In niet. ℈

fig. 9. Jan Brueghel the Elder, *Still Life of Roses, Tulips, and Other Flowers in a Glass Vase on a Ledge,* c. 1610. Courtesy Richard Green Gallery

influenced by the ideas of the Reformation these revelations reinforced the notion that the world contained mysteries that existed outside the Church's domain. One could even argue that by giving equal weight to each and every plant, botanists paralleled the reformers' insistence on the equality of all men in the scheme of salvation.[18] That this attitude extended throughout most of the seventeenth century is evident in the attestation given by Church Fathers in Delft on behalf of the

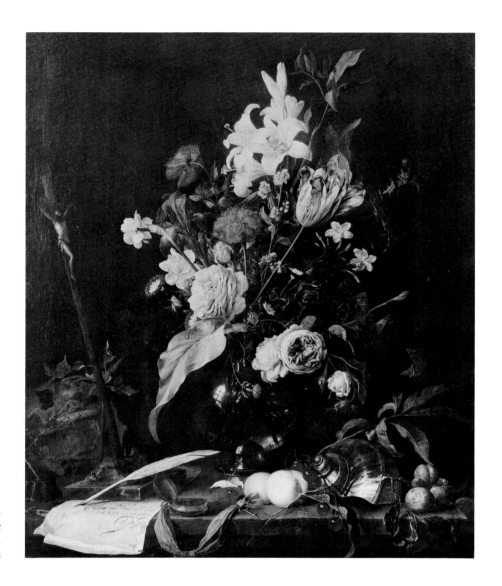

fig. 10. Jan Davidsz. de Heem and Nico-
laes van Veerendael, *Flowers with
Crucifix and Skull*, c. 1665.
Alte Pinakothek, Munich

famed Delft microscopist Anthony van Leeuwenhoek in a letter writ-
ten to the Royal Society in London on 18 May 1677:

Considering that nothing contributes more to the honour of God, the Creator
of everything, or incites us more to the admiration of Him who alone is
Goodness, Wisdom, and Power, than the exact observation of creation: ''for
the invisible things of him from the creation of the world are clearly seen,
being understood by the things that are made, even his eternal power and
Godhead'' (Romans 1. 20), the investigators of the Creation should by no
means be deprived of the honour due to their unflagging labour.[19]

This positive attitude toward God's munificence was strengthened in
the north by the pride the Dutch had in their economic prosperity.
Among the greatest sources of pleasure were the exotic plants that had
been brought to the Netherlands by the far-reaching trade of the
Dutch republic. Jacob Cats, for example, described with obvious won-
der the garden of a friend from Middelburg:

There she has many fruits from divers foreign lands,
A multitude of plants from divers distant strands,
And unknown, nameless blooms. . . .
There runs a playful brook with a hundred leaps and bounds,
There multiply the fish, the deer bring forth their young.[20]

The development in Haarlem in the early seventeenth century of the so-called breakfast pieces, in which tabletops are covered by plates and bowls of nuts, fruits, sweets, and cheeses, would also seem to reflect the sense of well-being that artists and patrons felt at that time. In such paintings the artist makes it very clear that these delicacies are to be consumed and enjoyed. Inevitably, the cheeses have been partially eaten, the apple peeled, crumbs of the sweets left on the table, and a few of the mussels consumed (fig. 11).

The irony for us today is that it is often extremely difficult to determine whether the objects in a still-life painting have been included to demonstrate God's bounty or whether they are there to provide a warning against excessive attachment to sensual pleasures. It may well be that the two approaches were not mutually exclusive. The combination of cheese and butter in the breakfast piece by Floris van Schooten (fig. 11), for example, may have been viewed by the Dutch as an indication of waste and as an appeal to moderation.[21] The still lifes by Flegel and Brueghel both represent a vast array of flowers that bloom from all periods of the year (figs. 4, 5) and seem to be celebrations of God's bounty. Nevertheless, the explicit *[moment]o mori* warning in Flegel's still life and the implicit religious symbolism in the wine, nuts, fruits, and choices of flowers are indications to the viewer that he should not be distracted from God's word by such beautiful objects. No such clear statement is evident in the painting by Brueghel, although its composition is similar in type to his still life illustrated in fig. 9 that explicitly states the message conveyed in Flegel's work.

Whatever the religious motivations, by the end of the sixteenth century all levels of society were fascinated by the explorations of the physical world. The scientific naturalism that Joris Hoefnagel practiced in the court of Rudolf II was but one aspect of a widespread interest in describing and codifying the excitingly rich and varied specimens from the plant and animal kingdoms. Books and catalogues describing and illustrating rare and unusual species of flowers, herbs, insects, and animals proliferated. Of the many prominent botanists of the day, perhaps none was more important to the Dutch than Carolus Clusius. Clusius, after a distinguished lifetime of work in Frankfurt am Main, Vienna, and Prague, took up residence as the warden of the *hortus botanicus* at Leiden in 1593. Not only did he introduce to the Netherlands that strange and wonderful flower from Turkey, the tulip, but he was also instrumental in hybridizing it to develop rich possibilities of shape and color.

True to this foundation in scientific naturalism, most early seven-

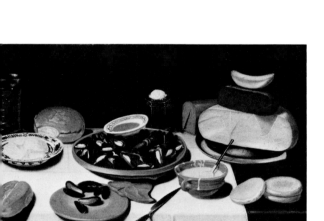

fig. 11. Cat. 32

teenth-century still lifes portray the indiviual objects with great care and with an effort to maintain the individuality of each compositional element.[22] Floral pieces are arranged along a central axis and blossoms are not obscured from vision (fig. 4); breakfast pieces are depicted from a high vantage point so that objects do not overlap and can be clearly seen (fig. 11). Colors tend to be bright and clearly distinguishable. By the 1640s compositional demands had changed and artists sought to subordinate individual objects to achieve a more unified composition. Artists not only obscured the individuality of specific objects by overlapping them, but also deemphasized their color qualities to enhance tonal relationships (cats. 39, 40). These early tendencies came to fruition in Haarlem with the imposing tabletop paintings of Pieter Claesz. (cat. 10) and Willem Claesz. Heda (cat. 18).

By the middle of the seventeenth century a number of stylistic and thematic tendencies come together to create new and vibrant directions for still-life painting. While Jan van Kessel continued to work in the tradition of scientific naturalism (cats. 21, 22), other artists, inspired largely by Jan Davidsz. de Heem, began to incorporate a greater sense of movement into their flower still lifes (fig. 12). When he was in Antwerp during the 1640s De Heem also developed a bold new type of painting, the *pronk* still life, that had tremendous influence in both Flanders and Holland (see cats. 24, 26). In these large-scale works artists included sumptuous displays of fruit and flowers, rich fabrics, unusual shells, musical instruments, finely crafted gold and silver vessels, Chinese import vases and bowls, meat pies, lobsters, and other exotic and costly items.

While suggestions of *vanitas* themes occur in these works, their impetus seems different than was evident in still-life paintings earlier in the century. Partly because of their large scale, but also because of the sheer quantity of objects represented in the paintings and the florid style in which they are executed, these works are more decorative than didactic. This tendency, which allowed artists to demonstrate their extraordinary virtuosity, eventually shifted the focus of still-life painting away from the scientific, religious, and philosophical underpinnings that had so characterized its earlier development. Flower painters delighted in creating complex floral arrangements that demonstrated their ability to depict blossoms twisting and turning in and about one another (fig. 12); trompe l'oeil paintings, which demonstrated an artist's imitative skills, flourished (fig. 2); even images of snakes and butterflies eerily engaged in mortal combat in the depth of night seem less haunting than fascinating for the effects the artist could achieve (cat. 34).

This tendency toward decorativeness at the end of the century gives some measure of support for the objections of the art theorists that still-life painting lacked the seriousness and importance of other genres of painting. Nevertheless, still-life artists continued to consider their

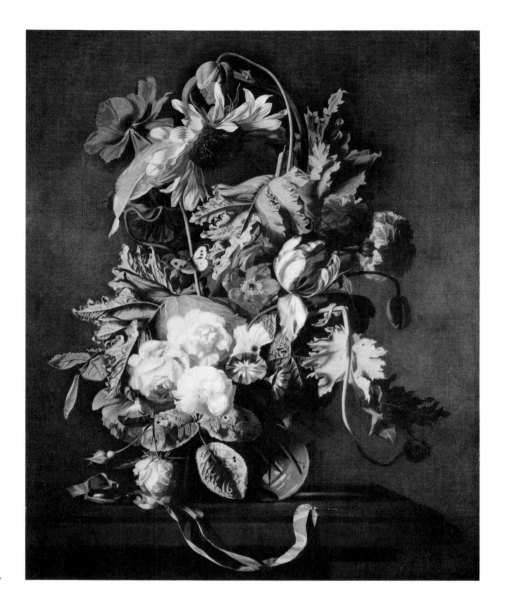

fig. 12. Cat. 44

works worthy of the highest accolades. When Constantijn Netscher painted an allegorical portrait of Rachel Ruysch around 1710 (fig. 13), he emphasized that her fame was largely the result of her being a learned painter. He included references to music in the still-life elements on the table and wisdom in the statue of Minerva in the background. The monkeys by her feet indicate that Ruysch based her art on the imitation of nature. Netscher stressed, however, that her artistic genius transforms still-life objects into images of lasting beauty that bring fame, personified here by the figure flying overhead blowing a trumpet, to her and to the arts in general.[23]

Despite the rhetorical language of Netscher's portrait, the philosophical and moral issues that had been so burning in the early 1600s were no longer of such concern to Dutch society. Elegance, refinement, and

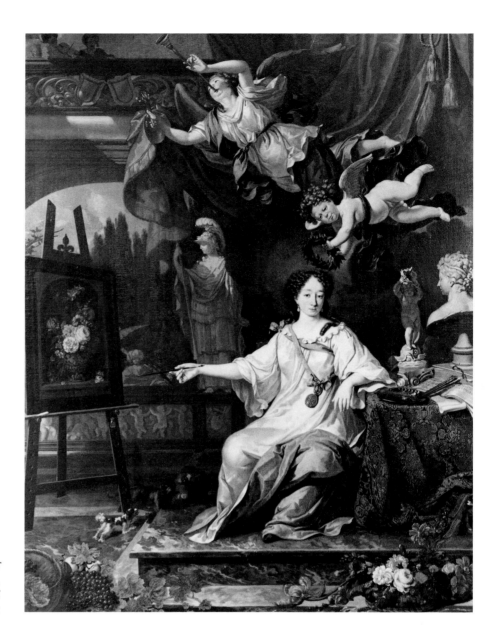

fig. 13. Constantijn Netscher, *Portrait of Rachel Ruysch in Her Studio*, c. 1710. North Carolina Museum of Art, Gift of Armand and Victor Hammer

delicacy of touch were qualities to be admired and prized, and no art form better satisfied these requirements than still-life painting. Not surprisingly, still-life artists were among the most revered painters of the day. Jan van Huysum (1682–1749), through his technical virtuosity and precise observations of flowers and fruit, was perhaps the most famous and influential, but Rachel Ruysch (cat. 31), who is shown in Netscher's painting with a gold medallion from her patron Johan Willem, prince elector of the Pfaltz, hanging from a blue ribbon around her neck, was no less honored by the great collectors of the day. Their combined legacy determined the concept of still-life painting throughout most of the eighteenth century.

NOTES

I would like to thank Cynthia N. Pinkston and Sara M. Wages for their help in conceiving this essay and for their thoughtful comments about its content.

1. See Susan Koslow, "'De Wonderlijke Perspectyfkas': An Aspect of Seventeenth Century Dutch Painting," *Oud-Holland* 82 (1967), 33–56.

2. For an interesting appraisal of the theoretical attitudes toward still life paintings, see Andrea Gasten, "Dutch Still-Life Painting: Judgements and Appreciation," in *Still-Life Painting in the Age of Rembrandt* [exh. cat., Auckland City Art Gallery] (Auckland 1982), 13–26. For the high values attached to still-life paintings, in particular the 600 guilders paid to Jacob de Gheyn for a still-life painting to be presented by the States General to Maria de Medici in 1606, see Van Gelder 1936, 158.

3. Van Hoogstraeten 1678, 76, complained that, while still lifes belong to the lowest echelon of painting, they are greatly admired by collectors. He lamented that the most famous collections are composed chiefly of depictions of "a bunch of grapes, a pickled herring, or a lizard, . . . a partridge, a game-bag, or something still less significant." See also note 5.

4. For a discussion of Dutch history painting, see *Gods, Saints & Heroes: Dutch Painting in the Age of Rembrandt* [exh. cat., National Gallery of Art] (Washington, 1980).

5. Hoogstraeten 1678, 75. "Maer deze Konstenaers moeten weten dat zy maer gemeene Soldaeten in het veltleger van de konst zijn."

6. H.-J. Raupp, "Musik im Atelier," *Oud-Holland* 92 (1978), 106–129.

7. A primary example of Joris Hoefnagel's craftsmanship is his four-volume manuscript *The Four Elements*, preserved in the National Gallery of Art. See *The Age of Bruegel: Netherlandish Drawings in the Sixteenth Century* [exh. cat., National Gallery of Art] (Washington, 1986), 198–200.

8. Bol 1960, 17–18.

9. As quoted in Klaus Ertz, "Introduction: Some Thoughts on the Paintings of Jan Brueghel the Elder (1568–1625)," in *Jan Brueghel the Elder* [exh. cat., Brod Gallery] (London, 1979), 19.

10. As quoted in Jones 1988, 269.

11. Hans Vlieghe, "Constantijn Huygens en de Vlaamse schilderkunst van zijn tijd," *De zeventiende eeuw: Cultuur in de Nederlanden in interdisciplinair perspectief* 3 (1987), 207.

12. For extensive discussions of the religious symbolism of flower and fruit paintings see recent discussions by Sam Segal, in particular. Amsterdam 1982 and Amsterdam 1983.

13. See E. de Jongh in Auckland 1982, 27–38.

14. Ter Kuile 1985, 25.

15. This translation is taken from Ter Kuile 1985, 38. The Dutch text reads: "Wat kyckt ghy op dees blom, die v soo schone schynt/En door des sonnen cracht seer lichtelyck verdwint/Ledt op godts woordt alleen dwelck eeuwich bloeyen siet/Waerin verkeert de rest des werelts dan, In niet."

16. For a fuller discussion of this painting, see *Masterworks from Munich: Sixteenth- to Eighteenth-Century Paintings from the Alte Pinakothek* [exh. cat., National Gallery of Art] (Washington, 1988), 136–138. The Dutch text inscribed on the paper reads: "Maar naer d'Aldershoonste Blom/daer En siet men niet naer 'om."

17. Jones 1988, 261–272.

18. A. G. Morton, *An Account of the Development of Botany from Ancient Times to the Present Day* (London, 1981), 125.

19. A. van Leeuwenhoek, *Collected Letters* (Amsterdam, 1952), 4:257. I would like to thank Aaron M. Kellem for drawing my attention to this reference.

20. Quoted from Bol 1960, 16. The Dutch text reads: "Daer heeftse menich fruyt uyt alle vreemde landen,/ Daer menich aerd-gewas van alle verre stranden,/ Daer bloemen sonder naem, . . ./Daer speelt het geestich nat met hondert watersprongen,/Daer teelt de gulle visch, de hertenkrijgen jongen."

21. See Auckland 1982, 65–69, for a discussion of this issue.

22. The standard book describing the evolution of seventeenth-century still life painting is Bergström 1956.

23. This painting is discussed in the context of an excellent essay on Dutch still-life painting by Susan Donahue Kuretsky. "Het schilderen van bloemen in de 17de eeuw," in *Flora & Pictura. Kunstschrift Openbaar Kunstbezit* (1987), 3, 84–87.

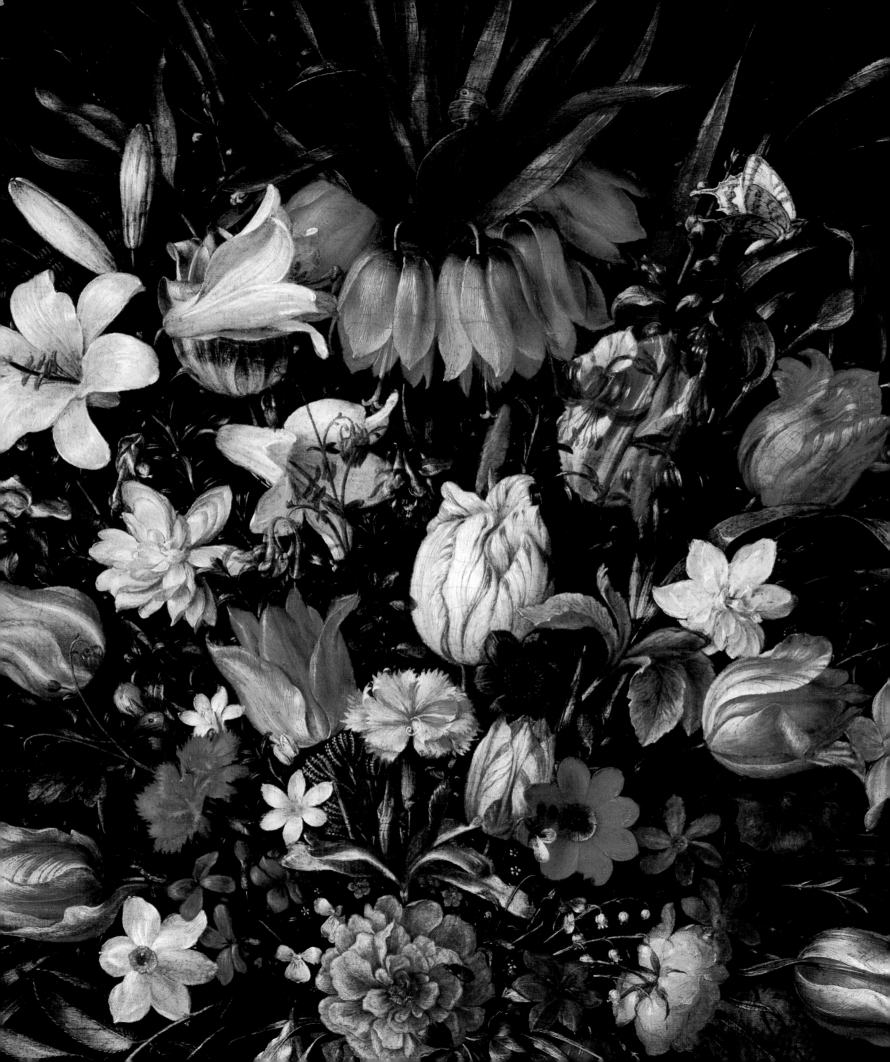

Flower Importation and Dutch Flower Paintings, 1600–1750

ELISABETH BLAIR MACDOUGALL

Tulips, martagon lilies, lilacs, hyacinths—today they are planted in the millions in gardens all over western Europe. Yet none of them are native to Europe, and all of them were considered rare and exotic in the sixteenth century, the period when most were first imported from Asia Minor. At first they were jealously collected and guarded by a small circle of aristocrats and botanists, but by the time flower paintings became a popular genre most of the importations had become widely distributed and available to the middle-class inhabitants of the cities of northern Europe.

Paleobotanists believe that the stock of flowering plants native to western Europe was severely depleted by the sheets of ice that covered most of the continent north of the Alps during the glacial era, and that the result was a smaller and less varied flora than is found in similar climates in non-glaciated lands. Certainly fewer flowering plants are known from the period before the era of plant importation began, and fewer varieties within the indigenous genera. Our knowledge, however, may not be complete, because the information from the Middle Ages has come down to us in the form of treatises on medicinal and culinary plants. It is possible that there were other flowers with purely decorative functions for which there is no record. Today many of the plants grown in the Middle Ages for medicinal and culinary purposes are grown as ornamentals.

Still, if one compares the number of flowers represented in early sixteenth-century manuscripts, as for instance the 59 in the margins of the Grimani Breviary in Venice,[1] with the variety represented in the printed herbals of later in the century, such as the 515 plants, the majority flowering, in Leonhart Fuchs' *De historia stirpium . . .*, or the 840 in Rembert Dodoen's *De stirpium historia Commentariorum Imagines . . .*,[2] the difference is overwhelming.

The explosion in the number of flowering plants available to gardeners in the late sixteenth century was the result of two trends in early Renaissance thinking. One was the development of an intellectual interest in plants above and beyond their use as medicine or for

food. This was part of the new interest in science and the attempt to organize natural phenomena into orderly systems of knowledge, which was seen as a means to a better understanding of God's creations. Botanists, usually medical doctors, began to study and describe all the plants growing naturally in areas near them and also to explore other regions.[3]

At the same time, the great sailing expeditions of exploration began, and with the discovery of the American continents and the establishment of trading colonies in the Far East, the rich and varied flora of these areas was studied and gathered to bring to Europe. These imports were valued for their contribution to the *materia medica*,[4] but also for their exotic nature, just as were the hitherto rare or unknown animal species and races of man—elephants, rhinoceroses, and people from the Americas and the Orient. Rulers and aristocrats collected all of them avidly; menageries proliferated, natives of exotic lands were brought back to Europe, and the gardens of the wealthy blossomed with plants from the distant points of the earth.

Dissemination of information about the discoveries at first was restricted to a small, elite group of aristocrats and to scholars in their service, whose interest was frequently restricted to the rarity and beauty of the plants. Later a more scientific approach was created with the establishment of botanical gardens where the exotica were grown and displayed,[5] the increasingly numerous publications of illustrated botanical treatises, and the emergence of a class of professional botanists. Both the wealthy collectors and the botanists corresponded about and exchanged plants in a network that extended throughout western Europe.[6]

It was almost certainly the interest of the circle of aristocrats that led Ogier Ghislin de Busbecq, Emperor Ferdinand I's ambassador to the sultan of Turkey in the 1550s, to bring back to Vienna what was to become the most famous of all plant importations, the tulip. It is no longer possible to identify exactly which variety he imported, but it was certainly a hybrid grown in gardens of the Ottoman court in Istanbul, the result of centuries of selection and cultivation by Turkish and Persian experts.[7] Specimens were solicited by directors of all the botanic gardens, including Charles l'Ecluse (also known as Clusius) at the newly founded garden in Leiden. There, the facility with which tulip varieties could be propagated was soon exploited and dozens of new hybrids were created. The brilliant hues and variegated color patterns of the new flowers were instantly popular, and a large commercial market for them developed.[8]

Commercial success spurred other ambassadors to the Near East to bring back examples of other "florist's flowers," that is hybridized cultivars, and soon many other plants had been imported and became established in European gardens. Florilegia of the period bear testimony to the Near Eastern origins of many of the plants depicted by calling

them "Constantinopolitan," "Chalcedonian," "Botryoides," "Greek," "Persian." American names such as "Canadian," "Peruvian" testify that plants were brought back from the New World too.[9] Dutch traders were particularly prominent as plant importers, for their ships sailed to the Far East and to the Americas, and they were among the first to develop commercial nurseries for the propagation and sale of the new discoveries.

The importations were popular because they introduced vivid colors—oranges in lilies and marigolds, yellows in roses and narcissus, reds in poppies and anemones, and blues and purples in hyacinths—which were not common or even existent in native plants. Also, many of the new flowers were striking in size and shape, as for example the crown imperial and the sunflower, both of which appeared in many flower paintings, with their large flower heads in brilliant orange or yellow rising on stems three or more feet high.

The majority of the imports were bulbous or tuberous plants, although there were exceptions, such as the marigolds, calendulas, and sunflowers. Bulbs were the easiest to bring back, since the long sea voyages made it impossible to transport live plants, and seeds were more difficult to culture than the bulbs. Even the latter were not uniformly successful; collectors' correspondence and the scanty horticultural literature of the period are full of complaints when plants failed to bloom or of disasters when bulbs rotted in the ground. That this must have often been the case seems clear, for many of the importations came from dry, hot climates, and could not tolerate the dampness of the air and the ground in western Europe.

Little is known about the way these plants were grown in the gardens, for planting plans except for botanical gardens have rarely survived. Paintings and prints show that the gardens were usually walled, especially the small town gardens characteristic of Belgium and the Netherlands (fig. 1). Pergolas of wood or evergreens trained over frameworks usually lined the walls, while the garden center was marked by a fountain, statue, or specimen tree. The enclosed space was divided into regular spaces, usually symmetrical, by paths, with flower beds in geometric shapes between them. Their outlines were clearly marked by bricks or low borders of clipped herbs. In one of the earliest florilegia, Crispin van de Passe's *Hortus Floridus*, the title page of each of the four parts represents a garden of this type (fig. 2).[10] Most of the plants depicted in this page are the popular imports. One can see tulips, the ever-popular crown imperial, martagon lilies, narcissi, double anemones, as well as European iris and what appear to be primulas. Except for the tulips, which are densely grouped, the plants are widely spaced; evidently the purpose of the design was to emphasize character and the importance of individual specimens, not to create large color patterns.

The *Hortus'* divisions correspond to the seasons; each of its title

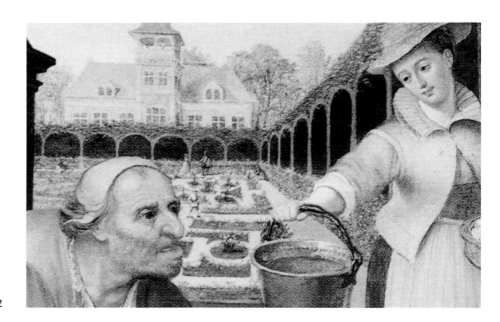

fig. 1. Detail, cat. 42

pages shows the same garden, but two, "Spring" and "Autumn," have different flowers.[11] This suggests that plants were removed after they flowered, and that new plants in flower were brought in for the new season. This practice of bedding out, as it is called, can be documented in other parts of Europe, so it was probably common practice.

If gardens were commonly planted as they appear in Crispin van de Passe's views with the aim of drawing attention to the single flower, flower paintings show an entirely different concept. Usually they consisted of mixed bouquets of flowers and greens densely packed in vases or other containers. Paintings of a single flower are extremely rare,[12] as are paintings of a single genus or variety of flower, such as Jacob van Hulsdonck's *Carnations in a Glass* (cat. 20). The flowers are usually shown in all stages, from bud to full-blown to wilted and dying, and in many different aspects, from the rear, from the side, or drooping from a stem, so that most of their characteristics of growth are shown.

This fact and the precision of the depiction of the flowers and their leaves permits botanical identification of the plants commonly found in these paintings.[13] Surprisingly, in view of the great numbers of plants available in the seventeenth century, a careful study of the flowers shows that a limited group was used, and that a few flowers tended to dominate the compositions. Most prominent are the tulips, which appear in every flower painting in the exhibition except Hulsdonck's *Carnations*. The decades of the tulipomania were a time when many flower paintings were created, but the popularity of tulips is

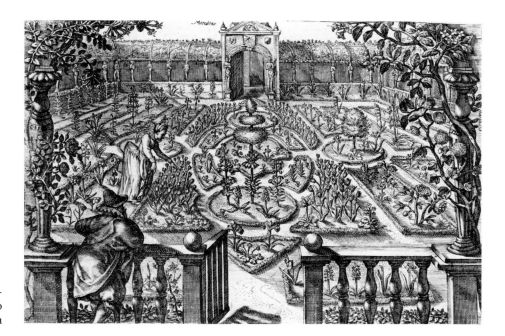

fig. 2. Crispin van de Passe, *Hortus Floridus* . . . (Utrecht, 1614), title page. Photo courtesy Dumbarton Oaks, Washington

constant throughout the period represented in this exhibition. Only a few solid-colored blooms appear, despite the fact that they were grown and sold in great numbers. Striped and multi-colored types were the favorites in these pictures, with mixtures of red and orange or yellow dominating. Some have blue or purple borders, and in a few white dominates (cats. 2, 8, 21). It is possible that some of these tulips were imported species, but it is much more likely that they were hybrids developed for the lucrative market.

Poppies and anemones appear frequently. The former are usually Opium or Oriental poppies, and were recent importations. They are shown in their original native forms. The anemones, however, are not only the plain *A. coronaria*, an import, but include many of the hybrids that were extremely popular in the seventeenth century.[14] Single and double forms and multicolored and plain-colored types are visible in many of the paintings.

The composition of the bouquets in vases is pyramidal and called for a strong accent at the peak. One of the most popular flowers for this position is the crown imperial (*Fritillaria imperialis*), an importation from Asia Minor. This striking plant with its heavy crown of pendant blooms provides a fitting climax to Georg Flegel's *Vase of Flowers, Wine Glass, and Fruit* (cat. 15) and features prominently in Jan van Kessel's *Flowers in a Porcelain Vase* (cat. 21).

Prominent among the importations are the martagon lilies, or Turk's Caps—some from the Near East, others species or hybrids of the Canadian lily—and the checkered fritillaries (*F. meleagris* L.) prized for their

distinctive shapes or patterns. Tazetta and poeticus narcissus, ornithogalums, hyacinths, and annuals such as marigolds, calendulas, and nasturtiums are frequently included in the bouquets.

Indigenous plants also play a prominent role. Roses are the second most common flower to occupy a dominant position in compositions. Many, of course, were native to Europe, such as the Gallicas and the Centifolias which are most common, but the yellow roses that appear in Balthasar van der Ast's *Basket of Flowers* (cat. 2) were recent importations from the Near East.[15] Irises, which also appear in most of the paintings, are usually native European; they, like roses and the big double peonies, had been popular garden flowers since Roman times.

Madonna lilies, probably not native to western Europe but documentable there in the Middle Ages, were also used in many paintings. Many of the smaller flowers are native to Europe: the lily of the valley, the columbine, the violas for example, as well as a number of the trumpet daffodils.

The flowers represented in the paintings in this exhibition and in the vast majority of flower paintings of this period are a fairly equal combination of native and imported plants. The importations, however, had long been established in gardens in Europe and were readily available commercially or by exchange. Numerically, those found in these pictures formed only a small proportion of the known importations. For example, the earliest two volumes of the painted atlas of plants in the botanic garden in Amsterdam represented ninety different species, and the record of a garden owned by a German cardinal in Eystatt, Germany, shows that more than a thousand different species grew there.[16]

By the seventeenth century even the imported flowers that appear in flower paintings had become widely available and were commonly grown in even the most modest gardens. All but a few, such as jasmine or orange blossoms, could be grown outside in the small town gardens, which were depicted by Crispin van de Passe (fig. 2) or in the book of garden designs by Vredeman de Vries.[17] They were no longer exotics.[18]

Whatever their allegorical content may have been, it seems safe to say that these paintings represented the flowers that were grown by the Dutch middle class in the gardens that were part of their everyday life. By depicting flowers from all seasons of bloom, the paintings brought indoors an undying record of their gardens in spring and summer.

NOTES

1. Biblioteca Marciana, ms. Lat. I, 99. See Horst Wolf, *Die Meister des Breviarium Grimani* (Berlin, 1982). The floral margins appeared in many manuscripts produced by a school of illuminators active in Ghent in the late fifteenth and early sixteenth centuries. For other examples of this school, see Patrick de Winter, "A Book of Hours of Queen Isabel la Católica," *Bulletin of the Cleveland Museum of Art* 67 (1981), 342–407.

2. Basel, 1542, and Antwerp, 1559, respectively.

3. Pietro Andrea Mattioli, *De plantis epitome . . . Compendium de plantis omnibus . . . Accessit . . . opusculum de itinere, quo è Verona in Baldum montem plantarum refertissimum itur* (Venice, 1586); Charles L'Ecluse, *Rariorum aliquot stirpium per Hispanias obseruatorum historia* (Antwerp, 1576).

4. Nicolas Monardes, *Primera y segunda . . . partes de las cosas que se traen de nuestras Indias Occidentales que siruan en medicina* (Seville, 1574). It was translated into English by John Frampton and published with the title, *Joyfull newes out of the newe founde worlde, wherein is declared the rare and singular vertues of diverse & sundrie herbes, trees . . .* (London, 1577).

5. The earliest of these gardens, in Pisa and Padua in Italy, were founded in the 1540s; in the Netherlands, a garden in Leiden was founded more than forty years later.

6. Georgina Masson had discussed specific examples of this kind of correspondence and exchange between collectors, botanists, and explorers in "Italian Flower Collectors' Gardens in Seventeenth-Century Italy," *The Italian Garden*. First Dumbarton Oaks Colloquium on the History of Landscape Architecture, ed. David Coffin (Washington, 1973).

7. There is a large literature about the importation of tulips and the subsequent craze we call tulipomania. See Schama 1987, 350–365, and bibliography, 666.

8. These blazed tulips, a kind now called "Rembrandts," were actually the result of a virus, and as a result did not breed true. This added immeasurably to the risks and rewards of the tulip trade in the 1630s, when speculation created the tulipomania.

9. Florilegia, books with illustrations of ornamental flowers and with no scientific purpose, were a new genre that developed in the late sixteenth century. Most of the early ones were published in Belgium and the Netherlands. A typical example is Emmanuel Sweerts' *Florilegium* of 1612, printed in Frankfurt, but advertising the plants for sale at his nursery in Amsterdam.

10. (Utrecht, 1614).

11. The title pages for "Summer" and "Winter" are replicas of the title page of "Spring."

12. Two examples, one by Balthasar van der Ast in the Müllenmeister Gallery in Solingen and another by Dirck van Delen in the Boymans-van Beuningen Museum in Rotterdam, were included in Amsterdam 1982, cats. 39, 40.

13. This has been done by Sam Segal for six paintings in Amsterdam 1982, 83, 95, 104, 109, 113.

14. Masson 1973, 220–224.

15. Yellow roses are indigenous to Iran, Turkey, and neighboring countries. They had been introduced to western Europe by 1560. The large, double, bright yellow rose seen in many paintings was first mentioned in print c. 1600.

16. For the Amsterdam garden see D. O. Wijnands, *The Botany of the Commelins* (Rotterdam, 1983), 22–24. The plants in the German garden were represented by Basilius Besler in *Hortus Eystettinius* (Eichstatt; Nuremberg, 1613). A facsimile of a colored copy in the Musée d'Histoire Naturelle in Paris has recently been published as *L'Herbier des quatre saisons ou le jardin d'Eichstatt* (Paris, 1987).

17. Johannes Vredeman de Vries, *Hortorum viridario elegances multiplices formae . . .* (Antwerp, 1583).

18. One should contrast the flowers in these paintings to the most unusual and rare plants, which could only be found in the great royal or aristocratic gardens of the period and in the botanic gardens stocked with importations studied for their potential as medicines or for their contribution to the new science of botany.

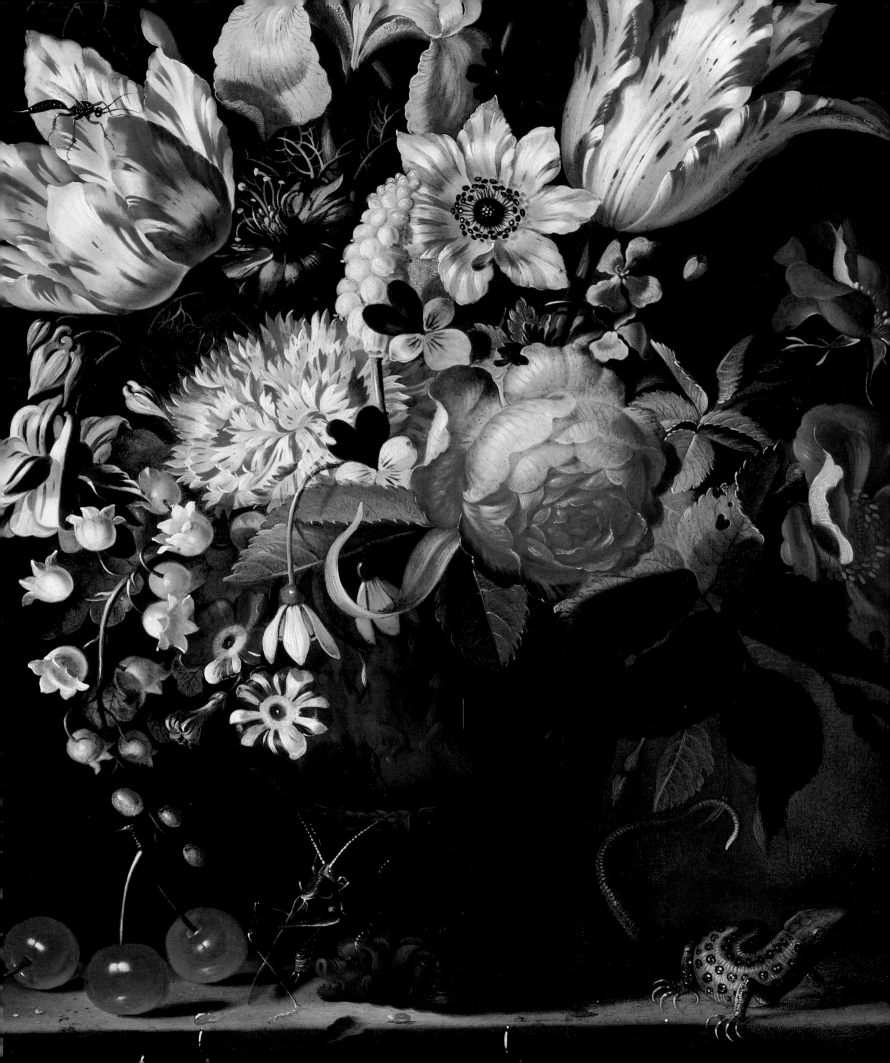

A Little World Made Cunningly: Dutch Still Life and Ekphrasis

LAWRENCE O. GOEDDE

Interpretations of Dutch still lifes as symbolic of the transience of life or of sensual pleasure have become increasingly familiar in recent decades.[1] The empty vessels in breakfast and banquet still lifes by Maerten Boelema or William Claesz. Heda and the presence of insects and drops of dew in flower pieces by Jan Brueghel the Elder, Jacob van Hulsdonck, or Jan van Kessel are details typically read as keys to the meaning of the pictures. In this view most still lifes are *vanitas* images, but some are also understood as containing admonitions to moderation or as symbols of such things as eucharistic doctrines.[2] Such interpretations depend upon a rich metaphorical vocabulary derived from emblematic sources, which are pictures with interpretive texts. In sharp contrast to this emblematic model, however, Dutch still lifes have also been traditionally seen as triumphs of accurate description, a view that has led to their being interpreted by analogy to the methods, outlook, and purposes of the new science.[3]

In many respects neither interpretation really satisfies. In applying emblematic sources to still-life paintings themselves,[4] we turn the paintings into emblems in effect, despite the significant differences between the two classes of imagery, not the least of which is the absence in most still lifes of the texts typical of emblems. The analogy of the emblem seems to result in images in which meaning and the objects themselves become divorced. On the other hand, the model of the new science is contradicted by the fact that these paintings, though marvelously naturalistic in appearance, turn out to be surprisingly conventional and selective in terms of what they portray. Their naturalism has neither the comprehensiveness nor the objectivity associated with scientific description.

One reason for our reliance upon these methods of interpretation lies in the near absence of seventeenth-century comment on still-life paintings. In the Dutch classicizing theory of art these pictures are considered hardly worthy of discussion, since they involve mere imitation of nature without regard for the selective representation of what is most noble and beautiful in nature, the human body;[5] such selectivity

is required to carry out the purposes of art: to delight, to instruct, to edify. Indeed, when the theorist Samuel van Hoogstraeten referred to still-life painters as foot soldiers in the army of art,[6] he put still life into the lowest of three levels of excellence, conceding value to it only because of its imitative capacity.[7] Yet highly gifted and skilled artists persisted in producing, and people persisted in buying, works in this low genre. Some such images, notably flower paintings, could on occasion command higher prices than most history paintings.[8] Moreover, despite the ever-stronger influence of classicizing tastes on Dutch culture, the proportion of still-life paintings in inventories of Dutch collections tripled, from less than five percent in 1610–1620 to more than fifteen percent in 1651–1675.[9]

Both classicizing theorists of the seventeenth century and modern scholars have neglected certain features of Dutch still life that deserve more consideration in an attempt to grasp the meaning and purpose of these pictures. These features are the conventionality and artifice of Dutch still lifes and the qualities of form and theme that provoke a meditative engagement on the beholder's part (such as allusions to the passage of time). Such characteristics suggest another anology for the interpretation of still life: depictions of the human figure in history painting, genre, and portraiture; and another method of discovering meaning in still lifes: descriptions of pictures in seventeenth-century Dutch literature.

Neither accepted model of interpretation addresses the consistency of objects, settings, compositions, and light effects in Dutch still life. Different categories of still life existed in the terminology of seventeenth-century inventories.[10] Examples include the flower piece, breakfast piece, banquet piece, fruit piece, kitchen piece, game piece, fish piece, *vanitas* or death's head still life, and the *bedriegertje*, perhaps best translated as trompe l'oeil. Within each class there is a limited repertory of objects and compositions that seem to be partly related to patterns of food consumption and levels of luxury.[11] We cannot, however, regard them solely as records of daily life and social customs, for the consistent repetition of objects and settings in, for example, breakfast pieces would lead us to believe that meals were eaten alone, standing at the corner of a table, and always beginning with the peeling of a piece of fruit. Dutch still lifes reveal neither a programmatic inventory of objects in the home nor records of real meals, and this selectivity argues against the notion that these pictures are direct records of the visible world of the Dutch home.[12]

Such conventions exemplify the artifice of these pictures. Contrivance is evident also in images that depict flowers that bloom at different times of year, such as the snowdrops and roses frequently seen in the same flower piece, or objects that were rare luxuries not owned by the artist, such as the elaborate goblets in Willem Kalf's paintings.[13] The objects and their arrangements were also not necessarily part of

daily life. This is obvious in the luxurious display banquet pieces by such artists as Kalf, Abraham van Beyeren (cat. 5), and Jan Davidsz. de Heem (cat. 19), which we now call *pronk* still lifes.[14] There is even doubt as to how common flower bouquets were in homes. They appear in genre interiors infrequently; and some authorities state, probably too categorically, that flowers were not ordinarily displayed in Dutch homes of that time.[15]

Artifice is also evident in the fact that objects are put into impossible compositions. Many flower pots would hardly stand up, and the fruit hanging nonchalantly over the edge of a table often defies gravity. Most revealing in this regard are the difficulties the photographer Stanley Wulc described in setting up real still lifes modeled on Dutch pictures, which he then photographed.[16] He found that fruit must be supported by hidden armatures; leaves kept alive by hidden vials of water; lighting controlled by boxes with a single opening; and in flower pieces, carefully wired bouquets rushed from the refrigerator when setting and lighting are perfect. Placement, form, and lighting in Dutch still lifes are contrived with the greatest care.

This artifice has a number of goals, chief of which is the presentation of objects so that they are believable and palpable but also heightened and dramatized. These objects are most often not set in rooms, but isolated in the foreground against neutral backgrounds. Dramatic revelatory lighting enhances their vivid presence. So also do spatial projections of knives, plates, and lemon peels over the edges of tables, an activation extended by crossing diagonal arrangements of objects into depth. Furthermore, compositions are carefully devised to create echoes and contrasts of texture, reflection, and form.

Dutch still lifes are isolated from ordinary life; yet they are given a temporal dimension and sensual immediacy similar to that found in history and genre painting. As in history and genre, still lifes have the capacity to induce an imaginative, empathic response. The paintings call for a scrutiny and savoring in the imagination and intellect that resembles the contemplation prompted by history and genre painting. It is this capacity to elicit "imaginative sympathy" that locates still lifes within the western tradition of mimetic naturalism.[17]

The analogy to depictions of the human figure conforms to the assumptions underlying metaphorical interpretation in the seventeenth century. Such interpretations depend on an accepted cosmology of purposeful correspondences between microcosms and a macrocosm that gives rise to what Marjorie Hope Nicolson called the "habit of thinking in terms of universal analogy."[18] Seventeenth-century man considered himself to be such a microcosm, "a little world made cunningly," whose entire being mirrors and is mirrored in the structure, order, and meaning of the cosmos in its entirety and in every detail.[19] Given such assumptions one may seek in still lifes metaphors of human experience and life, for still lifes too are microcosms, isolated

from ordinary life in both time and space.[20] Like man, a still life seems to figure in small the great world, as hinted at in those relatively rare still lifes depicting objects in landscape settings where the still life is literally a realm distinct from the vastness of nature and yet significantly juxtaposed with it.[21] Ambrosius Bosschaert more than once set a flower piece against a vast landscape, suggesting its relation to that world as an epitome of it.[22] De Heem too occasionally juxtaposed landscape and still life as in a painting in Toledo (fig. 1), where the still life seems to offer security and pleasure in contrast to the view of a storm with boats running into a harbor marked by a light tower. Yet here the two realms mutually comment on each other; the capacity for sensual over-indulgence suggested in the still life by the overtly erotic treatment of the ham and melon corresponds to the peril of the boats driving into shore in the storm, a commonplace metaphor for man in the throes of sensual passion.[23]

One further advantage of the analogy to figural imagery is that it closely complements the one seventeenth-century literary source that offers direct evidence for the interpretation of still life, rhetorical descriptions of works of art. In them authors described pictures with an expansive, imaginatively engaged projection of emotion and thought that responds to both the vivid naturalism and the dramatized compositions characteristic of seventeenth-century pictures, whether history paintings or still lifes. In the seventeenth century, accounts of art were directly modeled on the classical rhetorical figure of *ekphrasis*, an extended, elaborate description that aimed at the evocation in words of such subjects as people, places, buildings, incidents, and works of art, both real and imaginary.[24] Such *ekphraseis* were said to possess *enargeia*, which Quintilian remarked "makes us seem not so much to narrate as to exhibit the actual scene, while our emotions will be no less actively stirred than if we were present at the actual occurence."[25] This characteristic imaginative projection partly results from one of the standard preoccupations and themes of *ekphrasis* as a literary form, the capacity of words to rival and surpass the lifelike power of visual art. Competition with the visual arts was not, however, the only purpose of literary description. A pictorial vividness of description had as its explicit purpose to engage the reader in experiencing the scene described with as much intensity as possible and thereby to induce reflection on and awareness of its moral and philosophical implications.[26]

While *ekphrasis* is part of a long verbal tradition, its concerns and characteristics are closely related to those of artistic theory and practice in the Renaissance and the baroque era. The emphasis given to mimetic accuracy in *ekphrasis* corresponds to one of the primary criteria of value in all discussions of art and artists in that era; and, given the character of Dutch painting, we must assume that in practice this verisimilitude was highly prized by artists and their public alike. In addition, the pervasive belief in the essential kinship of images and words

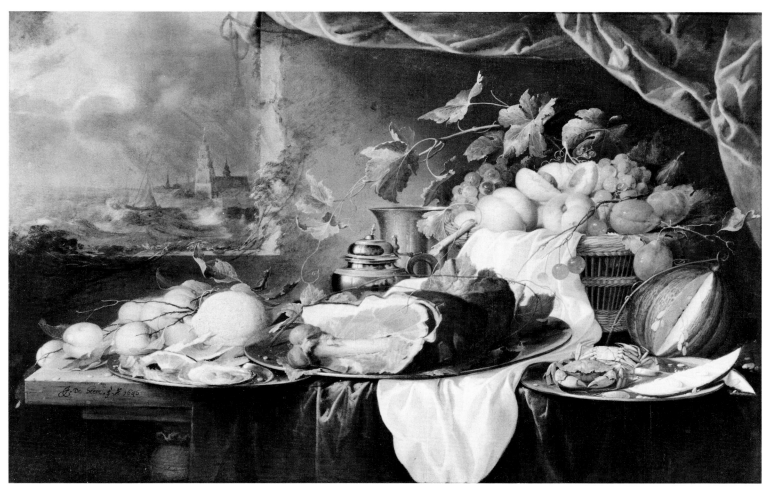

fig. 1. Jan Davidsz. de Heem, *Still Life with a View of the Sea*, 1646. The Toledo Museum of Art, Gift of Edward Drummond Libbey

by virtue of the principle of *ut pictura poesis*, that painting is mute poetry, poetry a speaking picture, meant that the preoccupations and characteristics of one art were sought and found in the other. From Leone Battista Alberti and Lorenzo Ghiberti in the first half of the fifteenth century through Vasari and into the eighteenth century, ekphrastic description was, as Svetlana Alpers observed some years ago, the ordinary means of discussing specific works of art.[27]

Although the Renaissance tradition of ekphrastic description originated in Italy, the Dutch were fully aware of and participated in it. Such descriptions are found in Karel van Mander's *Schilderboeck*[28] and in Constantijn Huygens' celebrated account of Rembrandt's painting of 1629, *Judas Returning the Thirty Pieces of Silver*, which is entirely typical of the emotional and temporal projection characteristic of the genre:

. . . the posture and the gestures of this one despairing Judas . . . who, out of his mind and wailing, implores forgiveness yet holds no hope of it, or has at least no trace of hope upon his countenance; that haggard face, the hair torn from the head, the rent clothing, the forearms drawn in and the hands clasped tight together, stopping the blood flow; flung blindly to his knees on

39

the ground in a violent access of emotion, the pitiable horror of that totally twisted body. . . .[29]

That history paintings should be "read" by analogy to *ekphrasis* seems obvious. But that *ekphrasis* offers a model for viewing other genres of painting, such as landscapes and still lifes, is indicated by the fact that all accounts of specific artworks more elaborate than inventory entries either implicitly assume such a reading or explicitly engage in one. Though less common than accounts of portraits and history paintings, seventeenth-century descriptions of landscape and seascape paintings respond to them in exactly this rhetorically expansive manner, and the rare instances in which seventeenth-century still lifes were described are similarly rhetorical in character.[30] Moreover, Dutch still lifes themselves invite and provoke exactly this sort of meditative, empathic response from the viewer through their engaging realism, their subject matter resonant with human connotations, and their compositions that resemble those of history paintings in being contrived to draw the viewer into the space and incident of the image. Furthermore, this process of engaged viewing respects and responds to the naturalism of the images and allows metaphor to emerge within the whole of the picture.

Perhaps the most elaborate description of a Dutch still life is a poem from a cycle of *ekphraseis* dated 1646 by the Dutch poet Joachim Oudaan titled "On Painting, Drawing, and Needle-Work in the Home of Miss J. V. D. B."[31] The poem is titled simply "On a Flower Pot," and while we cannot know exactly what he was looking at, in all likelihood it was a typical Dutch flower piece (perhaps such as cats. 8 or 25). Throughout the poem the poet's sentiments are expressed in a way that addresses the visual richness of such images and expands the range of association beyond what iconographic analysis ordinarily finds in such flower paintings.[32] The poem of five stanzas begins thus:

See how sweet spring amorously glances. A chest of ornaments adorns her: her embroidered gown is enriched with gold and purple threads. And where she sets her feet, our eyes wander in the color, and also her fragrance permeates more than musk.

In the first stanza the poet seemingly turns the bouquet into an almost Arcimboldo-like personification of spring, for he juxtaposes the prosaic title, "On a Flower Pot," with a sensually vivid allegorical figure, as though the flower pot had come to life. That he is not describing an actual allegorical figure in the painting is suggested by both the disappearance of this figure in stanza two and the presence of similar personifications of spring in Jan Vos' *ekphraseis* of flower still lifes by Willem van Aelst and Daniel Seghers.[33]

Oudaan's account is remarkable for its emphasis on the viewer's participation in viewing the scene. He directs the viewer to "see" how Spring glances and describes how our eyes wander in the color. And

Spring herself glances amorously, perhaps at us. One aspect of these flower pictures that ordinary iconographic interpretation has neglected is their remarkable sensuousness, which is clearly one of the qualities of the picture that interested Oudaan the most. Indeed, Oudaan found in the flower piece virtually the embodiment of four of the five senses. In this stanza not just sight but smell is evoked, as are taste and touch in subsequent stanzas. The poem itself can be heard, and thus perhaps triumphs over art. In any case, Oudaan's appeal to the senses is linked to the typical ekphrastic concern with the affective power of painting and the capacity of poetry to rival this power.[34] And this concern is in turn related to the theme of creating as means of rivaling and surpassing the sensual opulence of nature and of defying the power of time. These themes are more evident in the second stanza where it becomes clear that the figure of Spring is distinct from and, in its ephemerality, inferior to the painting itself:

But alas! The time already approaches when she is put to flight. Now a bold hand gathers the wealth of her blossoms and binds them in a bouquet so that these flowers (as sweet as sugar) might not be lost so soon to time's bitter bite.

The juxtaposition of sweetness with bitterness articulates a sensuousness in this image that persists even in death.

In the third stanza it is the power of the image to defy death and time that is celebrated:

But alas! How short a time and the blossom must wither. Yet there is a means whereby the rose will not wither and perish. It will endure in secure colors, planted to measure by Zeuxis' hand, much better than in damp sand.

Being "planted to measure," the artist's activity possesses an order of rhythm and proportion like that of nature itself but surpassing nature in that it endures. This puts a different light on the symbols of transience everyone has learned to identify in these pictures: the flies, bug holes in leaves, dew drops, blown flowers, wilted leaves, and so forth. For Oudaan such motifs aroused not just thoughts of death but also reflections on creativity in defiance of death. The depredations of insects and of time have been forever halted by the artist.[35] This theme is elaborated in the fourth stanza, which emphasizes the actual making of the work as a metamorphosis of matter into something of enduring beauty and pleasure:

He sets his brush to the panel and works briskly, beginning a stroke that becomes a flower. In the midst of the crusts of piercing frost and packed snow, Winter will view this with pleasure in Spring's place.

In this stanza the bouquet replaces the allegorical figure of the first stanza as an embodiment of spring, which gives it a much broader, indeed a cosmic reference, tying it to the cycle of life and making it an epitome of landscape as a whole. This relation to landscape, a sense

that a still life like a human being is a representative, a microcosm, that manifests in small the macrocosm, is something suggested in a number of still lifes set against landscapes. This identity of the flower piece with a landscape is, in fact, crystallized in the last stanza, as the rivalry of art and nature is resolved in the victory of art, for the picture evokes for Oudaan a perfect paradisaical garden.

This work indeed yields nothing to life. No trained rose arbor gives more beautiful roses. No tulips, no narcissus ever met so suitable, so fine a likeness. Neither caterpillar nor butterfly will ever put this to shame.

The reflections stimulated by the painting move from voluptuous sensuality to death to transcendence.

It is striking that the individual associations a flower piece evokes from Oudaan are not essentially different from those discovered by purely iconographic research. However, the monitory theme of transience, which is usually identified as the moral of such pictures, turning them into *vanitas* images, is given in the poem a more sensuous fullness than our approach of treating them as catalogues of decay and evanescence. In the poem, moreover, transience is considered in a broader context, for the bouquet becomes the embodiment of youth, love, and spring, and consequently a work that induces meditation on human life, emotion, the cycles of life and of nature, and on human creativity in time.[36] In the context of seventeenth-century culture any of these themes would be as appropriate to interpreting a flower piece as the themes of transience or *vanitas* alone. It is revealing, moreover, that Jan Vos' poems on flower pieces possess a nearly identical range of associations, though expressed in more conventional, less expansive terms.[37]

Oudaan's reading of the flower piece supports Anne Lowenthal's observation that Dutch still lifes are metaphors of choosing, for they invite meditation on objects charged with multiple sensual and metaphorical associations.[38] They demand our engagement as we study their many implications. Oudaan's poem recognizes both the figural and temporal qualities of Dutch still lifes much as we have discussed them: pictures painted not as records of daily life but as exemplary objects isolated from mundane life, and referring to the human body and to our lives both in the function of the things they represent and in the metaphors they evoke.

In proposing the analogy of figural art and the complementary rhetorical, ekphrastic model for interpreting still lifes, I do not mean to suggest that we free-associate in contemplating a picture, nor that we abandon iconographic research. Rather, I would propose that in interpretation we bring our knowledge of iconography, of metaphorical connotations and cultural associations and, indeed, everything we can learn about the cultural context, to bear on the pictures through a process of detailed, imaginatively engaged scrutiny like that used in *ek-*

phrasis. This is not to suggest that ekphrastic descriptions necessarily shaped or determined the character of a given picture or that a Dutch painter of fruit or flowers expected people to write descriptions of his pictures. Rather *ekphrasis* and the figural analogy provide insight into the ways people responded to images at that time, and they seem to suit actual visual properties of many Dutch pictures.

Viewed by analogy to the human figure and with a projection of thought and feeling akin to the rhetorical reading of images characteristic of *ekphrasis*, still lifes can be seen to function neither as moral lessons only nor as records of appearances only, but rather as evocative and compelling repositories of meaning, whose detailed naturalism and artifice of structure move the beholder. These pictures are much more like history paintings or genre scenes in this account; they are objects for contemplation and for emotional and intellectual engagement. The conventionality and artifice of Dutch still life present us with compelling sensual and temporal presences so that in a little world we may contemplate the great world and ourselves.

NOTES

1. See the pioneering work of Ingvar Bergström in Bergström 1955, 303–308, 342–349, and for *vanitas* symbolism, Bergström 1956, 154–189. See also the many *vanitas* and transience symbols proposed for fruit and flower still lifes by Sam Segal in Amsterdam 1982, and in Amsterdam 1983. See also Joseph Lammers, "Fasten und Genuss: die angerichtete Tafel als Thema des Stillebens," in Münster 1979, 402–428.

2. For still lifes and temperance, see Bergström 1956, 189–190. On eucharistic symbolism, see Christian Klemm, "Weltdeutung—Allegorien und Symbole in Stilleben," in Münster 1979, 182–190.

3. For the view of Dutch still lifes as faithful records of the visible world painted with a scientific naturalism, see Andrea Gasten, "Dutch Still-Life Painting: Judgements and Appreciation," in Auckland 1982, 14–19. On the analogy between Dutch still life and the new science, see Alpers 1983, 72–109.

4. See E. de Jongh's critical assessment of this kind of interpretation of still life: "The Interpretation of Still Life Paintings: Possibilities and Limits," in Auckland 1982, 27–37.

5. Hoogstraeten 1678, 75–77, 86–87, is generally dismissive of still life. Gerard de Lairesse, in contrast, devotes two books of his *Groot Schilderboek* (Lairesse 1740/1969, part 2, books 12, 13) to still-life and flower painting, but his comments bear little relation to actual Dutch paintings. His prescription of the most beautiful and pleasing as the only proper subject of still life (259–260) and his rejection of all that is common, ordinary, old, and ugly, no matter how well or naturalistically painted (267) excludes a vast range of Dutch still life. While De Lairesse required a still life to have a concealed meaning ("verborgene betekenis") in order to instruct the beholder in virtue, his conception of such meaning in practice involves viewing a still life as a detailed allegory in which each object has a specific significance in an almost hieroglyphic manner (268–298).

6. Hoogstraeten 1678, 75. For the Dutch text, see Wheelock essay in this volume, note 5.

7. Hoogstraeten 1678, 75–77.

8. Bergström 1956, 45–47, 54. Average prices for still lifes were roughly similar to genre and landscape paintings but lower than history paintings. See Alan Chong, "The Market for Landscape Painting in Sev-

enteenth-Century Holland," in Peter C. Sutton, *Masters of Seventeenth-Century Dutch Landscape Painting* [exh. cat., Museum of Fine Arts] (Boston, 1987), 116, table 1.

9. Chong 1987, 116, table 1. See also John Michael Montias, *Artists and Artisans in Delft: a Socio-Economic Study of the Seventeenth Century* (Princeton, 1982), 246, and table 8.3.

10. For this terminology, see Lydia de Pauw-de Veen, *De begrippen "schilder", "schilderij", en "schilderen" in de zeventiende eeuw* (Brussels, 1969), 141–157.

11. See the brief comments in Schama 1987, 160–161. See also Lammers in Münster 1979, 402–428. Lammers' symbolic interpretations should be treated with reserve, but he makes a number of comments about the degree of luxury represented in various images.

12. Important steps toward an inventory and classification of large numbers of paintings and the development of a typology of still life that might define the conventions governing the choice of objects depicted are the discussions of flower still lifes and fruit still lifes by Sam Segal in Amsterdam 1982, 26–27, 37, 44–46, 54–55; and in Amsterdam 1983, 44–49, 59–60, 70–72, 81–82.

13. That flowers of different seasons are assembled in Dutch still lifes was observed in Van Gelder 1936, 165–166. Sam Segal, "Symbol and Meaning in Still-Life Paintings," in *The Royal Picture Gallery Mauritshuis*, ed. H. R. Hoetink (Amsterdam and New York 1985), 95, commented that even with modern forcing techniques and jet travel, such flower still lifes could not be assembled from living blooms. On the precious objects in Kalf's paintings, some of which can be identified, see Grisebach 1974, 120–129.

14. Segal 1988.

15. Van Gelder 1936, 165–166, noted the rarity of bouquets in domestic genre scenes and pictures of banquets, and viewed the common usage of flowers in interior decoration as a nineteenth-century phenomenon. Peter Thornton, *Seventeenth-Century Interior Decoration in England, France, and Holland* (New Haven and London, 1978), 265–267, believes flowers were used indoors much as they are today but more casually. Thornton illustrated (plate XIII) a family portrait in an interior by Emanuel de Witte, formerly

in the London art market, that is among the very small number of Dutch domestic interior scenes with a vase of flowers. Bouquets, in fact, almost never appear in genre paintings themselves, but rather in portraits set in domestic interiors, which would indicate that the flowers have a symbolic rather than a decorative or documentary function in such scenes. See E. de Jongh, *Portretten van echt en trouw: huwelijk en gezin in de Nederlandse kunst van de zeventiende eeuw* [exh. cat., Frans Halsmuseum] (Haarlem, 1986), 55–56, figs. 47, 67a. 75a.

16. Thomas Hoving, "The Art and Artifice of Mr. Wulc," *Connoisseur* 213 (April, 1983), 124–125.

17. See E. H. Gombrich, *Art and Illusion: A Study in the Psychology of Pictorial Representation*, 2d ed. (Princeton, 1961), 136–145.

18. Marjorie Hope Nicolson, *The Breaking of the Circle*, rev. ed. (New York and London, 1962), 19.

19. Nicolson 1962, 1–46. S. K. Heninger, *The Cosmographical Glass* (San Marino, California), 1977. The quotation is from John Donne's "Holy Sonnet," V, line 1. Dutch familiarity with these commonplace concepts is evident in the title of Jan Moerman's emblem book, *De Cleyne wereld* (Amsterdam, 1608). See also the discussion of the analogical cosmology of Constantijn Huygens in Ignaz Matthey, "De betekenis van de natuur en de natuurwetenschappen voor Constantijn Huygens," in *Constantijn Huygens: zijn plaats in geleerd Europa*, ed. Hans Bots (Amsterdam, 1973), 392–429.

20. See the suggestive discussion of the cosmology of correspondences, its manifestation in the four elements, the four seasons, and the five senses, and the role these concepts played in the development of still life in the late sixteenth century in Klemm, in Münster 1979, 140–181.

21. See the analogy drawn between Roelandt Savery's flower pieces and landscapes in Sam Segal, "The Flower Pieces of Roelandt Savery," *Leids Kunsthistorisch Jaarboek* 1, (1982), 331–332. The discussion of Dutch landscape and still life as related phenomena by R. H. Fuchs, *Dutch Painting* (New York and Toronto, 1978), 103–142, is also suggestive if inconclusive. See also Gerhard Langemeyer, "Die Nahe und die Ferne," in Münster 1979, 20–42, discussing still life as a fragment or representative of the totality of nature embodied in the landscape.

22. For Ambrosius Bosschaert's flower pieces set against landscape vistas, see Bol 1969, 25 and fig. 21; and John Walsh and Cynthia Schneider, *A Mirror of Nature: Dutch Paintings from the Collection of Mr. and Mrs. Edward William Carter* [exh. cat., Los Angeles County Museum of Art] (Los Angeles, 1981), 15–19. Bosschaert's compositions strongly recall the Renaissance tradition of juxtaposing a portrait with a landscape, particularly in the parapet portrait type, as Langemeyer, in Münster 1979, 6, observed. The tensional relation of sitter to landscape offers a model for thinking about still lifes set before or near landscapes. See David Rosand, "The Portrait, the Courtier, and Death," in *Castiglione: the Ideal and the Real in Renaissance Culture*, ed. Robert W. Hanning and David Rosand (New Haven and London, 1983), 97–125.

23. De Jongh in Auckland 1982, 85–87. The seascape appears to be by another artist, very possibly Bonaventura Peeters. De Jongh correctly rejected the overspecific interpretation of the vessel as the Ship of Fools attempting to reach the Land of Cockayne represented by the still life, and proposes that the picture be seen as an allegory of the elements water and earth.

24. On *ekphrasis*, see Jean H. Hagstrum, *The Sister Arts: the Tradition of Literary Pictorialism in English Poetry from Dryden to Gray* (Chicago, 1958), 3–128; and Michael Baxandall, *Giotto and the Orators* (Oxford, 1971), 85–96. On *ekphrasis* in Dutch literature, see K. Porteman, "Geschreven met de linkerhand?: Letteren tegenover schilderkunst in de Gouden Eeuw," in *Historische letterkunde: facetten van vakbeoefening*, ed. Marijke Spies (Groningen, 1984), 103–108; and J. A. Emmens, "Apelles en Apollo: nederlandse gedichten op schilderijen in de 17de eeuw," in *Kunsthistorische opstellen* (J. A. Emmens verzameld werk, Part 3) (Amsterdam, 1981), 1, 5–60.

25. Quintilian, *Institutio oratoria*, VI.ii.32; trans. H. E. Butler (Cambridge, Mass. and London [Loeb Classical Library]), 2, 434–437. See Hagstrum 1958, 11–12, 63–65.

26. See, for example, Quintilian, *Institutio oratoria*, VI.ii.26–30; 430–435.

27. Svetlana Alpers, "*Ekphrasis* and Aesthetic Attitudes in Vasari's *Lives*," *Journal of the Warburg and Courtauld Institutes* 23 (1960), 190–215.

28. See Karel van Mander, *Den grondt der edel vry schilder-const* (Haarlem, 1604), ed. Hessel Miedema, 2 vol. (Utrecht, 1973). For ekphrastic descriptions, see, for example, vol. 1, chapter 5, stanzas 45–60 (an extended pastoral *ekphrasis*), chapter 6 (on gestures and facial expressions of emotions), and chapter 8 (on landscape). See also Miedema's commentary, vol. 2, 483.

29. A. H. Kan, *De jeugd van Constantijn Huygens door hemself beschreven* (Rotterdam and Antwerp, 1946), 79. The English translation is from J. Bruyn and others, *A Corpus of Rembrandt Paintings, Volume I, 1625–1631* (The Hague, 1982), 193.

30. For a discussion of *ekphrasis* and the interpretation of landscape and seascape, see Lawrence O. Goedde, *Tempest and Shipwreck in Dutch and Flemish Art: Rhetoric, Convention, and Interpretation* (University Park, Penna., 1989), 116–129. Porteman 1984, 106, observed the vast predominance of biblical, mythological, and historical pictures among Dutch poems on art works, which parallels the proportion in Italian and French literature. He attributed the absence of *ekphraseis* of landscapes, genre, and still life to their being lower in the social hierarchy and in the hierarchy of genres. Emmens 1981, 12–29, likewise saw social as well as religious reasons for the absence of poems on lower genres. The existence of Oudaan's extraordinary cycle of *ekphraseis* on these lower subjects (see below) and scattered descriptions by other writers would nonetheless seem to confirm the availability of *ekphrasis* as a model for describing virtually any subject. What is probably involved here is that *ekphrasis* was the literary model best suited to the arousal of a beholder's identification with the subject of an image, which is fundamental to the purpose of naturalistic imagery not only in Italian art but in the Netherlandish tradition from which Dutch painting

develops. See James Marrow, "Symbol and Meaning in Northern European Art of the Late Middle Ages and the Early Renaissance," *Simiolus* 16 (1986), 150–169.

31. Joachim Oudaan, "Op schildery, teikening en naelde-werk: ten huise van Joffr. J. V. D. B.," in *Poëzy* (Amsterdam, 1712), 2:115–138. The owner of the pictures has been identified as Johanna van der Burgh, for whom Oudaan also composed a tomb inscription. See J. Melles, *Joachim Oudaan: heraut der verdraagzaamheid 1628–1692* (Utrecht, 1958), 35–36. The cycle of poems is also discussed by G. A. van Es, in *Geschiedenis van de letterkunde der Nederlanden 5*, part 2, *de letterkunde van Renaissance en Barock* (s'Hertogenbosch and Antwerp, 1952), 294–295. Oudaan, a tile baker by trade, was university educated, and in his poetry and prose took an active role in the religious controversies that animated Collegiant, Remonstrant, and Anabaptist circles in the second half of the seventeenth century. See C. C. de Bruin, *Joachim Oudaan in de lijst van zijn tijd* (Groningen, 1955). The cycle of *ekphraseis* is the work of an eighteen-year-old and little resembles his mature poetry.

32. My discussion of this poem owes much to the comments of Paul Barolsky. Oudaan 1712, 126–127:

Op een BLOMPOT
Siet hoe de lieve lente lonkt;
Een Cabinet cieraden
Tooit haer; haer stiken tabbaert pronkt
Met goud en purp're draden,
En waer sy set haer solen,
Doet sy de ooge dolen
 In al de kleur,
 En ook haer geur
Dringt boven muscus deur.

Maer ach! de tyd genaekt al, dat
Sy sal voorvluchtig wesen:
Nu komt een stoute hand, de schat
Uit al haer bloemtges lesen,
En bintse tot een ruiker,
Om die (soo soet als suiker)
 Niet door de tyd,
 Die vinnig byt,
 Soo ras te worden quyt.

Maer ach! wat is 't een korte poos!
En 't bloemtge moet vordorren:
Weer weet men middel, dat de roos
Soo niet sal over snorren,
Soo niet en sal verstersven,
Sy duurt in vaste verven,
 Door Zeuxis hand,
 Op maet geplant,
 Veel bet, dan in nat sant:

Hier komt het syn pinceel te bord,
En stelt sig schrap, 't begint'er
Een streepje dat een bloempje word,
Dit sal de scharpe winter,
In 't midde van de korsten
Van aengedrongne vorst, en
 Gepakte snee'
 In lentens stee,
 Met lust aenschouwen mee:

Dit freutelarisjen voorwaer,
En wykt niet voor het leven;
Geen net geleiden roselaer
Sou schoonder rosen geven;
Geen Tulpen, geen Narcissen,
Trof oyt gelykenisse
 Soo hups, soo wel;
 Rups nog capel
 Dees oit beschamen sel.

33. *Alle de gedichten van den poëet Jan Vos*, ed. J. Lescaille (Amsterdam, 1662), 534, 566. The poem on Willem van Aelst also appears in Houbraken 1753, 1:230. For these poems, see below note 37.

34. On sensuous description and the rivalry of the arts, see Hagstrum 1958, 66–81.

35. Themes of nature versus art and the enduring qualities of art in defiance of death are commonplace in Renaissance poetry, aesthetics, and philosophy (see Hagstrum 1958, 81–82). Interestingly, in view of the strongly portraitlike format of most Dutch flower

pieces, these themes are characteristic of poems on portraits. See above note 23 and Rosand 1983, 91–129.

36. See the discussion of flower and fruit symbolism by Sam Segal in Amsterdam 1982, 12–24, and in Amsterdam 1983, 14–43, in which the broadest possible range of meaning is sketched out in addition to transience metaphors.

37. On a Flower Piece by van Aelst:

Hier komt de lieve Lent by wintertyd verschynen.
 Natuur, die al wie maalt door haar penceel verdooft,
Begint, nu zy dit ziet, van enk'len spyt te kwynen.
 Aurora, leg uw pruik vol roozen van uw hooft:
Hier groeijen roozen die uw hulsel overtreffen. Zoo
 word VAN AELST, door Konst, de waereld door beroemt.
Wie and'ren overwint behoord men te verheffen. Zyn
 hand, vol geesten, heeft het blad van dit gebloemt
Beschildert met een glans, die nimmer zal verslensen.
 Het loof dat heet en koud verduurt zal eeuwig staan.
Vrouw Venus zou haar krans om dit gewasch verwenssen;
 Om, als zy hoogtyd houd, te pronken met de blaän:
Of als zy 't hart van Mars aanminnig komt bestryen.
'T cieraad der Vrouwen is de lyst der Schilderyen.

Here sweet Spring appears in wintertime. Nature, who stupefies with her brush all who paint, goes into a decline out of vexation now that she sees this. Aurora, set aside your covering of roses from your head. Here roses grow that surpass your coiffure. So Van Aelst through art becomes renowned the world over. One ought to extol him who has overcome others. His hand, full of wit, painted the leaf of these flowers with a splendor that will never wither. The leaf that endures heat and cold will last forever. Lady Venus will exchange her garland for this growth in order to show off the leaves when she makes merry or when she charmingly contests the heart of Mars. The roster of paintings is the adornment of ladies.
(*Alle de gedichten van den poëet Jan Vos*, ed. J. Lescaille, Amsterdam, 1662, 566.)

Op de geschilderde bloemen van Pater Zeegers

Bekoorelijke Lent, priëel der jaargetyen!
Gy pronkt, doch voor een poos, met uwe schilderyen;
 Maar Zeegers laat zich niet bepaalen op paneel.
 Hy schept, wanneer 't hem lust, door 't strijken van 't penseel,
Een leevendige Lent van bloemen uit zijn verven,
Die door geen zoomerzon, noch wintersneeuw bederven.
 Gebreekt het hem aan geur, u aan stantvastigheidt.
 Heeft hy de keurge bie geen honighdouw bereit?
De spin die weet by hem, als u, geen gift te haalen.
Gy kunt niet dan het veldt met uw gebloemt bemaalen;
 Maar Zeegers maalt gebloemt op autaar en aan muur.
De kunsten zijn bywijl veel starker dan Natuur.

On the Painted Flowers of Father Seghers
Enchanting Spring, garden of the seasons, you show off your paintings for but a while. But Seghers will not be limited on panel. He creates when it pleases him by the working of the brush a living spring of flowers from his colors, which are ruined by neither summer sun nor winter snow. He lacks fragrance, you constancy. Has he prepared no honey dew for the dainty bee? The spider with him manages to fetch no poison, as with you. You can paint nothing but the field with your blooms. But Seghers paints flowers on altar and on wall. The arts are sometimes much stronger than Nature.
(*Alle de gedichten*, 534.)

38. Anne Walter Lowenthal, "Response to Peter Hecht," *Simiolus* 16 (1986), 188–190. See also her discussion of moral ambiguity as a principle of rhetoric, pictorial presentation, and the grounding of this approach in contemporary faculty psychology: *Joachim Wtewael and Dutch Mannerism* (Doornspijk, 1986), 57–60. See also Amsterdam 1983, 18–20, 40.

Colorplates

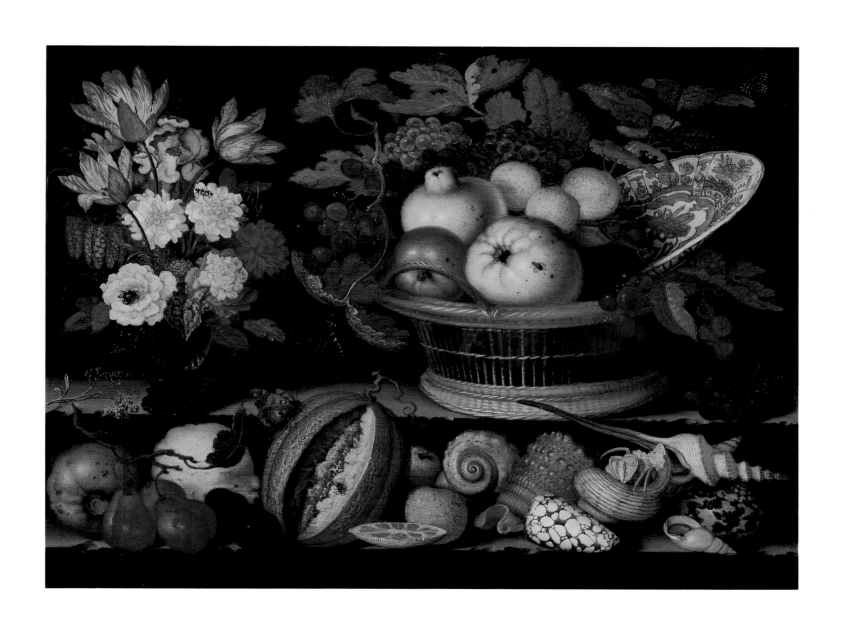

1

BALTHASAR VAN DER AST

Vase of Flowers, Basket of Fruit, and Shells

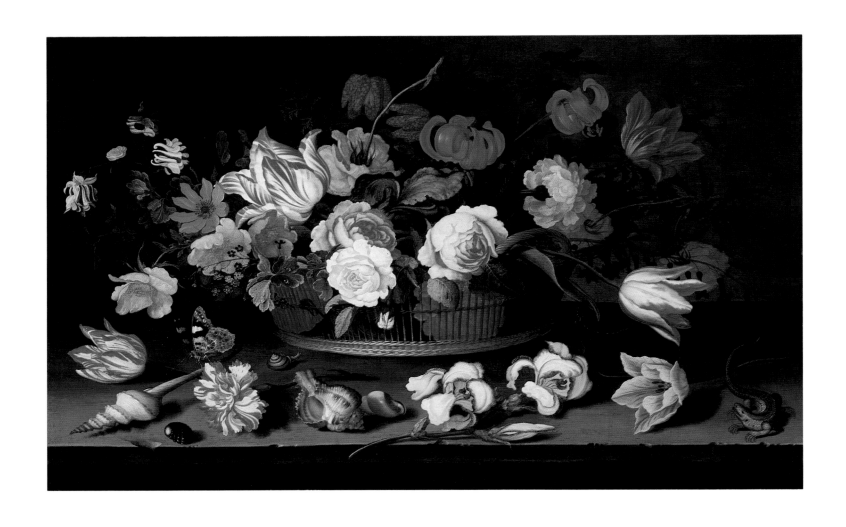

2

BALTHASAR VAN DER AST

Basket of Flowers

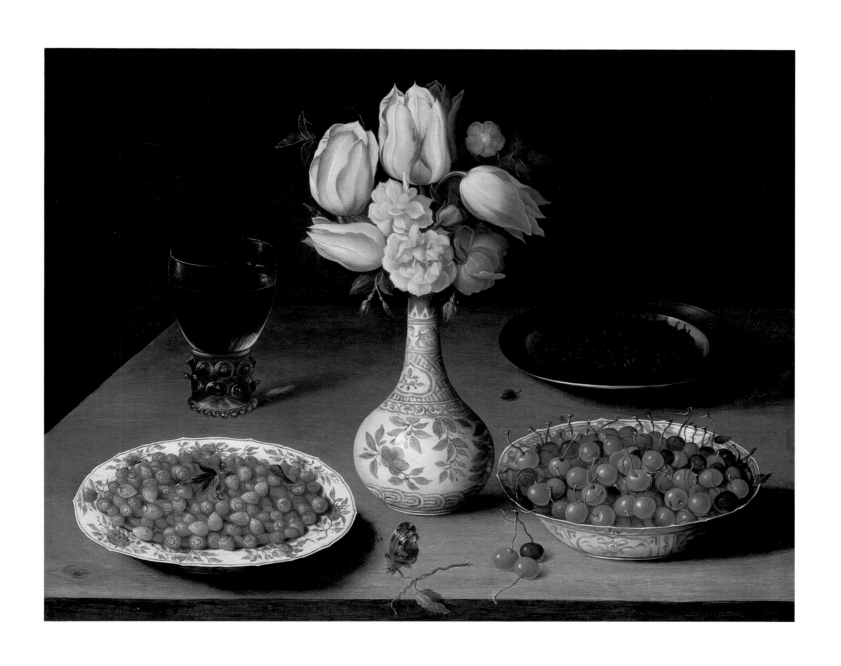

3

OSIAS BEERT THE ELDER

Vase of Flowers with Dishes of Fruit and a Drinking Glass

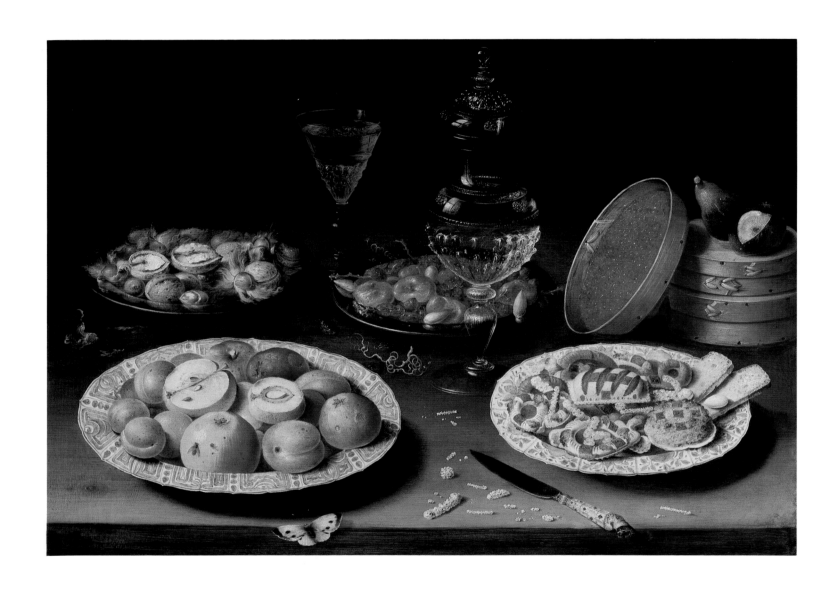

4

OSIAS BEERT THE ELDER

Fruit, Nuts, Wine, and Sweets on a Ledge

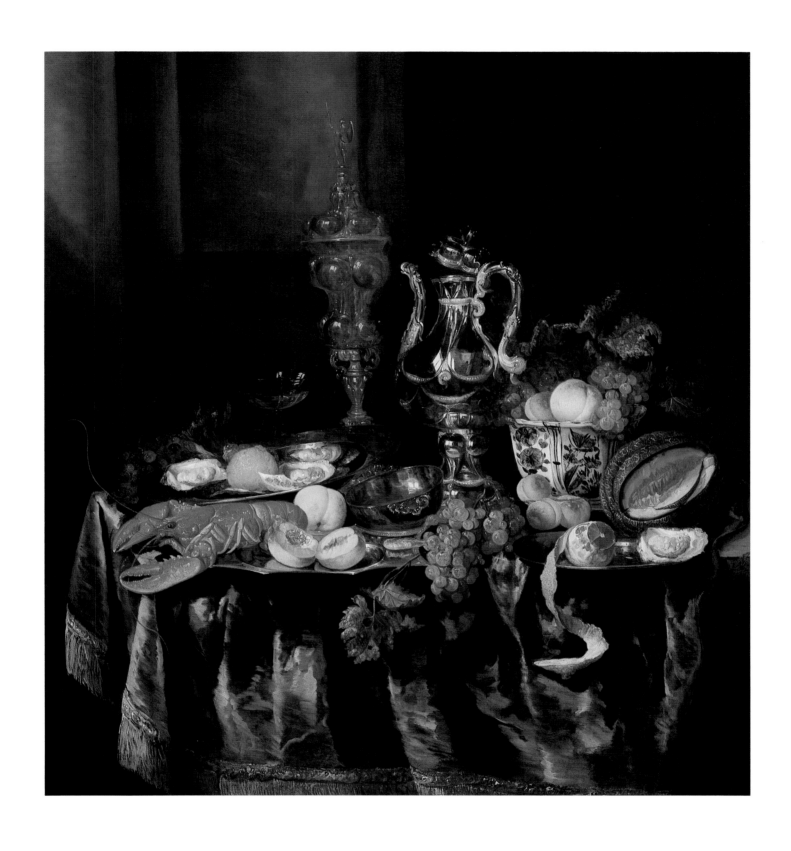

5

ABRAHAM VAN BEYEREN

Lobster, Oysters, and Fruit on a Table

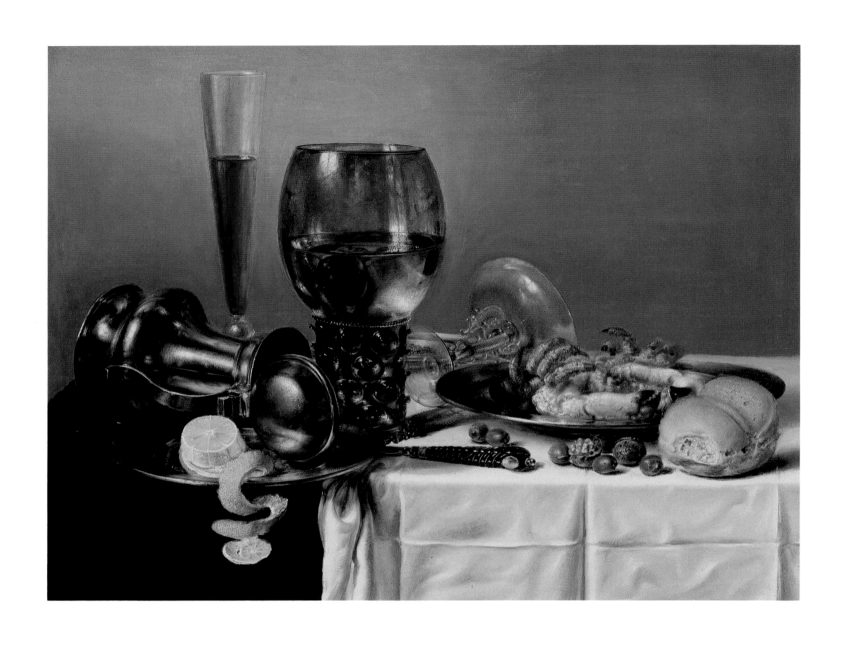

6

MAERTEN BOELEMA, called "de Stomme"

Tabletop with Drinking Glass, Tankard, Bread, Fruit, and Shellfish

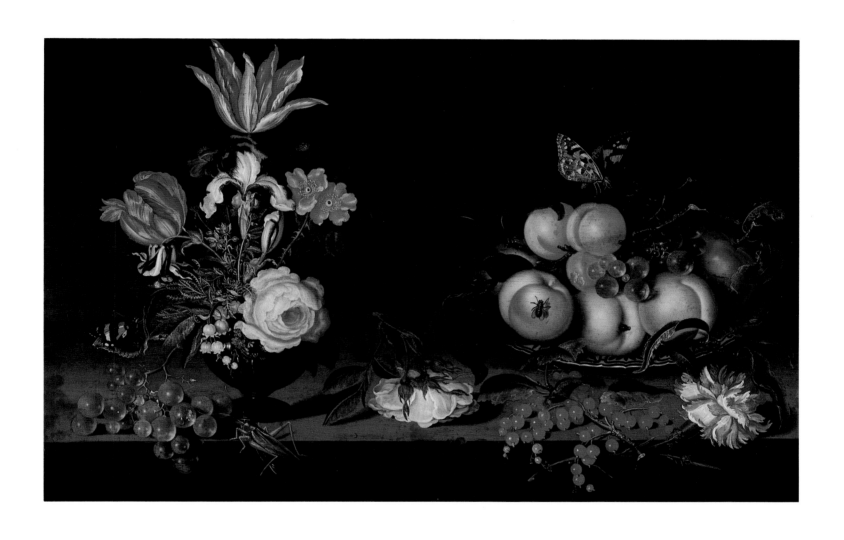

7

JOHANNES BOSSCHAERT

Flowers and Fruit

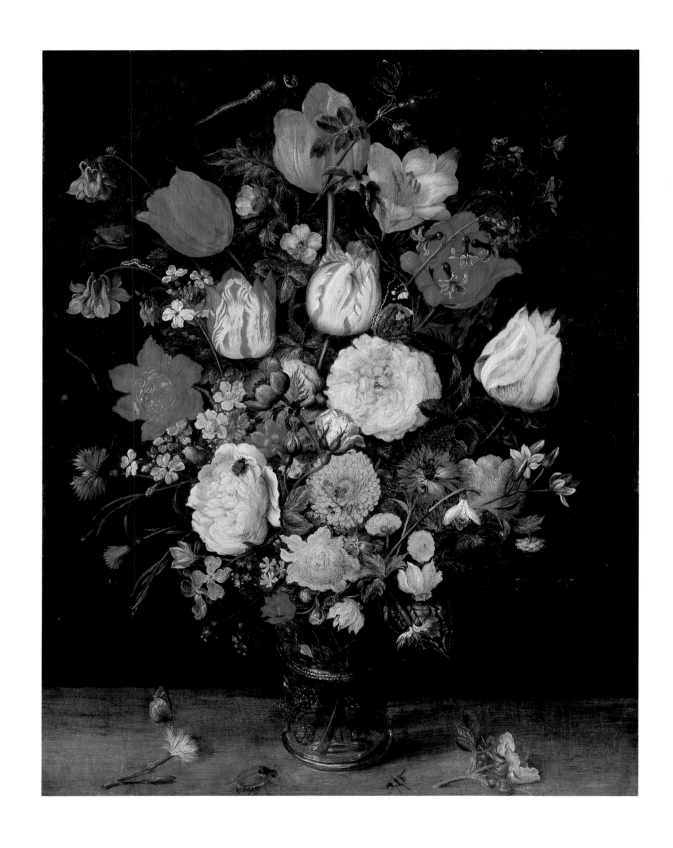

8

JAN BRUEGHEL THE ELDER

Flowers in a Glass

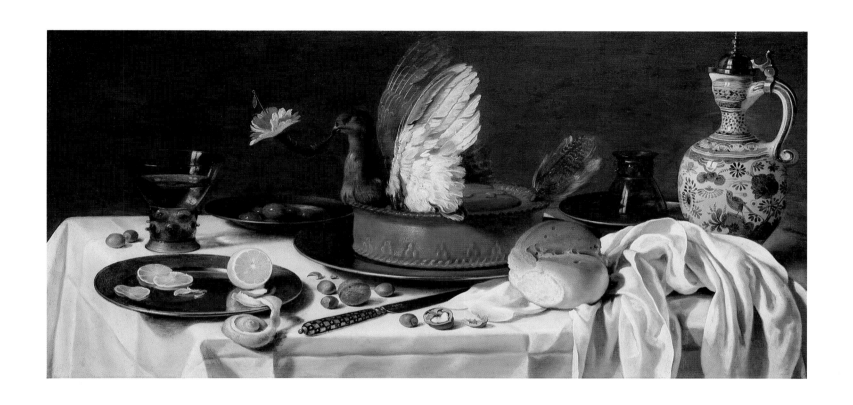

9

PIETER CLAESZ.

Tabletop with Pigeon Pie

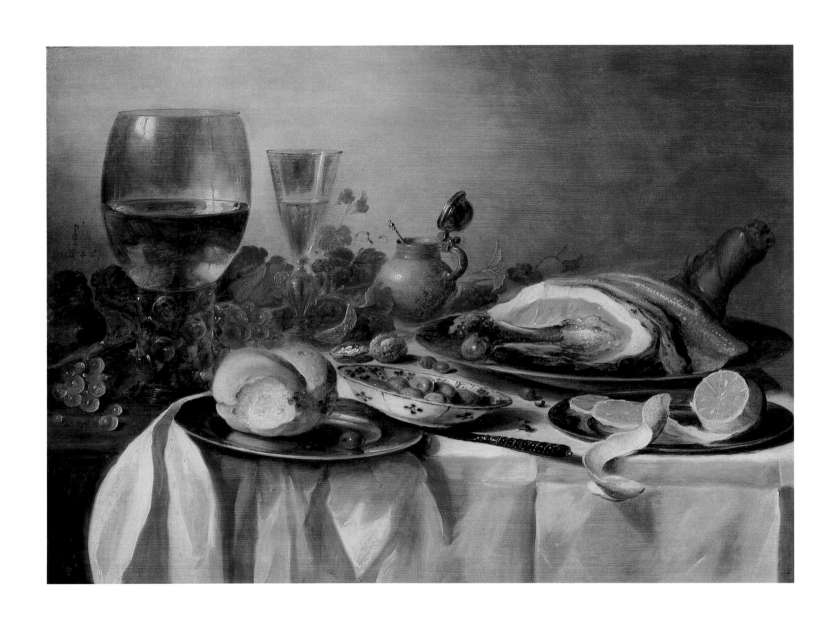

10

PIETER CLAESZ.

Table with Ham, Fruit, and Drinking Glasses

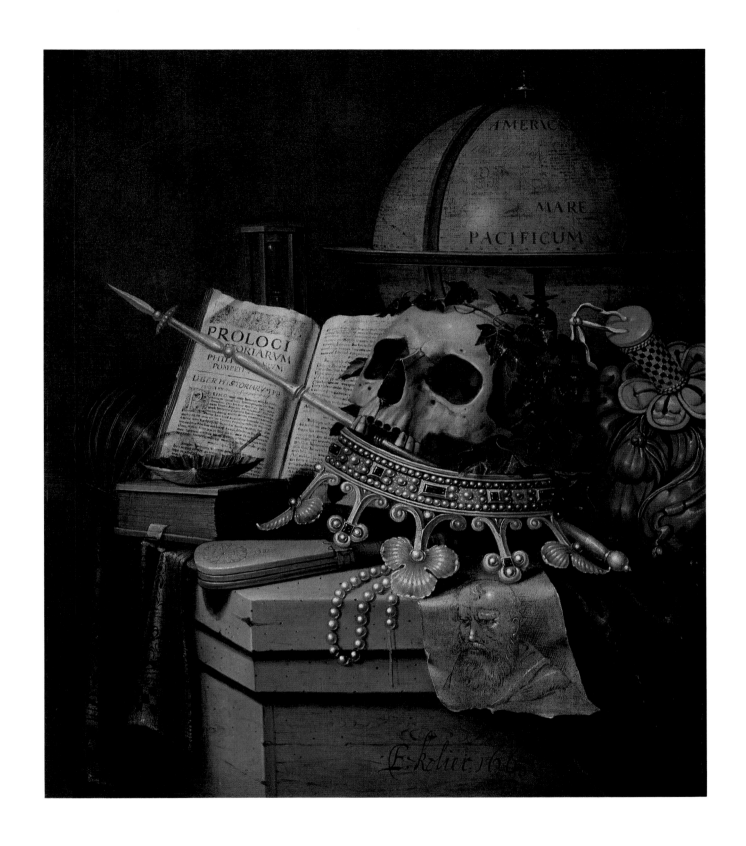

11

EDWAERT COLLIER

Vanitas with Skull and Coronet

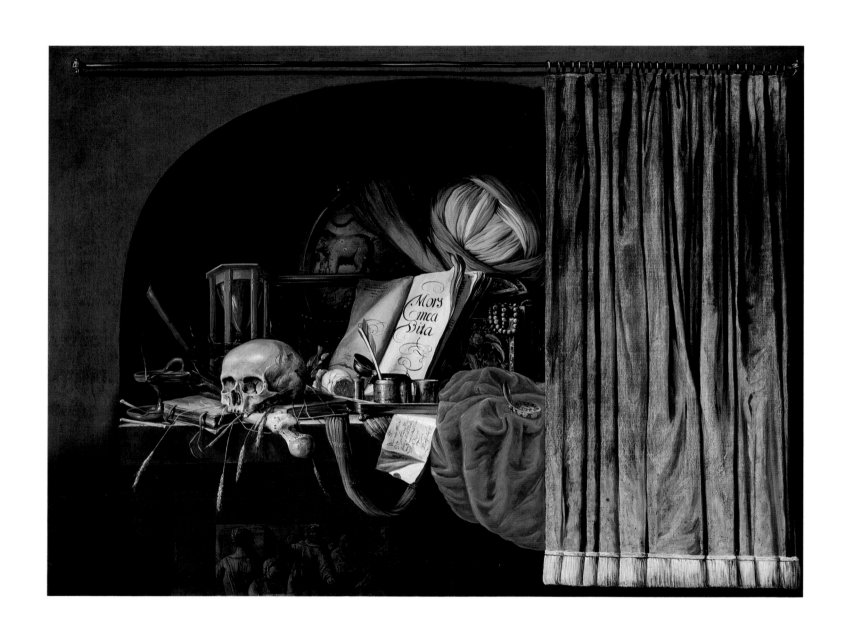

12

JOHANNES CUVENES THE ELDER

Vanitas with Green Drape and Skull

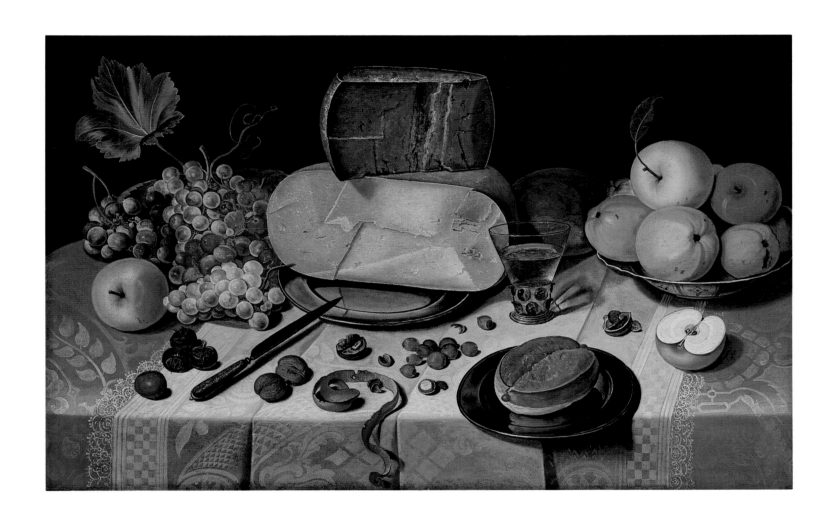

13
FLORIS VAN DIJCK

Cheese, Fruit, and Bread on a Red Silk Cloth

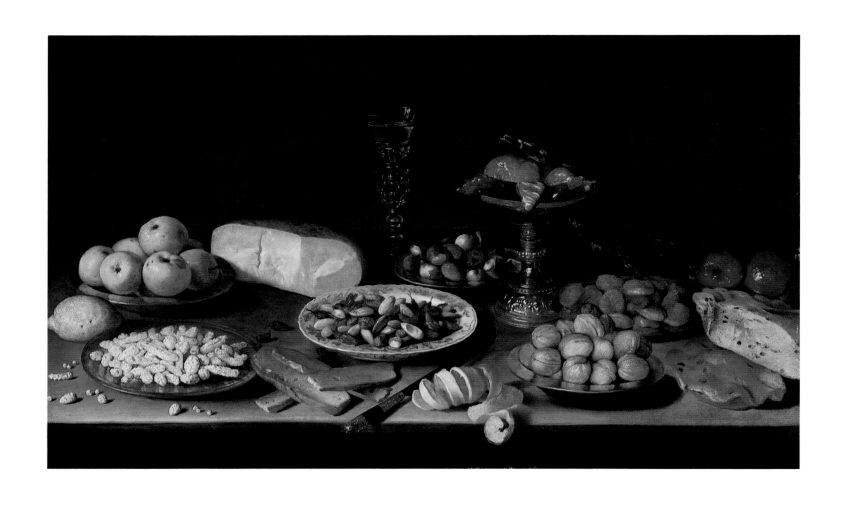

14

JACOB FOPPENS VAN ES

Banquet

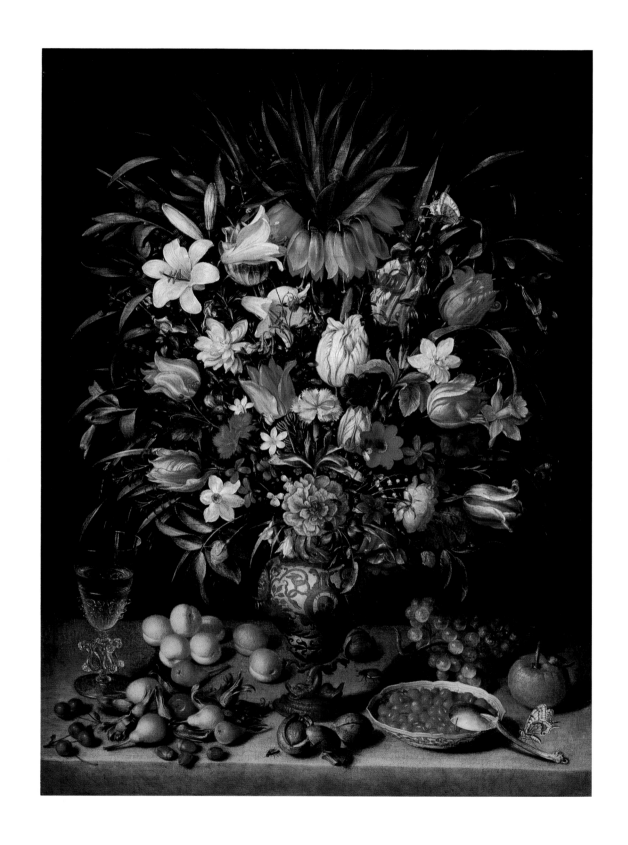

15

GEORG FLEGEL

Vase of Flowers, Wine Glass, and Fruit

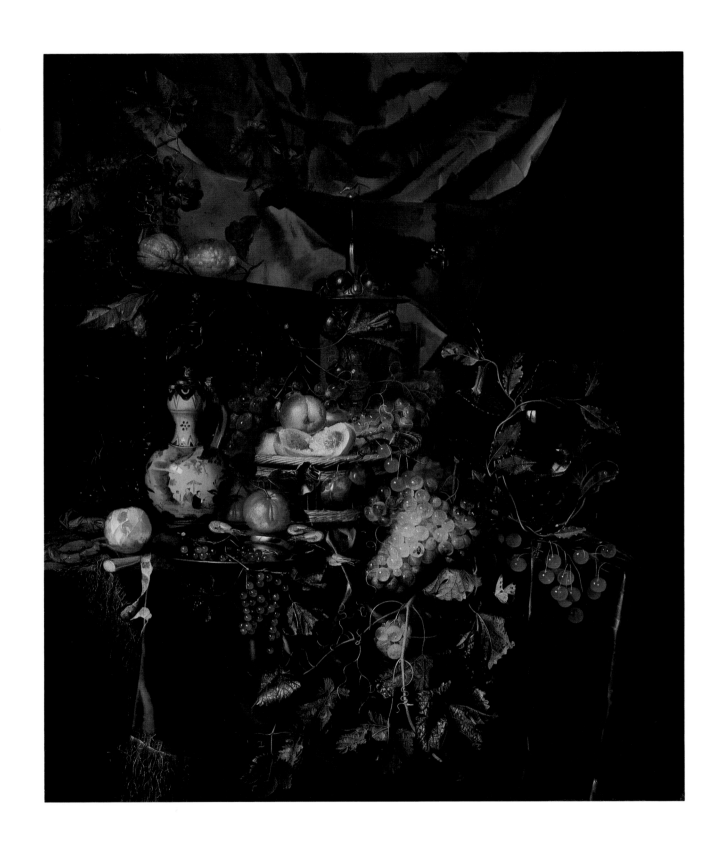

16

NICOLAES VAN GELDER

Basket with Fruit on a Draped Table

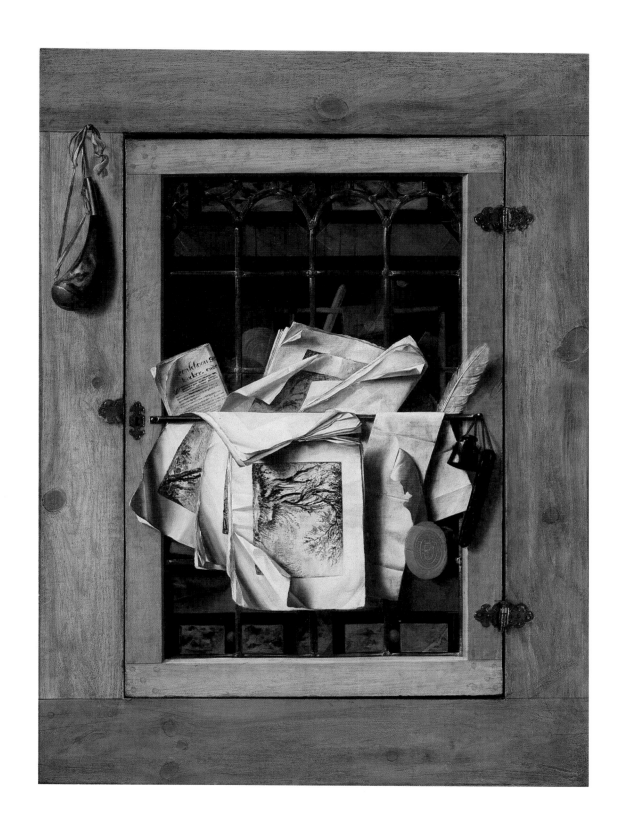

17
FRANCISCUS GYSBRECHTS
Trompe L'Oeil Window
(recto)

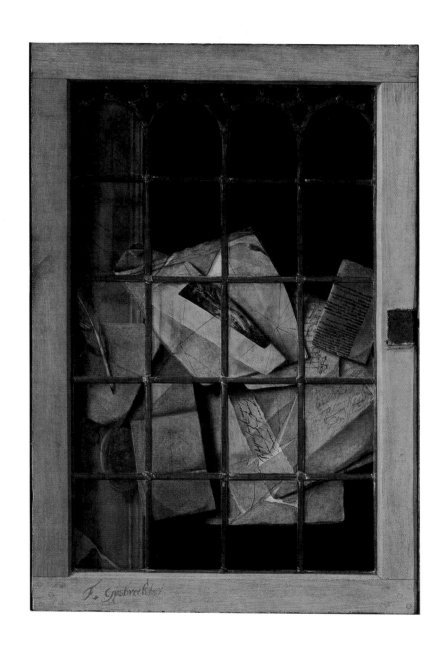

17
FRANCISCUS GYSBRECHTS
Trompe L'Oeil Window
(verso)

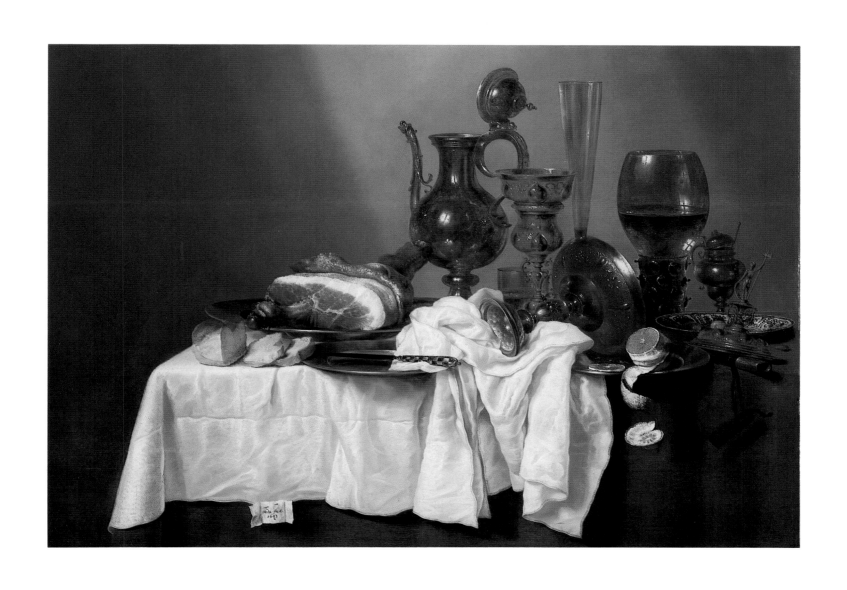

18

WILLEM CLAESZ. HEDA

Still Life with Ham and Drinking Vessels

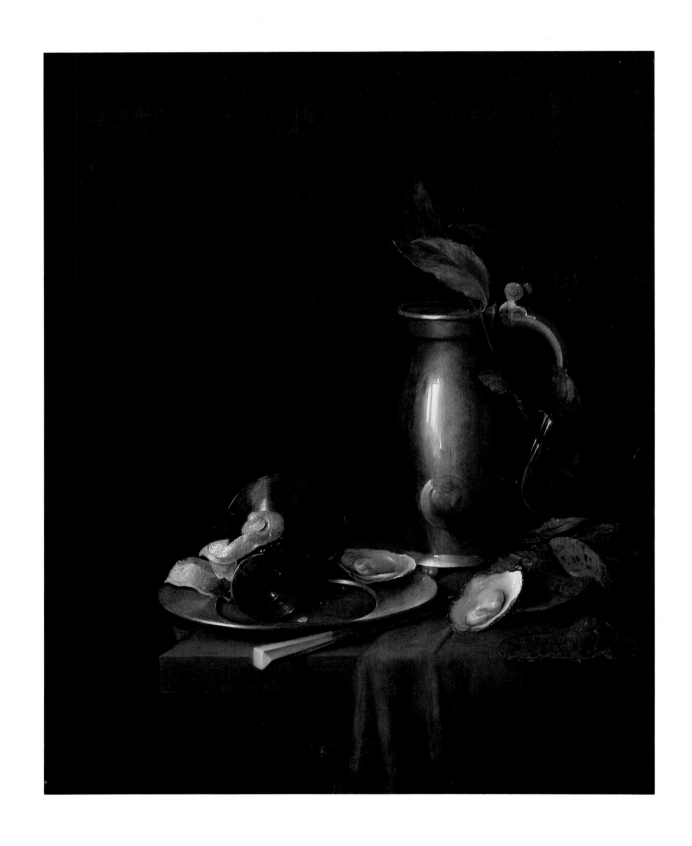

19

JAN DAVIDSZ. DE HEEM

Tabletop with Lemon, Oysters, and Pewter Jug

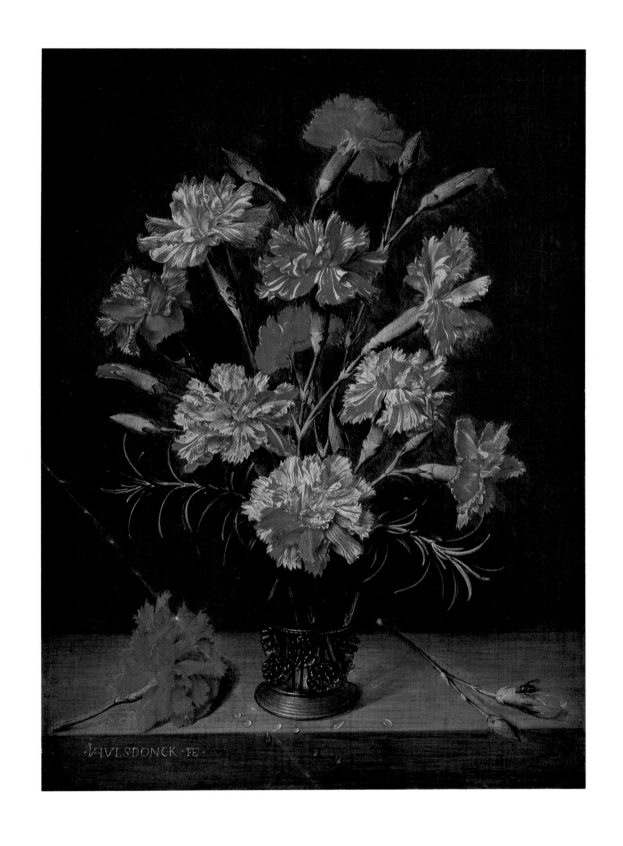

20

JACOB VAN HULSDONCK

Carnations in a Glass

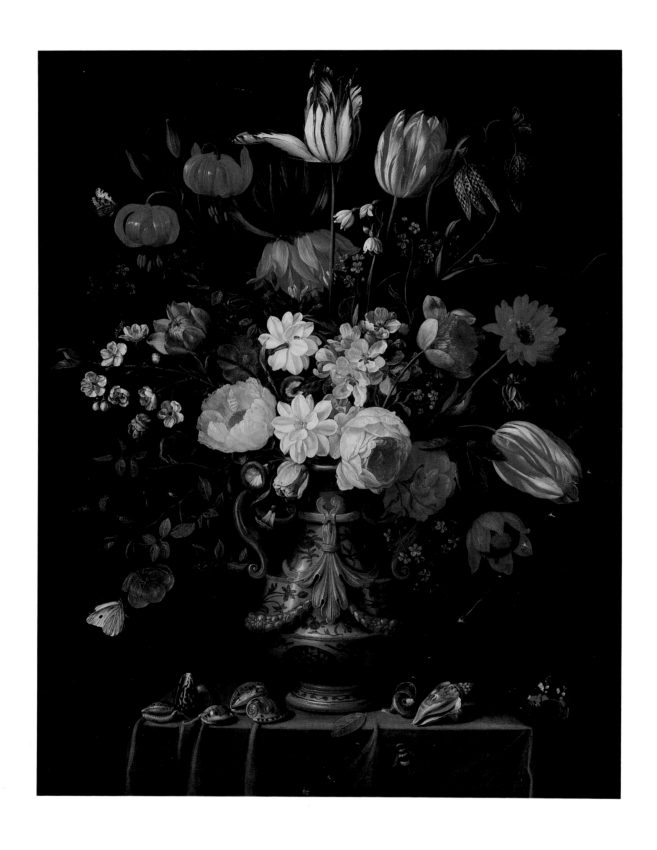

21

JAN VAN KESSEL THE ELDER

Flowers in a Porcelain Vase

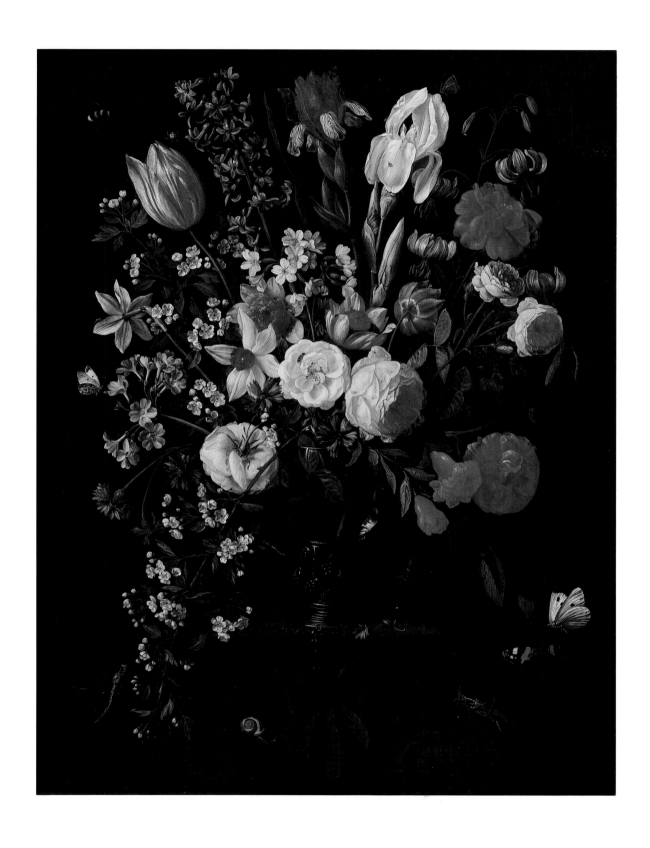

22

JAN VAN KESSEL THE ELDER

Flowers in a Glass Vase

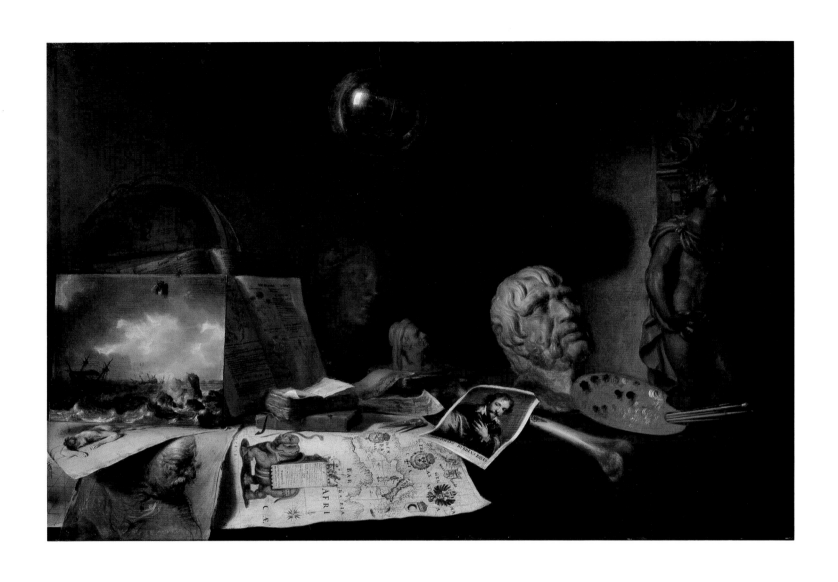

23

SIMON LUTTICHUYS

Allegory of the Arts

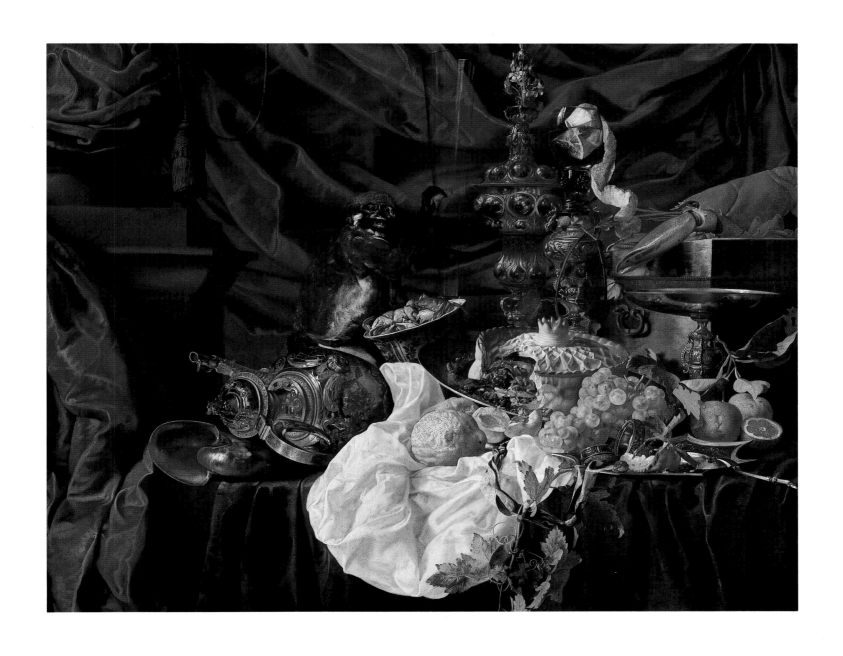

24

CERSTIAEN LUYCKX

Banquet with Monkey

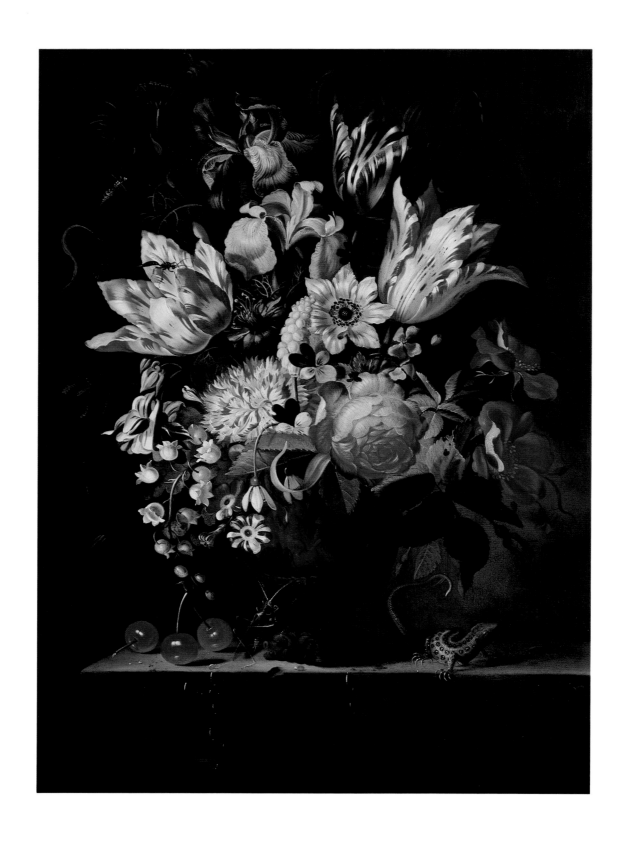

25

JACOB MARREL

Flowers in a Vase

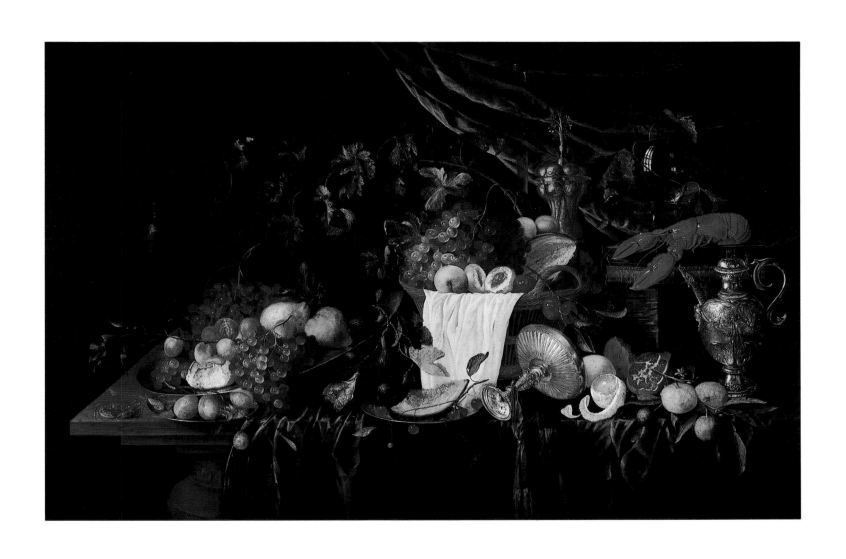

26

WOUTER MERTENS

Tabletop Still Life

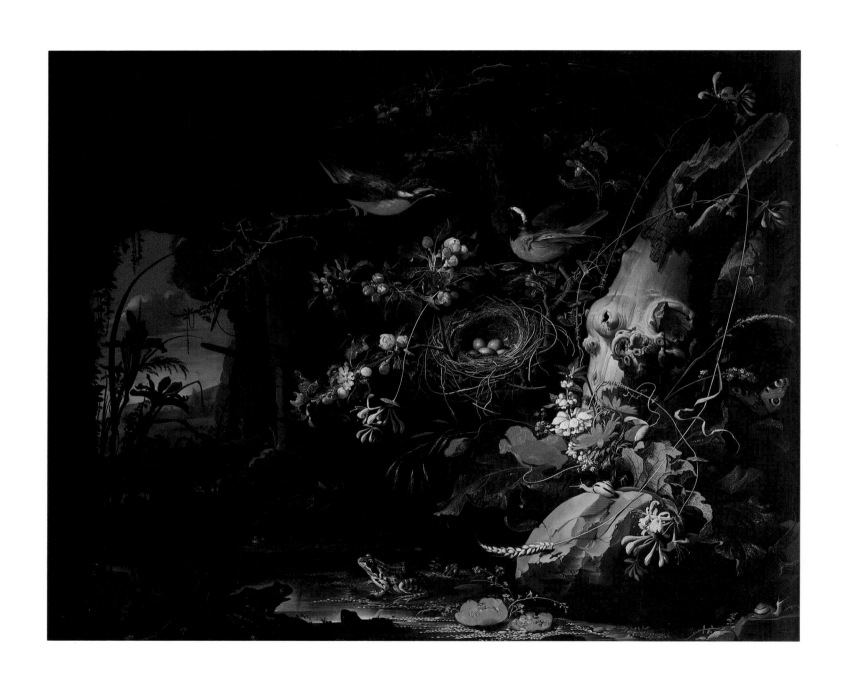

27

ABRAHAM MIGNON

Cavern Scene

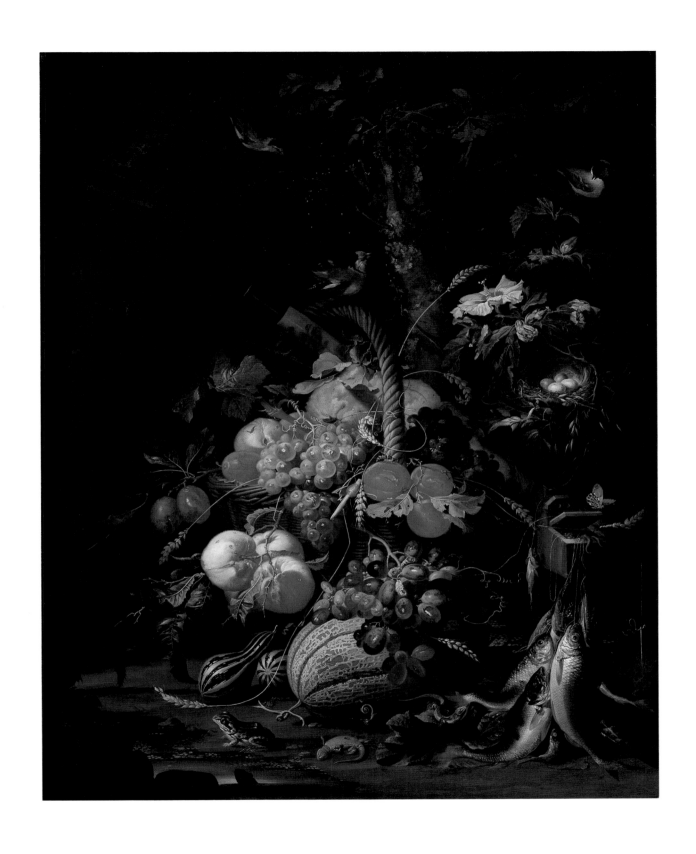

28

ABRAHAM MIGNON

Still Life with Fruit, Fish, and a Nest

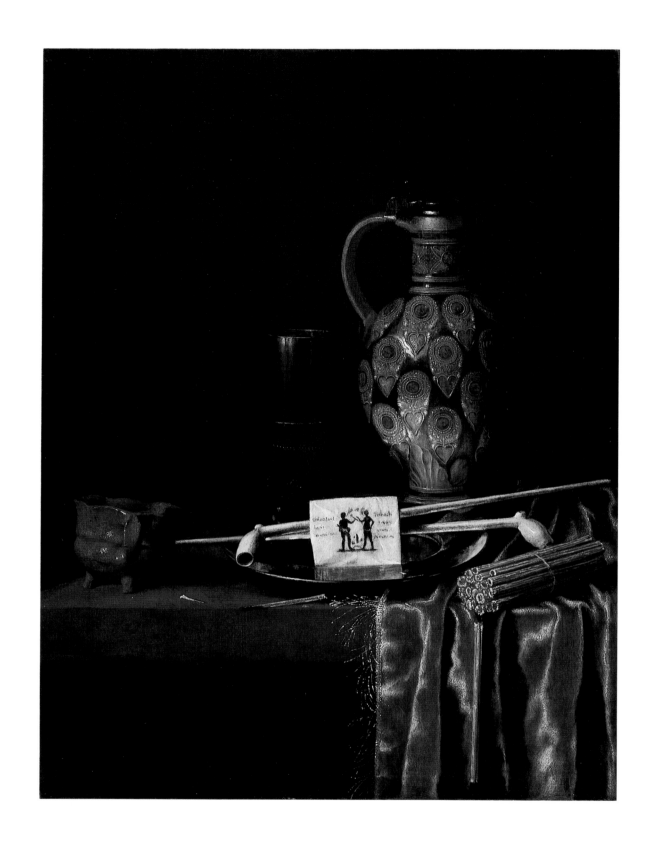

29

HUBERT VAN RAVESTEYN

Tobacco Still Life

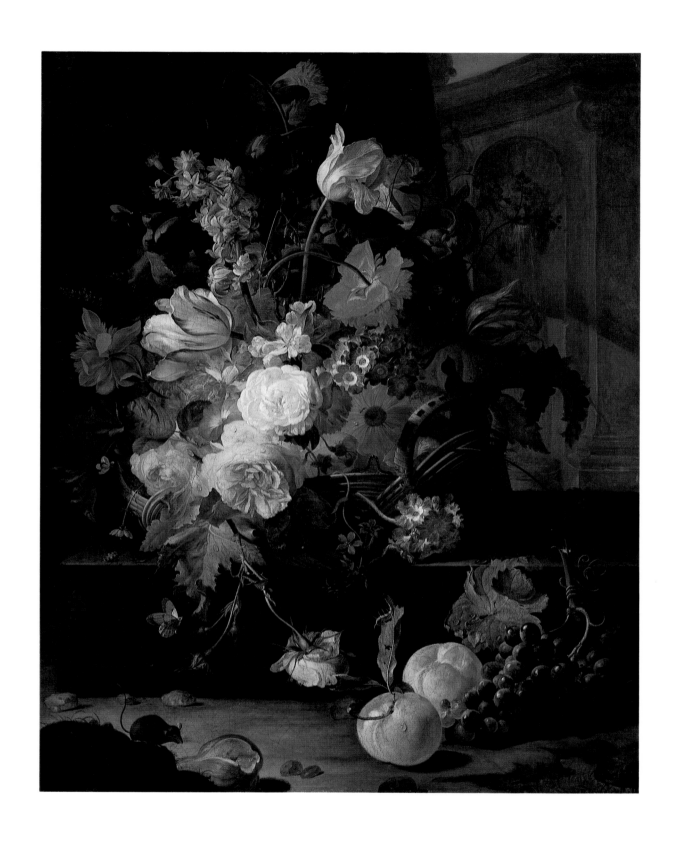

30
COENRAET ROEPEL

Flowers and Fruit

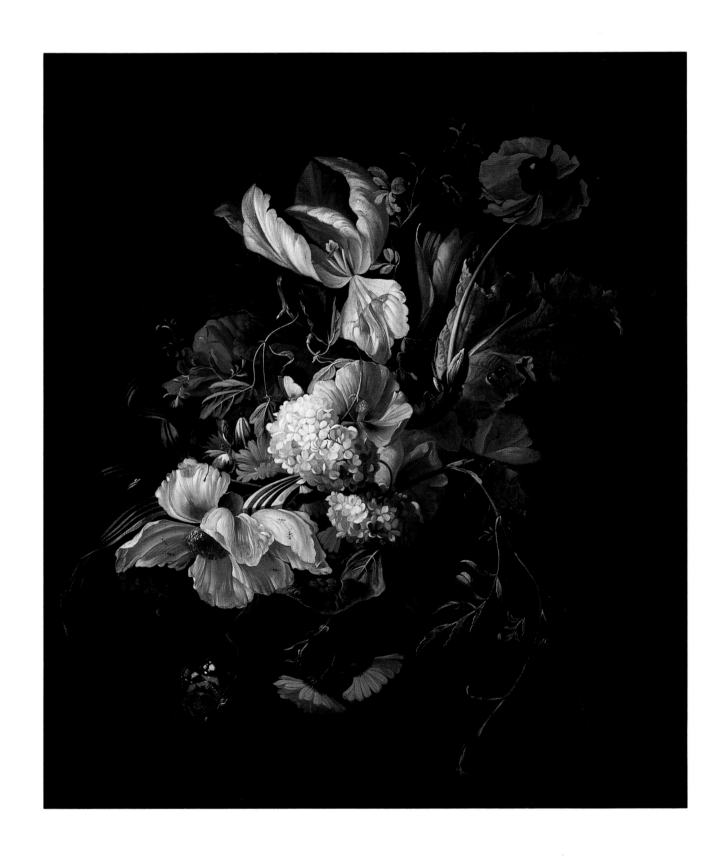

31

RACHEL RUYSCH

Vase of Flowers on a Table

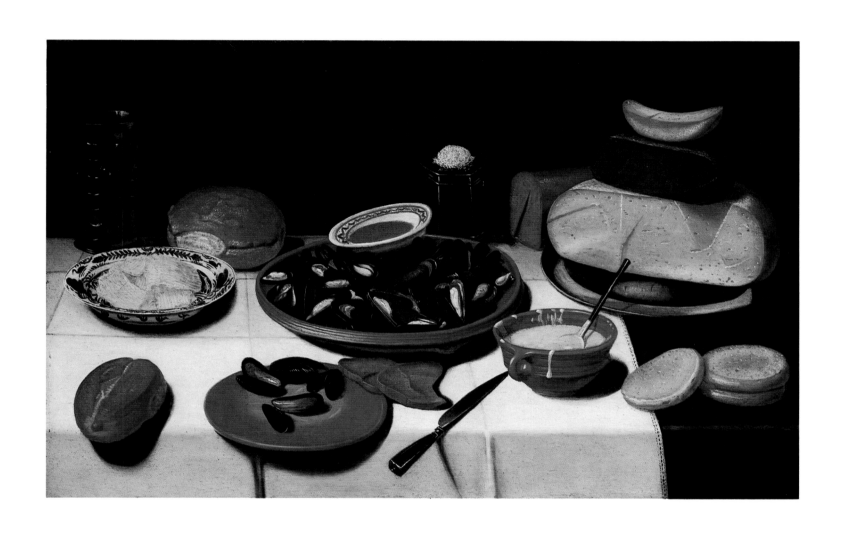

32

FLORIS GERRITSZ. VAN SCHOOTEN

Breakfast of Mussels, Cheese, Bread, and Porridge

33

FLORIS GERRITSZ. VAN SCHOOTEN

Kitchen Scene

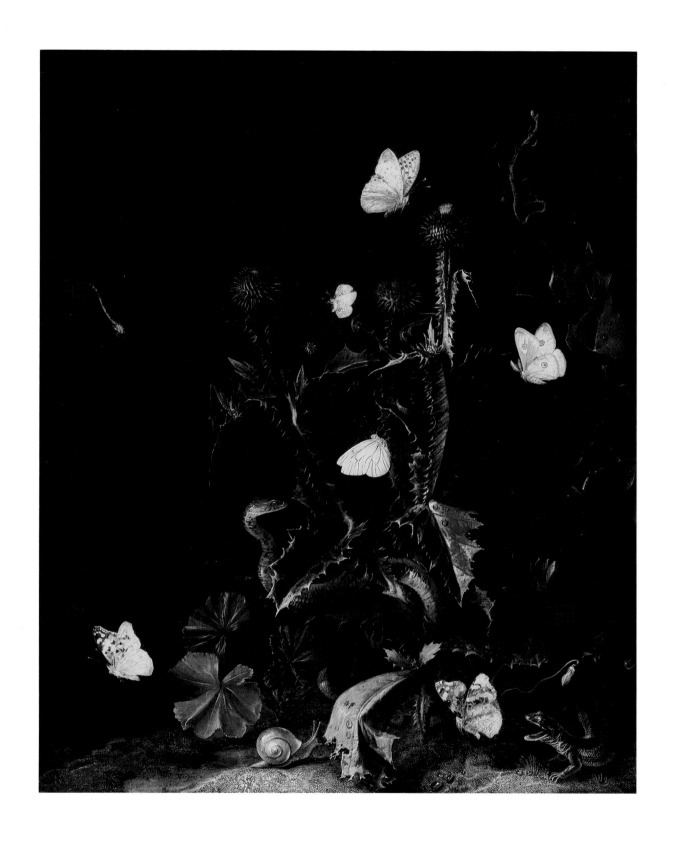

34

OTTO MARSEUS VAN SCHRIECK

Nature Study

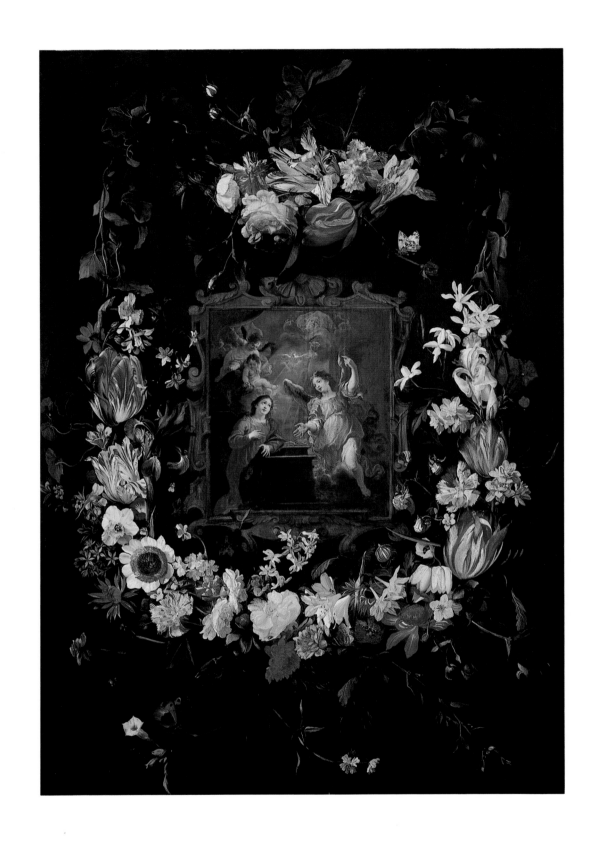

DANIEL SEGHERS · CORNELIS SCHUT THE ELDER

Garland of Flowers with the Annunciation

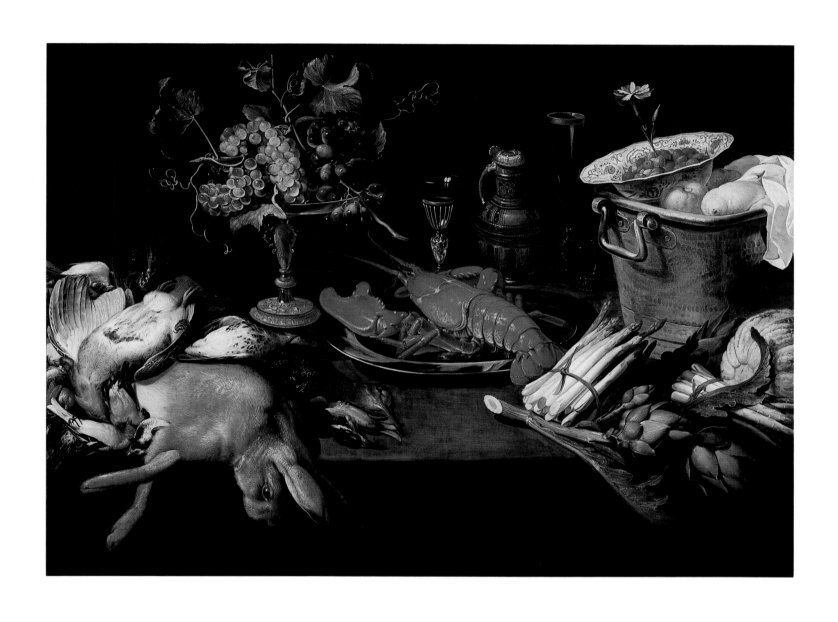

36

FRANS SNYDERS

Game, Shellfish, Fruit, and Vegetables

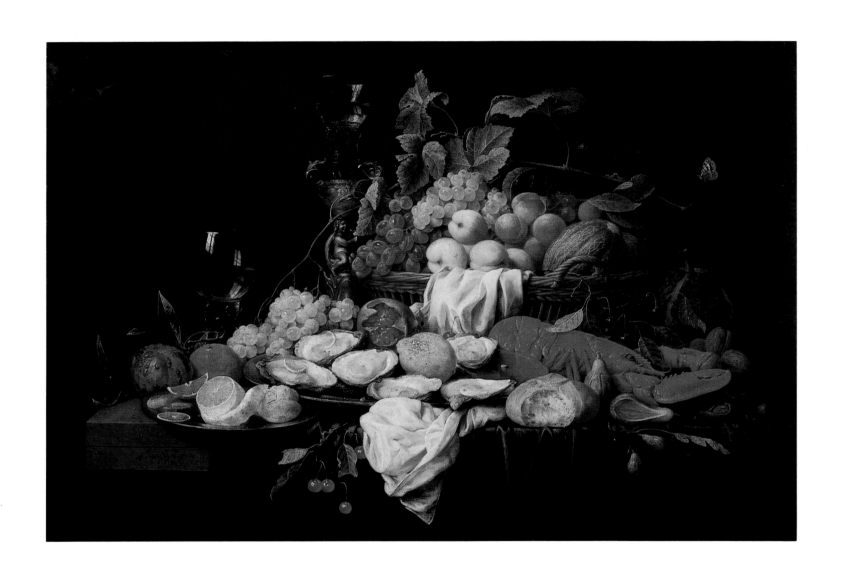

37

JORIS VAN SON

Melon, Oysters, Lobster, and Fruit

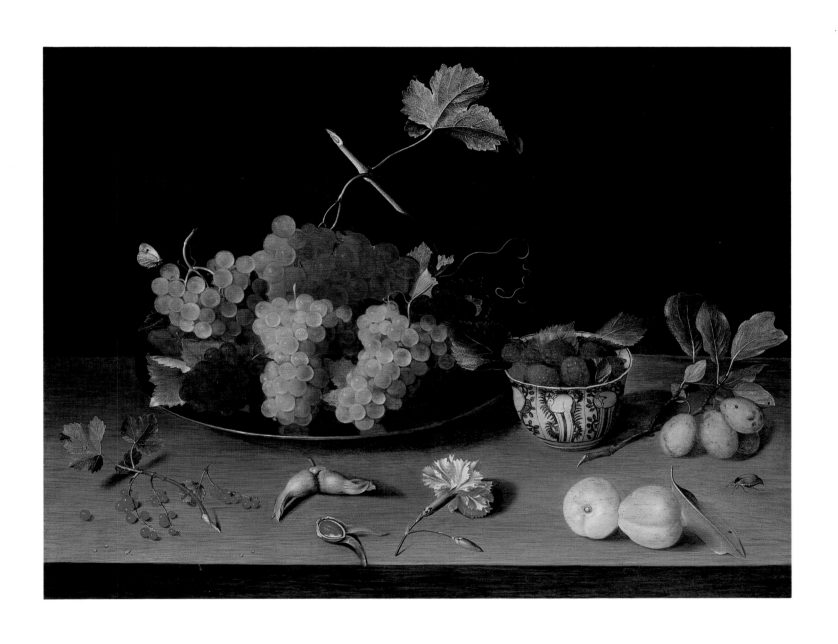

38

ISAAC SOREAU

Tabletop with Plate of Fruit

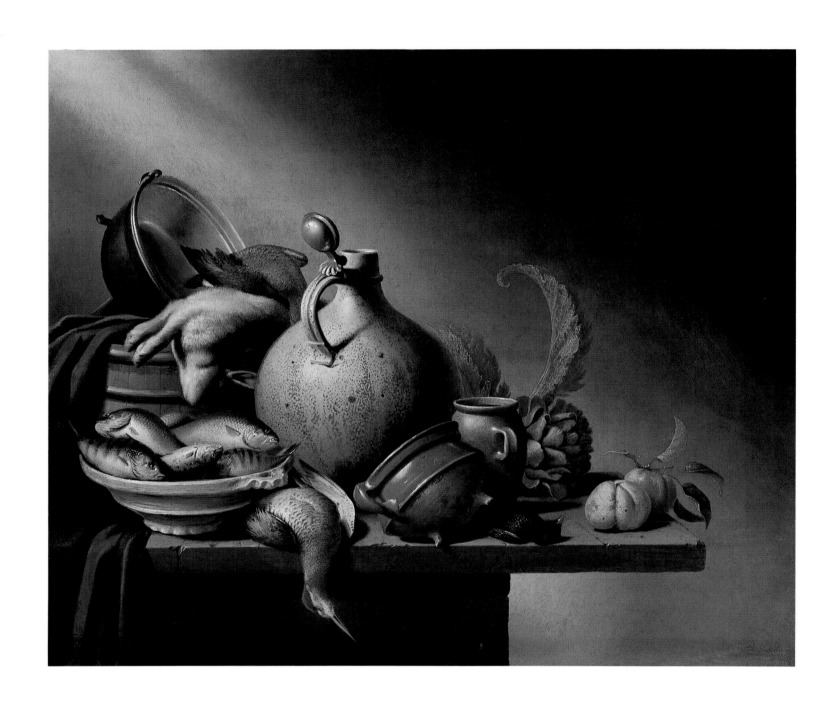

39

HARMEN VAN STEENWYCK

Stoneware Jug, Game, and Fish

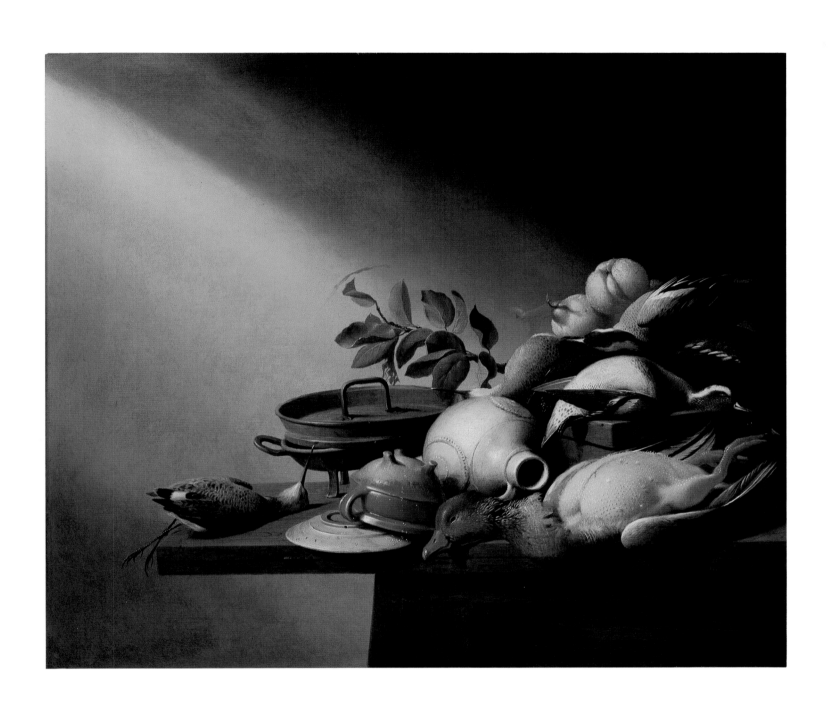

40

HARMEN VAN STEENWYCK

Skillet and Game

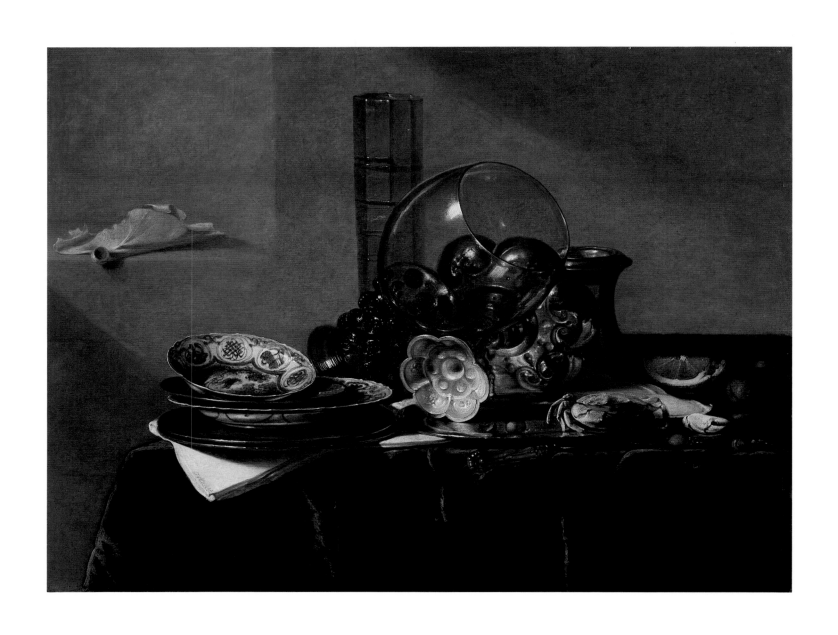

41

JAN JANSZ. TRECK

Tabletop with Saltcellar, Dishes, and Glasses

42

LUCAS VAN VALCKENBORCH · GEORG FLEGEL

Allegory of Summer

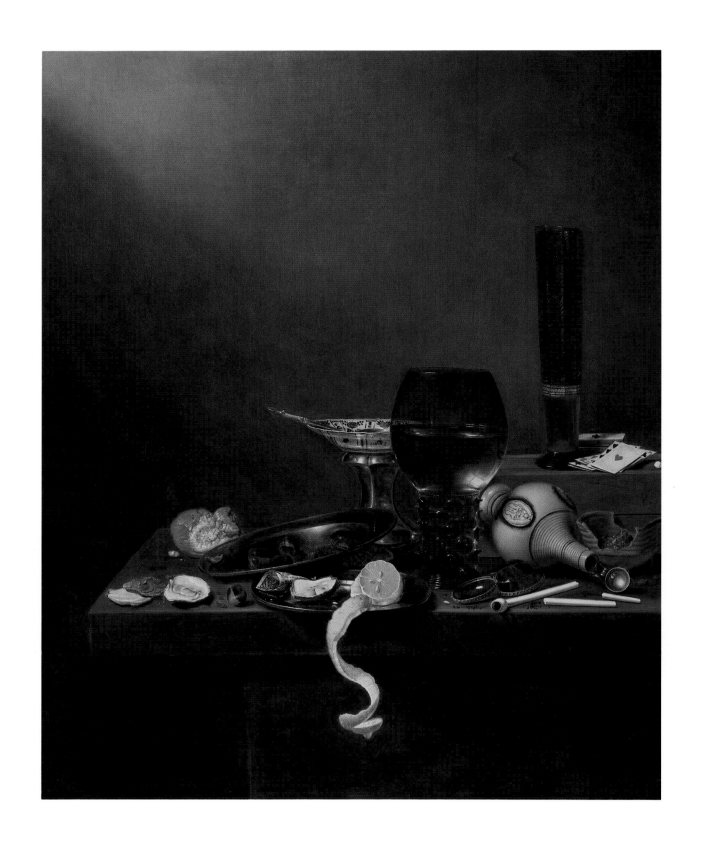

43

JAN JANSZ. VAN DE VELDE III

Breakfast with Cards and Pipe

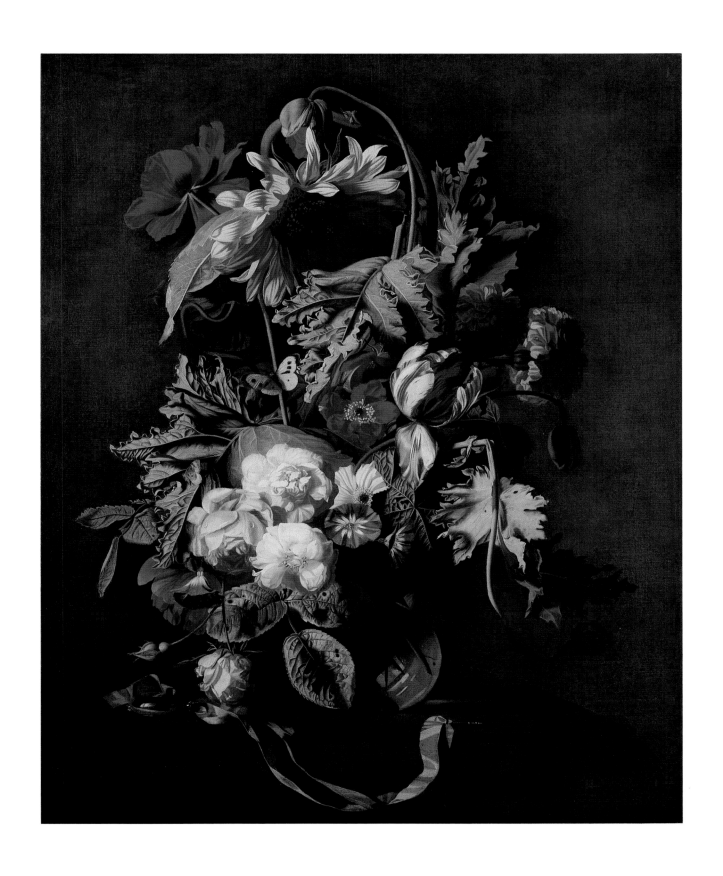

44

SIMON PIETERSZ. VERELST

Vase of Flowers with Watch and Key

Catalogue

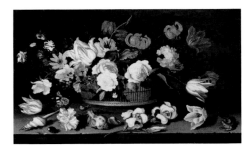

Balthasar van der Ast

(1593/1594–1657)

Balthasar van der Ast was probably born in Middelburg. He was 15 years old when his father, a widower, died. Balthasar then went to live with his sister and to study painting with her husband, the still-life painter Ambrosius Bosschaert the Elder. In 1615 Van der Ast followed Bosschaert to Bergen op Zoom and then to Utrecht, where Van der Ast entered Saint Luke's Guild as a master.[1] Van der Ast stayed in Utrecht until about 1632, the year he joined the guild in Delft. There his long bachelorhood came to an end when on 26 February 1633, at the age of 40, the banns were published for the marriage of Balthasar van der Ast, painter in the Oosteinde, and Margrieta Jans van Buyeren.

Van der Ast, who specialized in depictions of flowers, fruit, insects, small animals, and shells, usually signed and dated his paintings.[2]

1. Bol 1955, 138–141.
2. List of paintings in Bol 1955, 152–154.

1

Vase of Flowers, Basket of Fruit, and Shells

panel 9¾ x 12¾ inches (24.5 x 32.5 cm)
signed *B van der Ast f 1623*

This picture belongs to a small group of paintings by Van der Ast in which the objects are rendered smaller than their natural sizes. His composition creates a variation on the traditional scheme devised by his teacher Ambrosius Bosschaert the Elder. Van der Ast abandoned the classical tabletop or ledge arrangement and introduced instead two steps in stone. On the lower one he placed fruit and shells, among which is one sheltering a hermit crab. On the upper step appear a rummer with flowers and a basket with a leaning dish with fruit.

Ambrosius Bosschaert the Elder taught Van der Ast to paint three types of pictures: a vase with flowers, a basket or dish with fruit, and a basket with flowers (cat. 2). He combined the first two types in this picture, and added a group of shells as well. This complex composition provides an image with an appealing pictorial richness.

provenance Sale Liphart Ratshoff, Mak van Waay, Amsterdam, 11–12 October 1921, lot 14; Eugen Slatter Gallery, London, 1958; Sale Ingram, London, 3 March 1964; Private collection
exhibition Nieuwe Kerk, Amsterdam 1986 (Kunsthandel P de Boer)
literature Bol 1960, cat. Van der Ast, no. 109

2

Basket of Flowers

panel 14¼ x 23¾ inches (56 x 60.5 cm)
signed *B. van der ast, 1625*

Van der Ast's *Basket of Flowers* develops a theme used often by Ambrosius Bosschaert the Elder. An example of Bosschaert's work (fig. 1) represents a willow basket on a grayish stone ledge filled with various flowers. In front of the basket along the edge of the slab in a row are a group of three fruits (on one of which sits a fly), a white and red anemone (on which sits a butterfly), and a white rose. The vertical axis of the panel passes through the middle of the basket and cuts at right angles the line formed by the objects in the foreground. As a result the composition is serene and classicistic.

Ambrosius Bosschaert the Elder's compositional scheme for these flower paintings was taken over by his three painting sons, Ambrosius the Younger, Johannes, and Abraham, and was of particular importance to Van der Ast.[1] When Balthasar van der Ast became a pupil of Ambrosius the Elder around 1610, the master had been painting the type of

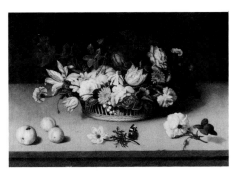

fig. 1. Ambrosius Bosschaert the Elder, *Still Life with Flowers and Fruit*. Private collection, West Germany

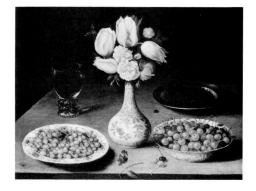

flower and fruit paintings discussed above for a number of years.

The composition of Van der Ast's basket with flowers, painted in 1625, contains considerably more movement than do Bosschaert's earlier examples. Van der Ast abandoned the strict central axis around which Bosschaert's objects are oriented. His flowers are also more flowing than those of his master. Van der Ast, as is evident in this painting, was a marvelous painter of shells, and also executed a number of shell still lifes.

provenance Schagerström Collection, Sweden; John Håkansson Collection, Stockholm; R. Steenhoff Collection, Stockholm; Mrs. R. Steenhoff Collection, Stockholm

exhibition *Holländska mästare i svensk ägo*, National-museum, Stockholm, 1967, 2d ed., no. 197

literature O. Granberg, *Inventaire générale des trésors d'art. . . en Sude*, vol. 3 (Stockholm, 1913), 28, no. 93; Bergström 1984, 43, fig. 37

1. See I. Bergström, "Baskets with Flowers by Ambrosius Bosschaert the Elder and their Repercussions on the Art of Balthasar van der Ast," *Tableau* 6:6 (December 1983–January 1984), 66–68.

Osias Beert the Elder

(c. 1580–1623)

Osias Beert was probably born in Antwerp. He entered Saint Luke's Guild in Antwerp in 1596 as an apprentice to Andries van Baseroo, and was admitted as a master in 1602. He had six pupils.[1] On 8 January 1606, Beert married Margarita Ykens in the church of Notre Dame. Their son Elias (1622–c. 1678) also became a painter. He used Osias as his first name when he became a master in the guild in 1643.[2] Osias the Elder, who combined his work as a painter with being a seller of corks, belonged to the Chamber of Rhetoric "De Olijftak" from 1615 until his death in 1623.

1. Hans Ykens in 1603, Frans vander Borcht in 1610, Peeter Doens in 1611, Frans Ykens in 1615, Pauwels du Pont in 1616, and Joes Willemssen in 1617. Greindl 1983, 35.
2. Greindl 1983, 36.

3

Vase of Flowers with Dishes of Fruit and Drinking Glass

panel 19¾ x 26½ inches (50 x 66.5 cm)

The visibility of the objects forming this still life is at a maximum because the artist used a high viewpoint, making the tabletop rise steeply toward the background. The five main components are distributed in such a way that none of them overlaps another. The conception belongs to a quite early stage within the development of composition in Netherlandish seventeenth-century still-life painting. It gives an enhanced presence to the objects depicted. This early picture should be dated close to the artist's acceptance as master in the guild at Antwerp, and in any case not after the first decade of the century.

The early masters did not paint flowers from life, but from preparatory drawings of individual flowers. In an early flower painting by Beert, there are three tulips that are identical to flowers in this bouquet. Osias Beert, like Ambrosius Bosschaert, Balthasar van der Ast, and others used preparatory drawings for their depiction of flowers. These drawings allowed the artist to paint still lifes in winter and to construct bouquets that contained flowers from different seasons.

provenance Sale Sotheby's, London, 24 March 1971, lot 58; H. Terry-Engell Gallery, London, 1971; Mrs. Prescott Collection, Connecticut

literature Greindl 1983, 336, cat. 27

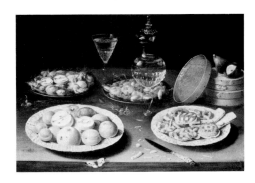

4

Fruit, Nuts, Wine, and Sweets on a Ledge

panel 32¾ x 25⅛ inches (65 x 85 cm)

A feature of this banquet picture that places it early in the artist's oeuvre is the high viewpoint. The overlapping of the objects represented, however, suggests a development beyond cat. 3. Beert's rendering of forms is highly energetic and powerful. The two Venetian-style glasses represented are typical of his work in that he, like no one else in Flanders, knew how to depict light glowing within their substance. His colors are brilliant, his technique most solid. In this work he reached full mastery. A likely date would be c. 1610.

The sweets represent a high achievement of the confectioner's art and were a great luxury in their time. Some of them are even highlighted with thin gold color. Such candies occur frequently in the still lifes of Beert.

In another early and splendid work by Osias Beert (fig. 1) a figural scene has been added in the upper right corner of the panel, showing the rich man at table with his guests and the poor Lazarus lying on the ground, dogs licking his wounds. The meal laid on the table in the foreground is, as in cat. 4, a luxurious one, and the glasses and porcelain dish are precious objects. The scene of the rich man and Lazarus is a moralizing comment on the splendid objects of the still life. Its implication is that living in wealth and luxury may jeopardize the salvation of the soul. On one of the apples in the Heinz painting is a fly. This insect, which appears rather frequently in Netherlandish seventeenth-century still lifes, is attracted by what will putrify. The fly is a symbol that the precious, splendid things on the table are perishable, as is Man.

provenance Private collection, Paris, 1938; Galerie Pardo, Paris, 1954; Private collection

exhibition *Natures mortes des 17ᵉ et 18ᵉ siècles*, Galerie Guy Stein, Paris, 15 May–3 June 1939, cat. 4

literature Benedict 1938, 311–312, 314, fig. 5; *Apollo* 1985, 376, plate VII; Greindl 1983, fig. 16 (reproduced in color), cat. 85

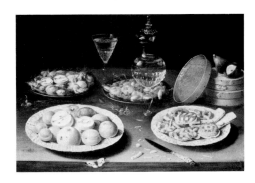

fig. 1. Osias Beert the Elder, *Still Life with Allegory*. Art market, photo courtesy Christie's, London

Abraham van Beyeren

(1620/1621–1690)

Hendrick Gillisz. van Beyeren, a glass painter in The Hague, declared when his wife died in 1637 that she had left him five children, of whom Abraham was 16 years old. Thus Abraham must have been born in 1620 or 1621. He married Emerentia Staecke from The Hague in April 1639, and lived in Leiden that year.[1] In the following year he entered the guild in The Hague. After Emerentia died, Van Beyeren married Anna van Queborn, the daughter of the painter Crispijn van Queborn. With this marriage he entered the Queborn circle of painters, which was important for his development as a still-life painter. The fish painter Pieter de Putter, also related through marriage to the Queborns, may have been Van Beyeren's teacher. In 1656 he was cofounder of the Confrérie Pictura in The Hague.[2]

Apparently Van Beyeren could not easily make a living as an artist; from 1647 on there were unpaid bills from the wine dealer, the baker, the seller of artists' supplies, and the tailor. Van Beyeren's paintings brought 10 to 35 guilders, and sometimes he paid his bills with paintings. Perhaps his finances were the reason for leaving The Hague for Delft, where he became a member of the guild in 1657.

Circumstances seemed better for Van Beyeren when he returned to The Hague in 1663, for there were few claims against him. In 1669 he moved to Amsterdam with his family, where he stayed until 1674, when he became a member of the guild in Alkmaar. In 1678 he moved to Overschie, buying a house and land. By then he must have been well-to-do, for he is called "Monsieur" van Beyeren by the notary. He died in 1690 in Overschie.[3] Van Beyeren is most famous for his fruit, flower, vanitas, and banquet paintings. He also painted seascapes and river views.[4] Van Beyeren stands out among seventeenth-century Dutch painters as a great colorist and handler of paint.

1. Moes in Thieme-Becker 1909, 3:570.
2. Bergström 1956, 229.
3. Bol 1969, 343; Van Gelder n.d., 21–25.
4. Van Gelder n.d., 29. See also G.C. Helbers, "Abraham van Beyeren Mr. Schilder to Overschie," *Oud Holland* 45 (1928), 27–28.

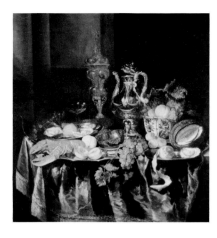

5

Lobster, Oysters, and Fruit on a Table

canvas 43¼ x 42¾ inches (110 x 108.5 cm)
signed *AB 165?*

Within Abraham van Beyeren's extensive oeuvre, this banquet painting of c. 1655 belongs to the group of monumental, overwhelming works. On a table covered by a richly draped, gold-fringed velvet cloth, he placed an arrangement of precious pieces of silver and porcelain, and a wealth of shellfish and fruit. He juxtaposed objects lying flat on the cloth with three others that have pronounced vertical shapes. This compositional organization is repeated in the verticals of the background architecture and the horizontal line formed by the edge of the bottom of the niche. This classicistic manner of composing is also observable within other

branches of Dutch painting of the period. By the interplay of horizontals and verticals this picture acquires its serene monumentality. The very size and the proportions of the nearly square canvas contribute to that effect, neither height nor width being allowed to dominate.

Clear daylight reigns, giving a mildly sensual character to the objects depicted. For example, the boiled lobster is not predictably red, but instead has a softly pinkish color. The brushwork is admirably free and broad.

Van Beyeren composed other large and splendid still lifes according to classicistic principles, including one of 1655 in the Worcester Art Museum in Massachusetts and one of 1654 in the Museum Boymans-van Beuningen, Rotterdam (fig. 1). Van Beyeren often repeated the same silverware in these magnificent compositions. Thus in the Rotterdam picture appear the octagonal dish, the two-handled bowl, and the big, splended pitcher with its cover partly opened, all represented in the same position as in cat. 5.

provenance Frits Lugt Collection, Maartensdijk; H. Terry-Engell Gallery, New York, 1951; Kunsthandel A. Staal, Amsterdam, 1968

literature *Mededeelingen van de Dienst van kunsten en wetenschappen* 2 (1926), 13 (reproduced)

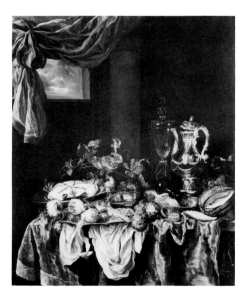

fig. 1. Abraham van Beyeren, *Still Life*, signed and dated 1654. Museum Boymans-van Beuningen, Rotterdam

Maerten Boelema, called "de Stomme"

(1611–after 1664)

Maerten Boelema, the third child of Dr. Martinus Martinides Boelema and his second wife, Evertien Tiaertsdr., was baptized in Leeuwarden, the capital of the northern province of Friesland, on 17 February 1611. He was deaf and could not speak. It is not known if he painted in Leeuwarden, though Wassenbergh dated a still life to c. 1640, thus before Boelema came to Haarlem, where he was a pupil of Willem Claesz. Heda in 1642.[1] His first dated painting is from the year he became Heda's pupil.[2] Boelema returned to Friesland after his apprenticeship,[3] though in 1664 he was in Haarlem again.[4]

1. Miedema 1980, 2:532.
2. A. Wassenbergh, "Een vroeg stilleven van Maerten Boelema de Stomme," *De Vrije Fries* 46 (1964), 200–204.
3. Vroom 1980, 1:130.
4. Bergström 1956, 140.

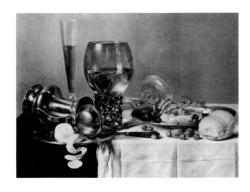

6

Tabletop with Drinking Glass, Tankard, Bread, Fruit, and Shellfish

panel 19¼ x 25 inches (49 x 63.5 cm)

Boelema started his apprenticeship with Willem Claesz. Heda, quite late, at the age of thirty-one years, perhaps because of his handicap. This still life, which is to be dated some years later, reminds us more of the work of Pieter Claesz. than of Heda. By this work Boelema rivals these two great Haarlem masters. The high quality of Boelema's work makes it seem possible that a number of his pictures may have had their signatures erased so that they could pass as works by Heda or Claesz.

Johannes Bosschaert

(1610/1611–after 1628)

Maria Sweerts, the daughter of the famous flower painter Ambrosius Bosschaert the Elder, wrote the history of the Bosschaert family. Her three brothers, Ambrosius the Younger, Johannes, and Abraham, were painters of flowers and fruit. Johannes Bosschaert was born probably in Middelburg in 1610 or 1611, the second son of Ambrosius the Elder. Johannes must have grown up in his father's workshop, for his earliest known painting is dated 1623, when he was thirteen. When Johannes' father died in 1621, Johannes possibly came under the protection of his uncle Balthasar van der Ast who then lived in Utrecht, and, along with other painters in Utrecht such as Roelant Savery, probably influenced his style.[1] The Bosschaert-Van der Ast family and Roelant Savery's family seem to have been on friendly terms.[2] Little documentary information about Johannes is to be found in Utrecht, but we know that he entered the guild of Haarlem in 1623.[3]

His study of fruit in oil paint dated 1623, now in the Herzog Anton Ulrich-Museum in Brunswick, shows that Johannes made studies in oil, rather than in watercolor, as was usual at that time.[4] He also might have worked in Dordrecht, since paintings by Johannes Bosschaert are mentioned in at least two Dordrecht inventories.[5]

1. Bol 1956, 133–134.
2. Amsterdam 1984, 63.
3. Van der Willigen 1870/1970, 87.
4. Amsterdam 1984, 63.
5. Bol 1956, 132–135.

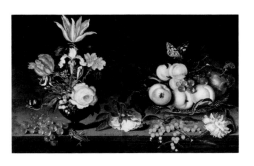

7

Flowers and Fruit

panel 14½ x 22¾ inches (37 x 58 cm)
signed *I Bosschaert f 1626*

Johannes Bosschaert painted about two dozen bouquets of flowers and/or fruit in baskets and dishes in his short life. They are outstanding achievements that place him among the most important early seventeenth-century Dutch flower and fruit painters. Johannes painted this picture, signed and dated 1626, when he was fifteen or sixteen years old. It is an admired and well-known masterpiece that has been exhibited many times.

Johannes received his initial training from his father Ambrosius Bosschaert the Elder, who painted symmetrically arranged flowers in a vase and baskets or dishes with flowers or fruit. Balthasar van der Ast, Johannes' uncle who was the brother-in-law and pupil of the elder Bosschaert, created a new type of still life around 1620, combining a vase with flowers and a dish or basket of fruit in one picture (cat. 1).

Johannes Bosschaert must have learned to combine flowers and fruit in one painting from Van der Ast. When composing his bouquets Johannes some-

times used studies of individual flowers by various people, including his father, Van der Ast, and also the Utrecht artist Roelant Savery. Despite these tangible influences the very young master displays an artistic will of his own, rendering energetically and sensitively flowers, fruit, insects, and lizards. The brilliant picture in the exhibition is an outstanding example.

provenance Dr. H. Wetzlar Collection, Amsterdam (cat. 1952, no. 10); Sale Wetzlar Collection, Sotheby Mak van Waay, Amsterdam, 9 June 1977, lot 93; Private collection, Germany

exhibitions *La Hollande en fleurs*, Château de Rohan, Strasbourg, 1949, cat. 8; *Early Dutch Flower Paintings*, Manchester City Art Gallery, Manchester, England, 1949, cat. 6; *Boom, bloem en plant*, Dordrechts Museum, 1955, cat. 23; *Kunstschatten*, Singer Museum, Laren, 1959, cat. 30; *Bloem en Tuin in de Vlaamse Kunst*, Museum voor Schone Kunsten, Ghent, 1960, cat. 21; Münster 1979–1980, cat. 186; Amsterdam 1983, cat. 11; Amsterdam 1984–1985, cat. 22

literature Bergström 1947, 84, fig. 68; Bergström 1956, 76, fig. 68; Bol 1956, 134–136; Bol 1960, 41, 42, 90, cat. 15, fig. 50b; Bol 1969, 30; Laurens J. Bol, "Goede Onbekenden 7 . . .," *Tableau* 3 (1981:4), 581; Bol 1982, 57; Segal in Amsterdam 1983, 52–53, 108; Segal in Amsterdam 1984–1985, 63–64, 160

Jan Brueghel the Elder

(1568–1625)

Jan Brueghel, who was nicknamed "Velvet Brueghel" because of the delicacy of his brushwork, was one of the most important Flemish masters at the beginning of the seventeenth century. Famed for his still lifes as well as for his landscapes, genre scenes, history paintings, and allegories, Brueghel was admired throughout Europe, and his art was sought after by the most important collectors of the day. Brueghel was born in Brussels as the third child of Pieter Bruegel the Elder and Mayeken Coecke.[1] He learned watercolor painting from his grandmother, and later became pupil of Pieter Goe-kindt, who taught him to paint in oils. Following the footsteps of his father, he traveled to Italy between 1590 and 1596, where he painted religious scenes primarily.[2] In Italy he visited Naples, Rome, and eventually Milan, where he worked for Cardinal Federico Borromeo, who later served as godparent to Brueghel's daughter. By October of that year he was in Antwerp, and the following year he was accepted as a "master's son" (meesterssonen) in Saint Luke's Guild. In 1599 Brueghel married Isabella de Jode. In the same year he became codeacon of the guild, and was named deacon in 1602. In 1604 Brueghel bought a large house in Ant-

werp called "De Meerminne." Apparently he did not feel at ease too long in one place, because in the summer of 1604 he left for Prague. The next year he married his second wife, Katharina van Marienburg, and in 1606 he became a painter to the court in Brussels. While Brueghel was a court painter, Archduke Albrecht VII gave him certain privileges, such as exemption from his duty in the civic guard. In 1611 Daniel Seghers (cat. 35) became his pupil. Around 1613 Brueghel traveled to Holland with Rubens and Van Balen, where in Haarlem they were received by Hendrik Goltzius. In 1615 four of his paintings were offered by the city of Antwerp to the archduke as a farewell present after his visit to the city. In 1619 Brueghel bought another house in Antwerp, and in that same year he worked on a commission of thirty-eight miniatures for Albrecht VII.

Brueghel's son Jan Brueghel the Younger also became a painter, and his daughter Paschasia married the painter Hieronymus van Kessel. Brueghel died of cholera in Antwerp in January 1625.[3]

1. Ertz 1979, 14.
2. Van Mander 1604/1969, 234.
3. Ertz 1979, 14–16.

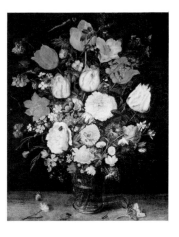

8

Flowers in a Glass

panel 19½ x 14½ inches (49 x 37 cm)

As the son of Pieter Brueghel the Elder, Jan Brueghel the Elder was born into one of history's most important families of painters. His oeuvre comprises a varied repertoire of flower paintings, wreaths of flowers, still lifes, landscapes, and series such as *The Four Seasons* or *The Four Elements*. Klaus Ertz has listed nearly four hundred pictures by him alone. Furthermore he collaborated with other masters, for instance Peter Paul Rubens and Joos de Momper, to whose paintings he contributed flowers, animals, or figures in a landscape. Jan Brueghel was one of the first important Flemish painters of flower pieces, a contemporary of such great masters as Osias Beert the Elder, Jacques de Gheyn the Younger, and Ambrosius Bosschaert the Elder.

Brueghel painted huge bouquets with hundreds of flowers and also a number in medium size, of which this picture is an excellent example. The vessel holding the bouquet is always extremely small, allowing the flowers to dominate the composition completely. In this painting the vase is a drinking glass, which keeps the mass of flowers in an elliptical arrangement of little depth.

A great patron of Jan Brueghel was Cardinal Federico Borromeo, the archbishop of Milan, for whom Brueghel painted a flower piece in 1608 (fig. 1). A series of letters from Brueghel to Borromeo in the Ambrosiana Library in Milan reveal how he worked and how he looked upon his flower pieces. In a letter of April 1606 the painter wrote from Antwerp: "I have commenced a bouquet of flowers for Your Eminence. The result will be a success and very beautiful, both because of its naturalness and because of

the rare beauty of the different flowers, many of which are unknown or seldom seen here; for this reason I have been to Brussels in order to copy from nature some flowers that are not to be found in Antwerp."[1]

Like other contemporary Netherlandish masters of flower painting, Jan Brueghel made preparatory studies of the individual flowers. Using these he built up his bouquets. Thus one arrangement may contain flowers of different seasons, and favorite flower studies could be used in quite a number of works. An interesting case is the red-striped white tulip under

the topmost one in the picture exhibited. It has been used also by Ambrosius Bosschaert the Elder (fig. 2) and Georg Flegel (cat. 15), where that tulip occurs again beneath the top flower. These two masters, respectively in the Netherlands and Germany, have in all likelihood quoted the tulip from some work by the Fleming Jan Brueghel.

The present flower picture has the admirable, poetical qualities of Jan Brueghel's art. Flowers of various species and shapes have been chosen, and the many colors balance one another. The touch of the brush is spirited, blurred, and of

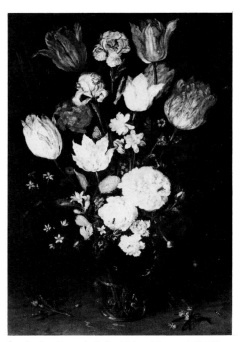

fig. 1. Jan Brueghel the Elder, *Flower Still Life,* signed and dated 1608. Pinacoteca Ambrosiana, Milan

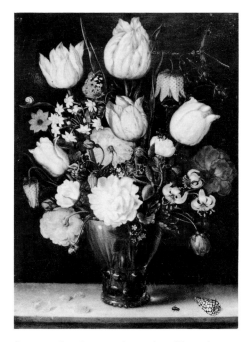

fig. 2. Ambrosius Bosschaert the Elder, *Flower Still Life,* signed and dated 1607. Private collection, Milan

much movement. Although Klaus Ertz questioned the attribution of this work to Jan Brueghel the Elder in his publication of 1979 before he had seen it in the original, he concluded in a communication of 30 September 1982 that it was painted by Jan the Elder shortly before the picture of 1608 (fig. 1). The date he suggested of 1607 or 1608 seems quite likely.

The many types of pictures that Jan Brueghel the Elder painted were influential after his death in 1625. They were used as models in the Antwerp studio of his son Jan Brueghel the Younger, whose assistants produced an enormous number of paintings. Many works were exported to such places as Spain and France. What left the studio after 1625 varied in quality, the best being by Jan Brueghel the Younger.[2]

provenance Thomas McLean Gallery, London; A. R. Holland, Esq.; Lady Scott; Sotheby's, London, 4 July 1956, lot 131; Frank Partridge Gallery, London; Sidney J. van den Bergh Collection, Wassenaar

exhibitions *1957 Exhibition of Fine Paintings of Four Centuries*, Hallsborough Gallery, London, 1957, cat. 5; *Twee Nederlandse collecties schilderijen . . .*, Singer Museum, Laren, 1959, cat. 33; *17de eeuwse meesters uit Nederlands particulier bezit*, Stedelijk Museum De Lakenhal, Leiden, 1965, cat. 7; *Terugzien in bewondering*, Mauritshuis, The Hague, 1982, cat. 20; Amsterdam 1982, cat. 25

literature A.B. de Vries, "Old Masters in the Collection of Mr. and Mrs. Sidney van den Bergh," *Apollo* 80 (1964), 352, fig. 1; Hairs 1965, 363; *Verzameling Sidney J. van den Bergh*, Wassenaar 1968, cat. 34 (reproduced in color); Ertz 1979, 276, 555–623, fig. 341, cat. 183

1. G. Crivelli, *Giovanni Brueghel pittor fiammingo, sue lettere e quadretti esistenti presso L'Ambrosiana* (Milano, 1868), 63–64.
2. About the oeuvre of Jan Brueghel the Younger and the activity of the studio, see J. Denucé, *Brieven en documenten betreffend Jan Brueghel I en II* (Antwerp and The Hague, 1934), and Klaus Ertz, *Jan Brueghel der Jüngere (1601–1678), die Gemälde mit kritischem Oeuvrekatalog* (Freren, 1984), who has classified a vast number of relevant pictures.

Pieter Claesz.

(1597/1598–1661)

Pieter Claesz. was a still-life painter working in Haarlem who was born in (Burg) Steinfurt in Westphalia. He married Geertje Hendricksdr. in 1617 in Haarlem. Houbraken wrote that he first painted fish still lifes, and later small pictures, usually of a table with all kinds of sweets, often in a silver bowl or porcelain dish.[1] There is some confusion between paintings by Claesz. and those by Willem Claesz. Heda and also those by Clara Peters (Peters used the same monogram).[2] The landscape painter Claes Pietersz. Berchem (Nicolaes Berchem) was his son.[3] Claesz. influenced a number of artists, including Johannes Cuvenes (cat. 12) and Maerten Boelema (cat. 6).

1. Houbraken 1753/1976, 2:110–111.
2. Vroom 1980, 1:25–26.
3. Van de Willigen 1870/1970, 76.

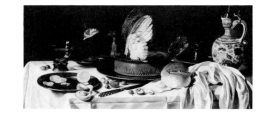

9

Tabletop with Pigeon Pie

panel 14½ x 30½ inches (37 x 77 cm)
signed in monogram

Pieter Claesz. was active as a still-life painter in Haarlem for four decades. His extensive oeuvre, from practically every year of which one or more dated picture is known, allows us to follow the changes in his art. In the 1620s he experimented with variations of motifs and with panels of different proportions.

The picture in the exhibition is unique among Claesz.' early works in its proportions, the length being more than twice the height. The meal pictured on the table is distinguished by a pigeon pie, decorated with the bird's neck, head, wings, and tail. Such show dishes were adornments of the tables of the rich and mighty in the baroque age, contributing greatly to the splendor of their banquets.

This painting can be compared to two other still lifes from the early years of Claesz.' artistic career, his earliest known work signed and dated 1621 (formerly E. C. Francis, England), and a second still life dated 1627 (Rijksmuseum, Amsterdam). All three pictures are composed in the same early unsophisticated manner, with the objects arranged along intersecting diagonals. The lighting and forms of the picture of 1627 are softer and the colors less strong than in the one of 1621. This change is characteristic of the development of the art of the master. The still life in the exhibition is also softer in lighting, color, and forms, and is thus later than 1621. It seems natural to regard it as an antecedent to the larger picture of 1627. Thus a likely date of the one exhibited would be c. 1625.

provenance Private collection

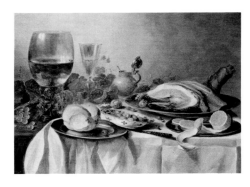

10

Table with Ham, Fruit, and Drinking Glasses

panel 18 x 22 inches (45.5 x 56 cm)
signed in monogram and dated 1646

This picture belongs in the category of the monochrome breakfast still life in which gray and brown predominate. What ought to be rather colorful—the red of the wine, the pink of the ham, the green of the leaves and the olives, and the yellow of the lemon—is all subordinated to a single tonality. With this tonality Claesz. makes the atmosphere surrounding the objects tangible. The first still lifes of this kind appear within his oeuvre around 1632. The present painting of 1646 belongs to a group of works by the master that display a similar choice of objects as the still life in the exhibition.

The brushwork of Pieter Claesz. is feathery, rapid, fluid, spirited. It reminds us of the fact he and Frans Hals were contemporaries in Haarlem.

provenance Kunsthandel Liernur The Hague; Sale Duprez, Brussels, 6–7 December 1938, lot 16; Private collection, France
literature Vroom 1945, cat. 62; Vroom 1980, cat. 128

Edwaert Collier

(c. 1640–after 1706)

*Edwaert Collier was a still-life and portrait painter who was born in Breda around 1640.[1] He entered Saint Luke's Guild in Leiden in 1673, but he probably had previously lived in that city for a considerable length of time since he was married there in 1670. By 1681 he had remarried three times, each time to a widow.[2] He moved to London after the revolution of 1688 and pursued a successful career as a painter of **vanitas** still lifes. By 1706 he was back in Leiden, according to an inscription on a painting.[3] His earliest painting, dated 1661, is a combination of the monochrome style of the Haarlem painters with the more colorful style of Van Beyeren and De Heem.[4] **Vanitas** still lifes were his favorite subject, and later he painted illusionistic still lifes with trompe l'oeil effects.*

There is some confusion about whether Edwaert Collier and Evert Collier are one person or two. Older literature mentions a person called Evert Collier who was a member of the guild in Haarlem in 1673; however, no such name is mentioned in the archives of the Haarlem guild.[5] Evert Collier is on the list of members of Saint Luke's Guild in Haarlem for 1646, and therefore cannot be the same person as Edwaert Collier, who was born around six years earlier in Breda. The relation between Edwaert and Evert Collier is not known.

1. Vroom 1980, 1:135.
2. In 1670 to Maria Franchoys, widow of Joost van Tongeren; in 1674 to Maria Pypen, widow of Petrus Willems; in 1677 to Cornelia Tieleman; and in 1681 to Anna du Bois, widow of Willem van Bombergen.
3. The 1706 date is mentioned in the catalogue of the Stedelijk Museum de Lakenhal (Leiden 1949), 35. Also in Vroom 1980, 1:135.
4. Vroom 1980, 1:137, repr. 179.
5. According to Moes in Thieme-Becker 1912, 7:263, Collier should not be called Evert, while Van de Willigen 1870/1970, 113, asks if Edwaert and Evert are the same person.
11. Vroom 1980, 1:135.

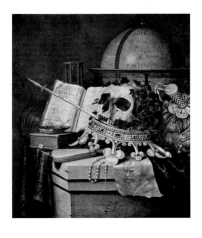

11

Vanitas with Skull and Coronet

canvas 22½ x 19 inches (57 x 48.3 cm)
signed and dated 1663

A strong tradition of *vanitas* still-life painting existed in Leiden throughout most of the seventeenth century, perhaps because of the theological attitudes evident in the university of that city. As early as the 1620s, David Bailly introduced depictions of skulls into his monochromatic still-life paintings to remind the viewer of the transience of life, an admonition that was reiterated by his students and followers, including Jan Davidsz. de Heem (cat. 19) and Harmen van Steenwyck (cats. 39, 40). A late exponent of this tradition is Edwaert Collier.

This remarkable painting proclaims unambiguously that Death rules over all. A human skull, crowned in a wreath of laurel, rests upon an overturned coronet and a king's scepter in a manner that is reminiscent of Shakespeare's line from Richard II (3.2.160–162), "Within the hollow crown, . . . Keeps Death his court." The transience of worldly treasures, symbolized by the globe, the money bag, the pearls, music, and even art, here represented by the pen drawing of a bearded man, is further reinforced by the soap bubbles rising from the shell and the hourglass in the background. The page of the Latin book open to a history of Pompeii is yet another reference to the temporality of all existence.

Collier painted this work in Leiden, but shortly thereafter he moved to London, where he anglicized the spelling of his name. He continued painting similar works until the end of his career, incorporating many of the same objects in different combinations.

A. K. W.

provenance Serge Philipson, Ireland
exhibition *Paintings from Irish Collections*, Municipal Gallery of Modern Art, Dublin, May–August 1957

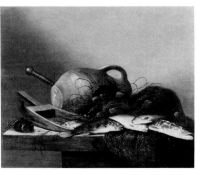

Johannes Cuvenes the Elder

(c. 1620–c. 1656)

The Cuvenes family of painters came from Germany. Johannes the Elder was the son of Joannes Kuvenestes of Bremen.[1] Bol called him a follower of Claesz. and Heda.[2] After working in Bremen, he seems to have moved to The Hague before 1647, for documents show that by 1647 around twenty-five paintings were sold in The Hague from a certain "Kuvenis."[3] He married Catharina Corn van Doesburch there in 1649 and became a member of Saint Luke's Guild in 1650. In 1655 and in the following year he was active in Amsterdam. He probably died shortly afterward in The Hague.

Paintings by Cuvenes have been attributed to Pieter Claesz. and Fray Juan Sanchez Cotan.[4] Other members of Johannes Cuvenes' family include his younger brother, Dirck Cuven, and his son, Johannes Cuvenes the Younger (1651/1652–before 1684), who entered the Leiden guild in 1677. There also was a Johannes Cuvenes III,[5] the son of Johannes the Younger.

1. Bredius in Thieme-Becker 1913, 8:221.
2. Bol 1969, 82–83.
3. Bredius in Thieme-Becker 1913, 8:221.
4. Vroom 1980, 1:146.
5. Bredius in Thieme-Becker 1913, 8:221.

12

Vanitas with Green Drape and Skull

canvas 42¼ x 55¾ inches (107.3 x 141.6 cm)
signed *J Cuvenes f*

Before this painting became known, Cuvenes was thought to have cultivated three genres of still-life painting. He painted some fine breakfast pieces that are closely inspired by Floris van Schooten (cats. 32, 33), so closely that it can be supposed that some still lifes now attributed to Van Schooten in reality are by Cuvenes. He also executed fish paintings. The suggestion throughout the literature that Cuvenes was influenced by Abraham van Beyeren (cat. 5) in these pictures is not correct. Comparison of a fish painting by Cuvenes (fig. 1) signed and dated 1647 with a painting (fig. 2) by Van Beyeren's teacher in this field, Pieter de Putter, shows De Putter's decisive influence on Cuvenes. De Putter was active in The Hague. The third genre within still life to which Johannes Cuvenes devoted himself is the representation of dead birds. Only one such picture is known, which is signed and dated 1645 (formerly Gemeentemuseum, The Hague). Its purely Dutch character would indicate that Cuvenes was already in the Netherlands by that year.

The impressive picture exhibited, hitherto unknown, shows that Johannes Cuvenes also cultivated a fourth genre, that of the *vanitas* still life. The setting is a wall with a niche, below which is a frieze in relief. A green curtain appears to the right, covering part of the niche. The term *vanitas* is biblical: "Vanity of vanities, saith the Preacher, vanity of vanities; all *is* vanity" (Eccl. 1.2). The transience of man is tangibly illustrated in the picture by Cuvenes. Human life is short like that of the rose near the skull; Horatius used the expression *rosa brevis* in this connection. The smoking wick of the oil lamp to the left reminds us of the verse from Psalms 102.3 "For my days are consumed like smoke." The inescapable flight of time is symbolized by the hourglass and the pocket watch. The puzzling ball of cloth on the jewel case is perhaps a shroud.

Cuvenes' message is not entirely pessi-

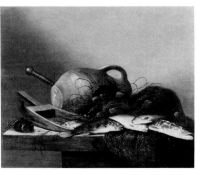

fig. 1. Johannes Cuvenes, *Still Life with Fish,* signed and dated 1647. Photo courtesy Brod Gallery, London

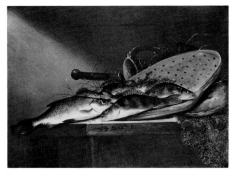

fig. 2. Pieter de Putter, *Still Life with Fish,* signed. Whereabouts unknown, photo courtesy Ingvar Bergström

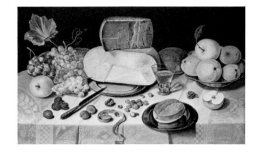

mistic. The wheat, which falls to the earth to grow into a new plant, is a symbol of hope. Like the grain, man must die and be buried to achieve eternal life. This idea has also been expressed by the inscription on a sheet of the volume in the center, *Mors mea vita*, meaning that death is a prerequisite to resurrection, to new life in heaven, indicated by the celestial globe.

The composition and execution of this *vanitas* still life are admirable, especially in the harmoniously balanced colors. The picture curtain (which was sometimes used in reality in protection against strong light and dust) strikes a strong trompe l'oeil note.

provenance Private collection

Floris van Dijck
(1575–1651)

The Dutch still-life painter Floris van Dijck was born in 1575, probably in Haarlem. Floris was part of the group of earliest Dutch still-life painters, and during his lifetime was considered Haarlem's best painter in the genre by Ampzing (1628) and Schreveli (1648). He was a member of a patrician family, a wealthy man who painted little. On a visit to Italy he was befriended by Cavaliere d'Arpino. In 1610 he entered Saint Luke's Guild in Haarlem and participated in the reorganization of the guild in 1631 and 1632.[1] In the archives he is mentioned as "vinder" (member of the board of the guild) several times.[2] In 1637, when he was elected deacon, he gave the guild a lifesize bust of Michelangelo. He died in Haarlem in November 1651.[3]

*Schreveli said Floris was "a painter of little objects, who could deceive and tempt [the eye] through cunning and guile."[4] Van Dijck's work resembles that of Nicolaes Gillis, who worked in Haarlem from 1622 to 1632. Floris also painted watercolors, such as the fruit still life in watercolor on paper signed "F v D" and dated 1624 that is part of an **Album amicorum** in the Koninklijke Bibliotheek in The Hague.[6]*

1. Lilienfeld in Thieme-Becker 1914, 10:270-271.
2. Miedema 1980, 2:1056.
3. Miedema 1980, 2:620.
4. Schreveli 1648, 6:390. "Soo ghy een Schilder soeckt van vruchten / ende allerhande snuystering / daer hebt ghy Floris van Dijck, die met fijn penseel / de lustige sonde kennen locken en verschalcken / ghelijck daer oock gheweest is van de selfde konst Willem Heda."
5. Other contributors to the album include Vossius, Matham, and Bailly. The album belonged to Cornelis de Montigny de Glarges (1599–1683), son of the Haarlem city attorney. Bol 1969, 17.

13

Cheese, Fruit, and Bread on a Red Silk Cloth

panel 21⅝ x 30¼ inches (55 x 77 cm)

This picture is an important example of an early Dutch breakfast piece. The viewpoint is high, the drawing is powerful with no softening of the outlines, and the local colors are strong and brilliant. The painting is a faithful replica of the still life by Floris van Dijck in the Frans Halsmuseum, Haarlem (fig. 1), which is signed in monogram *F V D FECIT 1613*.

The still life in the exhibition displays throughout the hand of Floris. An explanation for the existence of the two equal versions may be that a client admired the picture now in the Frans Halsmuseum, then already sold, and ordered another one like it. The version in this exhibition should be dated 1613 or slightly later.

The present work came to public attention for the first time in 1918 in a sale in Stockholm as a signed work by Clara Peeters. When the picture was brought to me for examination, I recognized that the signature, which has since been removed, was false and that the painting was an authentic work by Floris van Dijck.

provenance Auctioneers Hoving & Winborg, Stockholm, 22–26 April 1918, lot 1760; C. A. Persson, Malmö, Sweden

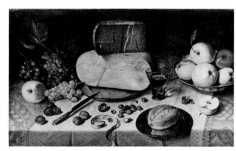

fig. 1. Floris van Dijck, *Breakfast Piece*, signed and dated 1613. Frans Halsmuseum, Haarlem, the Netherlands

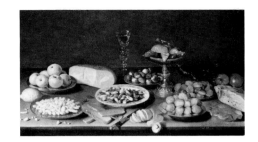

Jacob Foppens van Es

(c. 1596–1666)

Jacob Foppens van Es was a Flemish master who was born and who worked in Antwerp. In official documents his name occurs also as Jacob Fossens or Jacob Fobsen, which may indicate a Friesian background.[1] He was registered in Saint Luke's Guild in Antwerp as a master painter in 1616. When he finished his training period he was already married and had one son, Nicolaes, who later became a painter. His pupils included Jacob Gillis in 1621 or 1622 and Jan van Thiemen in 1623.

Van Es specialized in breakfast pieces, although he also painted fish and kitchen scenes with figures[2] and flower still lifes. His painting style and subjects can be compared to the work of Osias Beert the Elder (cats. 3, 4) and Jacob van Hulsdonck (cat. 20).

Although he is not well known today, he was highly esteemed in the seventeenth and eighteenth centuries. Peter Paul Rubens owned one of his paintings,[4] and Houbraken,[5] Cornelis de Bie,[6] and Weyerman[7] wrote about him with praise.

1. Greindl 1983, 54.
2. Zoege von Monteuffel in Thieme-Becker 1915, 2:20–21.
3. Greindl 1983; 49.
4. Greindl 1983; 54.
5. Houbraken 1753/1976, 1:217.
6. De Bie 1661/1971; 226–228.
7. Weyerman 1729, 2:6.

14

Banquet

panel 22 x 36¼ inches (55.5 x 91 cm)

Though this impressive still life has been attributed to Nicolaes Gillis (active Haarlem 1601–1628), it is unlikely that the painting is Dutch. The composition with elements juxtaposed in a pattern of intersecting diagonals and the choice of objects, not least the presence of a quantity of luxurious sweets, seems to indicate that the painter was influenced by Osias Beert. However, the hand is different than that of Beert. The execution displays a refined softness that resembles the youthful work of Jacob van Es of around 1620.

provenance Kunsthandel P. de Boer, Amsterdam, c. 1950 (as by Nicolaes Gillis); D. W. Gesink, Hilversum; Private collection, The Hague

exhibitions *Kunstbezit rondom Laren*, Singer Museum, Laren, 1958, cat. 93 (as by Nicolaes Gillis); Dordrecht 1962, cat. 55 (as by Nicolaes Gillis); *"Clarity in Awareness," An Exhibition of Dutch and Flemish 17th-Century Still-Life Paintings*, Alan Jacobsz. Gallery, London, Autumn/Winter 1984, cat. 2 (as by Jacob van Es, tentatively suggested by Ingvar Bergström)

Georg Flegel

(1566–1638)

Flegel was born in Olmütz, Moravia (now Czechoslovakia), and died in Frankfurt in 1638. The year of his birth was long believed to be 1563, but in reality is 1566 in light of inscriptions on two of his paintings.[1] According to documents in the Frankfurt archives, Flegel was not a Roman Catholic, so perhaps he left his native country for religious reasons.[2] He went to Frankfurt, perhaps in 1592, in the employ of Lucas van Valckenborch.[3] They executed several paintings together (cat. 42). The godfather of Flegel's eldest son Martin, who was baptized in 1594, was Martin van Valckenborch, brother of Lucas. Jacob Marrell became Flegel's pupil in 1627.

Joachim von Sandrart wrote that Flegel's naturalistic style and the variety of his still-life subjects made his work popular, especially among Netherlanders, and even though he painted rapidly, he was unable to keep up with the demand for his paintings.[4] Schram suggested that Flegel was educated in the Netherlands, where he learned still-life painting, although his teacher is not known.[5] He painted fruit, flowers, fish, poultry, insects, glasses, and metalware in a very naturalistic way. It is certain that he also painted portraits, for Eberhard Kieser engraved a portrait after one of his works.

1. Müller 1956, 65.
2. Müller 1956, 67.
3. Müller 1956, 87.
4. Sandrart 1675/1925, 164.
5. Schram in Thieme-Becker 1916, 12:84.

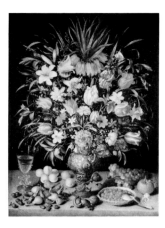

15

Vase of Flowers, Wine Glass, and Fruit

canvas 34 x 24¾ inches (86.5 x 62.5 cm)

In Germany the arts prospered tremendously during the sixteenth century, from Albrecht Dürer onward. A wealth of great masters were active in all fields. Against this background, the following century forms the strongest imaginable contrast. There are only two painters of true greatness, both connected with Frankfurt: Adam Elsheimer and the still-life painter Georg Flegel.

The flower painting in the exhibition is the largest among Georg Flegel's six known pictures of the kind. The richly colored bouquet is magnificent, consisting of a great number and variety of flowers. It is like a fireworks display, flashing out from a center formed by the pink-violet rose at the opening of the vase. The vertical middle axis of the mass of flowers is emphasized, starting with that rose and running upward through the darkish-brown iris and the white and red carnation to the splendid finale, the crown imperial (*Frittilaria imperialis*).

Flegel's bouquet, the flowers spreading like a peacock's tail, belongs to a type that I have termed radial composition.[1] It was developed and used in the years around 1600. Quite early works of this kind were watercolors by Georg Hoefnagel, who was staying in Frankfurt in 1591–1594.

Flegel's big bouquet is shown in a very small vase, by which the impression of an overwhelming mass of flowers is strengthened. The vase with a foot of two twisted dolphins seems to be a precious enamel or enamellike manneristic work, with a painted yellow decoration. On the front is a medallion with a skull, out of which spring stems with heads of grain, and the inscription *(MEMENT)O MORI*.

The duration of the splendid flowers of the bouquet is short, a visual metaphor of the brevity of human life, and the grain, which has to fall into the earth to grow a new plant, is a symbol of death and ressurection.[2] Around the vase on the grayish-brown stone slab appear a Venetian-style glass of golden-yellow wine, cherries, piles of peaches, pears, nuts, a Chinese porcelain dish with wild strawberries, and grapes and an orange. Insects are also present. Because they are attracted to what is perishable, these insects belong to the *vanitas* iconography.

In the 1590s Georg Flegel worked in Frankfurt as an assistant to Lucas van Valckenborch. The two artists collaborated, Flegel painting still-life details, and the elder master painting his specialty, landscapes, architecture, and figures. The drawing of the flowers of the bouquets in Flegel's collaboration with Van Valckenborch of *Summer* dated 1595 (cat. 42) is thinner than that in the present flower painting. The latter, of complete radial composition, is therefore to be dated slightly later than 1595.[3]

provenance Private collection, France; Collection R. P., Paris, 1953–1972; Sale of Collection R. P., Palais Galliera, Paris, 23 November 1972, lot 24 (as attributed to Pieter Binoit); Mme Anne Wertheimer, Paris (who identified it as a work by Georg Flegel); Private collection, Switzerland

literature Bergström 1977, 137, 139, 141, 145–146, fig. 94; Sam Segal, "Georg Flegel als bloemenschilder," *Tableau* 7 (December 1984), 74

1. I. Bergström, "Flower-Pieces of Radial Composition in European 16th and 17th Century Art," *Album Amicorum J. G. van Gelder* (The Hague, 1973), 22–26, 11 ills.
2. See for instance Gabriel Rollenhagen, *Nvclevs Emblematvm Selectisimorvm Itali Vvulgo Impresas . . .* (Arnhem, 1611), no. 21, with the motto *MORS VITAE INITIVM.*
3. Bergström 1977, 145–146.

Nicolaes van Gelder

(c. 1636–1675/1677)

Nicolaes van Gelder was probably born in Leiden around 1636. He was the son of the tailor Pieter Harmensz. van Gelder and Hester Claesdr. de Koningh. He is probably the same as the Nicolaes van Gelder who became a student at the Leiden academy in 1659. He painted banquets in the style of De Heem and later, when he lived in Amsterdam, he came under the influence of Willem van Aelst, painting game pieces.[1] On 17 April 1677 his wife, Catharina Nederhoven, is mentioned as a widow. Van Gelder left her in difficult circumstances since he had failed to pay the rent for two years.

The few paintings he painted are dated between 1660 and 1675. He concentrated on fruit still lifes, sometimes with game or poultry, which are very refined in technique.[2]

1. Vorenkamp 1933, 68.
2. Lilienfeld in Thieme-Becker 1920, 13:361.

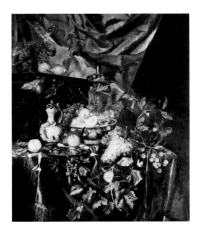

16

Basket with Fruit on a Draped Table

canvas 24⅜ x 19⅜ inches (61.9 x 49.2 cm)

This overwhelming banquet scene is an important exponent of the style of painting Jan Davidsz.de Heem (cat. 19) developed in Antwerp and later practiced in Utrecht after he returned there in 1669. To be found in this work are a rich display of fruits and berries, a gilt-silver-mounted Ming jug, a rummer of white wine crowned with leaves, and a big gilt-silver cup. The splendor of the composition is enhanced in the true De Heem spirit by the fringed velvet cloth and the heavily draped curtain.

Among Van Gelder's rare works are smaller, simpler compositions, for instance in the Nasjonalgalleriet, Oslo (fig. 1) and in the Muzeum Narodowe, Warsaw (signed). There are also two banquet pictures by Van Gelder that are more closely related to the picture exhibited, one of which is in the Rijksmuseum, Amsterdam (fig. 2), signed and dated 1664. Nicolaes van Gelder's banquet painting in this exhibition surpasses the aforementioned ones in its baroque feeling—a considerably increased expressive intensity. The drapery is more agitated, and the sense of movement is enhanced by the sprigs with berries and leaves abundantly streaming down in the foreground over the velvet cloth. A likely date of this masterpiece would therefore be the 1670s.

Franciscus Gysbrechts

(active 1637/1638–1676/1677)

Not much is known about the Dutch/Flemish still-life painter Franciscus Gysbrechts. He probably came from Antwerp, because of the stylistic connections between his work and that of Cornelius Norbertus Gijsbrechts, who seems to have come from that artistic center. In 1674 Fransiskus Gijsbrechts was mentioned in the guild in Leiden, and two years later he was mentioned in Antwerp.[1]

Franciscus used very little color in his large **vanitas** *still lifes and trompe l'oeil paintings, which contain books, musical instruments, and manuscripts.[2]*

1. Poul Gammelbo, "Cornelius Norbertus Gijsbrechts og Franciskus Gijsbrechts," *Kunstmuseets Arsskrift* 1952–1955, 141.
2. Vorenkamp 1933, 108.

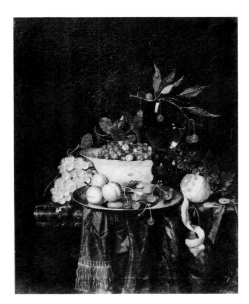

fig. 1. Nicolaes van Gelder, *Tabletop Still Life,* signed and dated 1660. Nasjonalgalleriet, Oslo

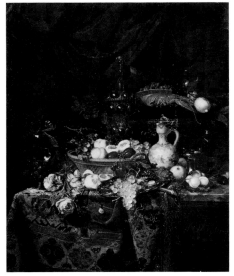

fig. 2. Nicolaes van Gelder, *Banquet Still Life,* signed and dated 1664. Rijksmuseum, Amsterdam

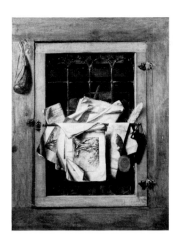

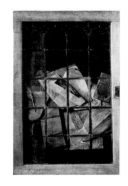

17

Trompe L'Oeil Window

canvas, wood, and metal 53¾ x 40¼ inches (136.5 x 102.3 cm)

signed *F. Gysbrechts/*

The fascination with illusionistic paintings so evident throughout the early years of the seventeenth century culminated in the extraordinary trompe l'oeil paintings that were produced in the Netherlands between the mid-1650s and mid-1670s. One form of trompe l'oeil was the perspective box, in which Dutch artists, among them Samuel van Hoogstraeten, created the illusion of complex interior spaces by painting scenes on the inner walls of a box with a distorted perspective that would be corrected by viewing the scene through a peephole, such as in the National Gallery, London. A second type of trompe l'oeil painting that Hoogstraeten developed was an illusionistic board or window upon which objects appear to be tacked.[1]

This latter type of painting, which Hoogstraeten developed while he was in Vienna in the mid-1650s, became particularly popular with artists from Antwerp, who, because of the Hapsburg connections between these two centers, must have been familiar with Hoogstraeten's inventions.

The most famous of the artists who followed in the footsteps of Hoogstraeten was Cornelius Norbertus Gysbrechts, who became a court painter in Copenhagen in 1668 for King Frederick III and later for Christian V. In 1670 Cornelius Gysbrechts extended the illusionism of Hoogstraeten's door by painting a trompe l'oeil window that could actually open on metal hinges (Royal Museum of Fine Arts, Sweden, inv. 3076; deposited at Rosenborg Castle). The painting in this exhibition by Franciscus Gysbrechts is an elaboration of this conceit in that the illusionism exists on front and back.

The relationship between Franciscus Gysbrechts and Cornelius Norbertus Gysbrechts is not known, but there is no question that they were kin. Both were active in the 1670s and probably originated from Antwerp. Since signed and dated paintings by Cornelius Norbertus exist from the 1660s, it seems likely he was the older of the two. He was the more important artistic personality. It is interesting that Franciscus seems to have worked in Leiden for a period in the 1670s, for a strong interest in illusionistic painting existed there (such as Gerrit Dou's *Trompe L'Oeil Still Life,* Dresden, Gemäldegalerie). Also working in Leiden in the 1670s was Edwaert Collier (cat. 11), whose illusionistic images and monochromatic colors are comparable.

For this object Gysbrechts painted the window on stretched pieces of canvas that he then attached to a larger frame with metal hinges. The larger frame is covered on the front with canvas, which he painted to represent wood. Hanging from an illusionistic nail on this painted frame is a painted image of a powder horn. The complex illusionism of the window includes the glass and the leading that separates the various panes; reflections in the glass and/or objects faintly seen through the glass; and the various papers, including a series of landscape prints, tucked behind and hanging over an illusionistically painted metal rod. All of these objects are visible from the verso as though one has peered through the window itself.

Although the actual function of this painting is not known, almost certainly it was meant to be installed in a wall where it would deceive the eye, to delight the innocent viewer when he discovered the artistic conceit.

A. K. W.

1. I. Krsek, A. Jirka, and L. Slavíček, *Státní zámek Kroměříž. Katalog* obrazárny (Kroměříž, 1978), cat. 35.

Willem Claesz. Heda

(1593/1954–1680/1682)

Willem Claesz. Heda is one of the foremost still-life painters of the seventeenth century. He was probably born in Haarlem, although the year of his birth is not mentioned in archives. In 1678 Jan de Bray painted his portrait with the inscription "aetate 84," from which we can calculate that he was born in 1593 or 1594.[1] He died in Haarlem between 1680 and 1682. Willem is mentioned for the first time in the Guild of Saint Luke at Haarlem in 1631, and in 1644 he was elected deacon.[2] In 1642 Heda had three pupils: his son Gerrit Willemsz. Heda, Hendrick Heerschop Burger, and Maerten Boelema (cat. 6).[3]

*Willem Claesz. Heda may have been influenced by Van Schooten when he painted his first dated (1621) painting, a **vanitas** still life.[4] He also painted breakfast pieces and banquet scenes. Schreveli (1648) wrote that, like Floris van Dijck, Heda painted "fruit, and all kinds of knick-knacks."[5]*

1. Van Gelder n.d., 10.
2. Miedema 1980, 1:135, 182; 2:606, 1058–1059.
3. Miedema 1980, 2:532.
4. Van Gelder n.d., 13.
5. Schreveli 1648, 6:390. See Van Dijck biography, note 5, for Dutch text.

18

Still Life with Ham and Drinking Vessels

panel 30 x 43 inches (76 x 109 cm)
signed *Heda fecit 1643*

Willem Claesz. Heda's picture displays the left part of a large table, the short side of which is fully visible. It is covered by a dark green cloth, upon which are laid a white linen cloth and a crumpled napkin. The variety of objects represented includes a loaf of bread with slices, a ham on a big pewter plate, another pewter plate with a knife, a silver flagon, a silver *tazza* on its side, a third pewter dish with a peeled and sliced lemon, a tall flute glass with red wine in it, a rummer half-filled with golden white wine, a plate with a few olives, the lid of the gilt goblet, the case for the knife, and a silver mustard pot.

Heda organized this assortment of objects in a masterly way. The spectator feels a structure underlying the composition that forms a richly developed system of triangles, horizontals, verticals, and diagonals in a dynamic interplay. The pewter dish with the knife, the napkin, the dish with the lemon and its winding peel, and the knife case with its hanging cover protrude over the front edge of the table, forming a zigzag line. The movement created by the device is stabilized by the four firm verticals: the flagon, the goblet, the flute glass, and the rummer.

Typical of Heda is the perfection with which the interrelationship of the objects has been handled. Every single element has the full amount of space it requires—there is no doubt about the position of each. A generous quantity of empty space surrounds the table and the objects upon it. An oblique stream of light falls on the wall, giving a touch of drama to the composition. The application of paint and the choice of colors show great delicacy within a limited scheme of subdued tones of gray, brown, and green typical of the monochromatic ideals reigning in Haarlem still lifes of the period. Against the monochrome a few vivid colors—the gold of the goblet, the yellow of the lemon, the spot of red wine in the flute glass, the various shades of red of the ham, and the greenish-blue of the plate—stand out effectively. This highly sensitive coloristic economy, a purely Dutch feature, and the delicate brushwork make the atmospheric element tangibly felt. Heda signed the picture on an unfolded piece of paper: "Heda fecit 1643." This scrap of paper, which appears to be pinned to the hem of the white tablecloth, has a trompe l'oeil effect.

This work by Willem Claesz. Heda is an unusually large work by the master. However, it is not unique in his oeuvre. It belongs to a group of pictures, limited in number, among which the earliest

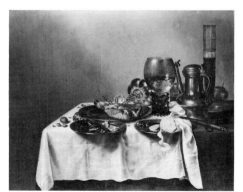

fig. 1. Willem Claesz. Heda, *Breakfast Piece,* signed and dated 1634. Alte Pinakothek, Munich

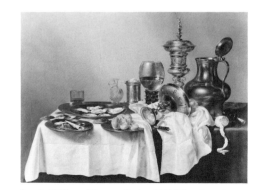

fig. 2. Willem Claesz. Heda, *Still Life,* signed and dated 1635. Rijksmuseum, Amsterdam

known is Heda's still life of 1634 in the Alte Pinakothek, Munich (fig. 1). Other paintings by Heda of this kind are dated 1635 (fig. 2), 1638 (Kunsthalle, Hamburg), and 1648 (State Hermitage Museum, Leningrad). These pictures are composed according to the same principles as Heda's still life of 1643 in the present exhibition.

The monumental pictures by Willem Claesz. Heda contrast with his other works, which are more intimate in character. An encounter with the art of the great master Jan Jansz. den Uyl (1595/1596–1640) probably inspired the master to these large works. A work by Den Uyl in the same monumental spirit, dated in 1632 (fig. 3), is two years earlier than Heda's Munich picture.

provenance The James Stuart Woodin Collection; Mrs. Maud Marsden; Knoedler Gallery, London; Alan P. Good Collection, London; his sale Sotheby's, London, 15 July 1953, lot 25; Private collection, Brussels

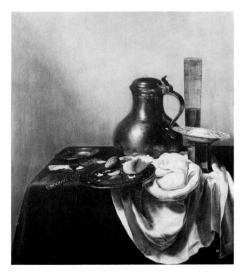

fig. 3. Jan Jansz. den Uyl, *Tabletop Still Life*, dated 1632, 31½ x 27 inches (80 x 68 cm). Národni Galerie, Prague

Jan Davidsz. de Heem
(1606–1683/1684)

Jan Davidsz. de Heem was born in Utrecht and died in Antwerp. His father, David de Heem the Elder, was his teacher in Utrecht. He moved to Leiden, where he married Aletta van Weede from Utrecht, in 1626. The painter Cornelis de Heem is the second child from this marriage. In 1635 or 1636 he went to Antwerp and entered Saint Luke's Guild. Aletta died in 1643, and Jan married Anna Ruckers from Antwerp in 1644; their son Jan de Heem II also became a painter. Jan Davidsz. de Heem spent many years in Antwerp.[1] In 1669 he returned to his native city, where he became a member of the guild, but he was soon forced to leave Utrecht to escape the French invasion, and lived for the rest of his life in Antwerp.[2]

Work from his first Utrecht period is difficult to trace with certainty.[3] It may have resembled that of the still-life painters of those days, such as Balthasar van der Ast (cats. 1, 2) and Abraham Bosschaert. In Leiden he painted still lifes with books, writing and smoking goods, musical instruments, and sometimes with a skull, hourglass, and other transitory symbols, which have some relationship to the work of David Bailly. His paintings in this period have a general brownish tone.

In Antwerp after 1636 the work of Daniel Seghers (cat. 35) served as his model, and De Heem started painting flowers in bouquets, baskets, and garlands, sometimes combined with glasses or little animals, with columns, drapery, or a view to a landscape or seascape in the background. De Heem was especially admired because of the realistic way he painted gold and silver. His paintings vary from very small cabinet pieces to very large banquet paintings containing luxurious objects, which are called **pronk** *pieces. Sometimes he collaborated with other painters, such as Nicolaes Veerendael and Jan Lievens. He had many students and followers, including Abraham Mignon (cats. 27, 28), Cerstiaen Luyckx (cat. 24), Joris van Son (cat. 37), and Wouter Mertens (cat. 26). His production was enormous during his long lifetime. According to Houbraken he painted until he was seventy years old, and the work from the last period had the best brushwork.*

1. Schneider in Thieme-Becker 1923, 16:223–225.
2. Houbraken 1753/1976, 1:209–212; Weyerman 1729, 1:407–412.
3. See Fred G. Meijer, "Jan Davidsz. de Heem's Earliest Paintings, 1626–1628," *Mercury* 7 (1988), 29–36.

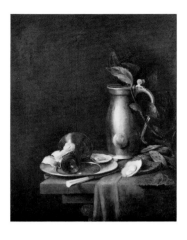

19

Tabletop with Lemon, Oysters, and Pewter Jug

panel 23¾ x 18½ inches (60.5 x 47 cm)

During his early years in Utrecht and Leiden, Jan Davidsz. de Heem was strongly inspired by leading masters in these cities. He appears to have been something like a chameleon in search of his artistic personality. From 1632 onward his works became more independent of the masters who had been his models. From 1635 or 1636, when he moved to Antwerp, he created a style of painting that is a synthesis of tendencies within Dutch and Flemish still life. The importance of this style can hardly be overrated, and he had a huge number of followers in both countries.

The unsigned still life exhibited has been previously attributed to Simon

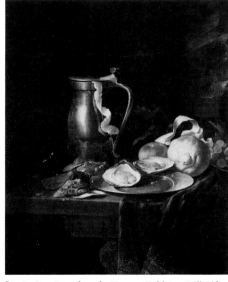

fig. 1. Jan Davidsz. de Heem, *Tabletop Still Life*, signed and dated 1633. Art market, photo courtesy P. de Boer Gallery, Amsterdam

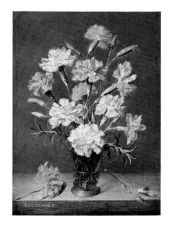

Luttichuys, but is instead from the early years of Jan Davidsz. de Heem, when he was experimenting to find his artistic personality. There are two more pictures by him with nearly the same restricted choice of objects, one unsigned, the other signed and dated 1633 (fig. 1). In these works, which all may be of the same year, De Heem achieved a grand and appealing simplicity. He wrapped the few objects in atmosphere. The air that surrounds them is made visible, like a light mist. The master achieved this effect by softening the outlines of the objects and by reducing the local colors and substituting for them a refined greenish-gray monochrome.

provenance Private collection, Boston

literature Vroom 1980, 2:92, cat. 459 (as by Simon Luttichuys); I. Bergström, "Another Look at De Heem's Early Dutch Period, 1626–1635," *Mercury* 7 (1988), 37–50, repr. 10

Jacob van Hulsdonck

(1582–1647)

The still-life painter Jacob van Hulsdonck was born in Antwerp and died there in 1647. He may have spent his youth in Middelburg as a pupil of Ambrosius Bosschaert the Elder, because some of his paintings show a striking resemblance to Bosschaert's paintings.[1] In 1608 he became a master in Antwerp. In 1609 he married Maria la Hoes; their son Gillis, one of seven children, later became a painter. Between 1613 and 1623 Jacob's pupils were Jacob le Moort, Hans van Pelt, Thomas Vermeulen, and Gillian van Schoodt.[2] In 1629 his wife died and three years later he married the widow Josina Peeters, with whom he had one son.[3] Hulsdonck stayed in Antwerp permanently, living in the same house from his first marriage until his death.[4]

He painted fruit, mostly in baskets or on plates, and often included a bouquet of flowers.

1. Greindl 1983, 43.
2. Zoege von Monteuffel in Thieme-Becker 1925, 18:113; Greindl 1983, 43.
3. Zoege von Monteuffel in Thieme-Becker 1925, 18:113.
4. Greindl 1983, 43.

20

Carnations in a Glass

panel 13¼ x 9⅝ inches (33.7 x 24.5 cm)
signed *I v HULSDONCK FE.*

On a wooden tabletop stands a small rummer with ten fullblown carnations and their buds. To the left of the glass lies a red carnation, and to the right a sprig with two buds, on one of which is a fly. The color scheme is restricted to red, white, and emerald green, and the symmetrical composition radiates joy and harmony.

This previously little-known, gemlike picture is remarkable because it displays just one species of flower. Another example of a bouquet with one kind of flower, carnations, by Hulsdonck appeared in 1953 in a sale at Galerie Charpentier, Paris. Flower paintings with a bouquet of one species are extremely rare. The great majority of Dutch and Flemish flower paintings of the seventeenth century consist of many species.

provenance Private collection, France

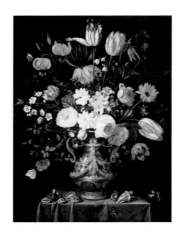

Jan van Kessel the Elder

(1626–1679)

The Flemish painter Jan van Kessel the Elder was a member of the Brueghel family, his grandfather being Jan Brueghel the Elder (cat. 8), and his parents Hieronymus van Kessel and Paschasia Brueghel. His uncle Jan Brueghel the Younger was his godfather and first instructor. Yet when he was registered in Saint Luke's Guild in Antwerp in 1634/1635, he was a pupil of Simon de Vos. At the guild he was considered a master on his eighteenth birthday in 1644. In 1647 he married Maria van Apshoven, and they had thirteen children, of which two, Ferdinand-Leonard and Jan van Kessel the Younger, became painters. Jan the Elder painted allegorical landscapes and animals in the style of the two Brueghels, but he specialized in flower painting, in which the influence of Daniel Seghers (cat. 35) and De Heem (cat. 19) is evident.[1]

1. Hairs 1985, 287–288.

21

Flowers in a Porcelain Vase

copper 30½ x 23¾ inches (76 x 60 cm)
signed and dated 1652

Jan van Kessel's oeuvre is one of the most extensive and varied of the Flemish painters in the seventeenth century. He depicted a great many subjects, for example flowers, fruit, animals, birds, insects, landscapes, allegories, and devotional paintings. Most of his works are miniature compositions on panel or copper with insects, small animals, or a few flowers represented against an even white background. They display the highest degree of perception, belong to the sixteenth-century tradition of scientific naturalism. Another group of miniatures are his pastiches, which were inspired by life-size works by contemporary Antwerp masters, such as Frans Snyders (cat. 36) and Jacob Foppens van Es (cat. 14). Van Kessel's small pictures were executed fluently with loaded, quick-working brushes. Considering the large number of these small paintings in existence, the conclusion must be that he produced them in next to no time. They are like shorthand notes.

The two pictures by Jan van Kessel in this exhibition form the strongest imaginable contrast to those just mentioned. They are perfectly finished and of monumental size. The many different species of flowers are composed of a rich variety of colors with much red, pink, yellow, white, and a wonderful deep blue. A number of insects are attracted by these gorgeous blooms. These bouquets stand on quite different bases. One is covered with a draped cloth on which stands a Chinese vase elegantly mounted in gilt with a group of shells on each side. The plinth of the other is of stone, carved with powerful and simple ornaments. In

22

Flowers in a Glass Vase

copper 30½ x 23¾ inches (76 x 60 cm)
signed

this case a drinking glass holds the flowers. Both vases are calm compared to the bouquets, which allows the masses of flowers to make an overwhelming impression on the spectator. In these pictures and others by Jan van Kessel with flowers in vases, the drawing and brushstrokes are firm and at the same time subtle and sensitive. They have little in common with the works by Jan van Kessel's grandfather Jan Brueghel the Elder, for the brushwork of the latter is spirited, blurred, and with great movement (cat. 8). Instead Jan van Kessel was inspired

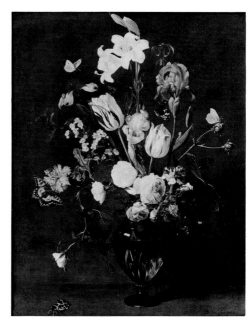

fig. 1. Daniel Seghers, *Bouquet in a Glass Vase*, signed and dated 1643. Staatliche Kunstsammlungen, Dresden

by the flower painting of Daniel Seghers (cat. 35), especially the exquisite purity of his drawing.[1] Seghers' influence is especially evident in a comparison of Van Kessel's flower pictures with a work by Seghers that is signed and dated 1643 (fig. 1), thus from Van Kessel's formative years.

These two flower paintings belong to a series of eight of the same size, and were originally in Spain.[2] Three more of the series are pictured (figs. 2–4). Jan van Kessel may well have painted them there when he was in residence as court painter to Philip IV and also as a captain in the king's army.[3] Although we do not know what Van Kessel the Elder painted for Philip IV, it is tempting to assign the series of eight monumental flower pieces on solid copper plates, which surpass in size by far his other pictures of bouquets, to that circumstance. The number and size of these pictures leads one to believe that they were commissioned by an important patron. Such a series may have been the reason for Jan van Kessel's appointment in Madrid as court painter to the art-loving king, who was, after all, a patron of Velázquez and Rubens.

Jan van Kessel the Elder was recorded as staying in Madrid, but not when. At least three of the eight pictures of the series are dated 1652. Although we do not know how long his Spanish settlement lasted, Jan may in likelihood have been back in Antwerp in 1654, when his son Jan van Kessel the Younger was born there. The next year he bought a house in that city, which suggests that he made his home there after that date.

We may speculate that Jan van Kessel the Elder was introduced to Philip IV by Daniel Seghers, that great flower painter of European fame. There is every reason to assume that Seghers and Van Kessel

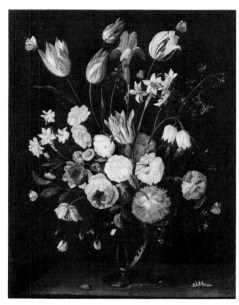

fig. 2. Jan van Kessel, *Flowers in a Glass Vase,* signed and dated 1652. Private collection, U. S. A., photo courtesy Edward Speelman Ltd., London

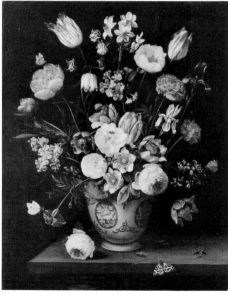

fig. 3. Jan van Kessel, *Flowers in a Porcelain Vase.* Private collection, U. S. A., photo courtesy Edward Speelman Ltd., London

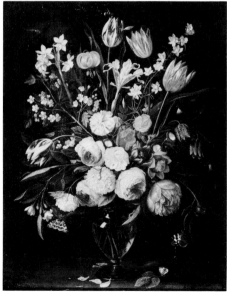

fig. 4. Jan van Kessel, *Bouquet in a Glass Vase,* signed and dated 1652. Private collection, U. S. A., photo courtesy Harari & Johns Ltd., London

knew each other well, since they were contemporaries in Antwerp. That Seghers had many Spanish patrons is clear from his inventory[4] in which he noted every picture he had painted, accompanied by the names of the buyers. Many of his Spanish customers belonged to the high nobility forming part of the king's immediate entourage. Daniel Seghers may in the early 1650s have drawn the attention of Philip IV to the qualities of the young promising Antwerp master Van Kessel. This series of eight monumental flower pieces, to which belong the two outstanding ones in this exhibition, is a prominent achievement in the art of seventeenth-century Flanders.

provenance Marquis de las Nieves 1935; Private collection

exhibition Madrid 1936–1940, cat. 135 (no. 34)

literature J. Cavestany in Madrid 1936–1940, 52, 80, Plate LVIII:1 (no. 34); G. Oña Iribarren, *165 firmas de pintores tomadas de cuadros de flores y bodegones* (Sociedad Española de amigos del arte) (Madrid, 1944), 31 (with reproduction of the signature of no. 34) and 93; Hairs 1955, cat. p. 226 (no. 34); Hairs 1965, cat. p. 292 (no. 34)

1. As already pointed out in Hairs 1955, 122, and in Hairs 1965, 215.
2. Madrid 1936–1940, 80.
3. This information is mentioned in a document in the Palacio Real in Madrid. See Francisco J. Sánchez Cantón, *Los pintores de cámara de los Reyes de España*. Madrid, 1916.
4. See Seghers biography, and Hairs 1985, 120.

Simon Luttichuys

(1610–1661)

The portrait and still-life painter Simon Luttichuys was born in London, where he was baptized in 1610. He probably had Dutch parents; his father was called Bernard Luttichuys.[1] His younger brother Isaac was a portrait painter. Simon also painted some portraits, but his main interest was still lifes. He may have been influenced by Jan Jansz. Treck (cat. 41), Den Uyl, or De Heem (cat. 19).[2] His association with Treck was documented in 1661 when Simon Luttichuys overpainted and completed a painting that had been begun by Treck.[3] Perhaps he was educated in Amsterdam, where he spent most of his active life. He made portraits of Charles II of England in 1660 in Breda and of the king's brothers, Henry and James (these portraits were lost in 1839 in the fire of Schloss Frederiksborg). When he died in Amsterdam in 1661,[4] Isaac became guardian of Simon's underage children. The inventory made after his death contained paintings of figures, animals, fruit and flower pieces, portraits, and some landscapes.

1. Bredius 1917, 4:1289.
2. Vroom 1980, 2:188, 190.
3. Bredius 1917, 4:1292.
4. Schneider in Thieme-Becker 1929, 23:483.

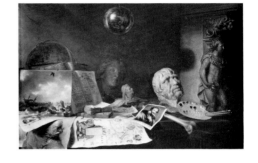

23

Allegory of the Arts

panel 18⅛ x 25½ inches (46 x 67 cm)
signed and dated 1646

Simon Luttichuys composed this still life on a wooden tabletop, with a seascape, a map with a pair of compasses, drawings, books, an engraving, three sculptured heads, a thigh bone, and a palette with brushes. Over these freely arranged objects hangs a glass globe. The room is defined by part of a mantelpiece with a laurel-crowned figure. The objects, lit by clear daylight, are firmly modeled with light and shadow.

Simon Luttichuys, who is thought to have been a pupil of Jan Jansz. Treck, was one of the leading still-life masters in Amsterdam, and was very prolific. He painted large compositions with precious objects in silver and porcelain and also small, quite intimate works with just a few objects—a glass of wine, fruit, and nuts. In his extensive oeuvre there are only half a dozen *vanitas*[1] pictures known, and each is different. The picture exhibited may be regarded as his masterpiece within the genre.

This *vanitas* of 1646 by Luttichuys is not at all as terrifying as his others. The human skull, which appears frequently in pictures of this kind, is left out. Instead we find only a thigh bone, a much more discreet reminder than the skull that man is mortal. A number of the objects represented—the picture, the drawings, the sculptures, the books—preach that works of art are also perishable. *Vanitas* associations may be found in all of the objects arranged on the tabletop. The seascape represents a tempest with ships at risk of being smashed against rocks, an image portending destruction and death. The conspicuous fly on the painting within the painting is a symbol of decay.[2] The

two drawings of a naked youth and an old man illustrate the inescapability of aging. The engraved portrait of Rubens, who had passed away only six years earlier, reminds us that even the greatest masters must die. The laurel-wreathed figure on the mantelpiece is Apollo, god of poetry, who with the books stands for the perishability of literature. The strongly lit bust of an elderly man represents what in that period was believed to be a portrait of Seneca[3] who, as a great stoic philosopher of morality and the author of the treatise *De brevitate vitae*, is a fundamental component of many Dutch *vanitas* still lifes. Leaning against the celestial globe are two books, one an open herbal with illustrations of plants, a reminder of the biblical image of the short duration of human life that is found in Job 14. 1–2: ''Man that is born of a woman, is of few days, and full of trouble. He cometh forth like a flower, and is cut down: he fleeth also as a shadow, and continueth not.''

The suspended glass globe merits our special attention. Such an object appears in some other Dutch still lifes, for example in an early work by Willem Kalf, to be dated c. 1643.[4] It is also to be found in a still life by Pieter van Roestraten.[5] In both cases the glass globe hangs over a representation of precious objects. In many instances in Dutch art, this object was often associated with symbolic meanings. The glass globe in these paintings seems to illustrate the idea of *Homo bulla*, man is but a bubble.[6] Furthermore glass, like man, has the quality of being fragile.[7]

In the three still lifes by Luttichuys,

Kalf, and Van Roestraten, the glass globes also reflect the studios of the masters with the arrangements of objects they are painting. A variation is the simple composition of 1645 by Luttichuys (fig. 1), which is dominated by a big glass bowl in the center and through which part of a skull is visible. The idea expressed in 1 Corinthians 13.12: ''For now we see through a glass, darkly; but then face to face. . .'' may be implied here. In this connection a little picture by Van Roestraten is of interest (fig. 2). It represents a glass globe with the reflection of the painter's studio, the artist himself seated at his easel, and is to be regarded as a

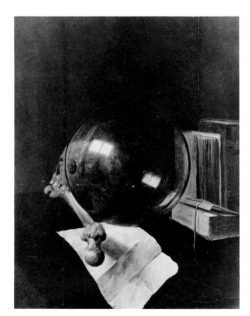

fig. 1. Simon Luttichuys, *Still Life with Glass Bowl*, signed and dated 1645. Whereabouts unknown, photo courtesy Ingvar Bergström

model for the previously mentioned glass globe by Van Roestraten.[6] Van Roestraten's globe hangs from a string attached to a cross crowning the globe. By that it becomes an orb, as in imperial regalia, which qualifies these glass spheres to be an image of *mundus*, the perishable world.[7]

The same significance can be attributed to the map hanging down over the edge of the table. The splendid coats of arms of the Netherlands, Germany, France, Turkey, and Spain on the map remind us, in true *vanitas* spirit, that on these mighty worldly realms also a time limit is imposed. The pair of compasses is an instrument for navigation when using the map. It may also have an intrinsic meaning: a symbol of temperance. It figures as one of

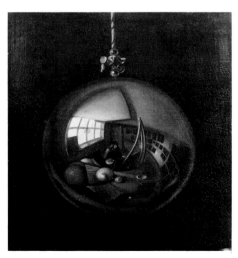

fig. 2. Pieter van Roestraten, *Glass Globe with Reflection of the Artist in His Studio*. Private collection, West Germany

the attributes to the Christian virtue *Temperantia*.

The message of the *vanitas* still life of 1646 by Simon Luttichuys is thus a negative one. At the same time it urges man to live a righteous life, so that there is hope for resurrection and eternal life, symbolized by the presence of the celestial globe, heaven, on the table.

provenance Lord Spencer, Althorp, Northamptonshire (acquired in the late eighteenth century); Private collection

literature K. J. Garlick, "Catalogue of the Pictures at Althorp," *Walpole Society* 45 (1976), 56, no. 433

1. The term *vanitas* applied to still lifes, allegories, and genre pictures is derived from Ecclesiastes 1. 2: "Vanity of vanities, saith the Preacher, vanity of vanities; all *is* vanity" (*Vanitas vanitatis et omnia vanitas*), meaning that everything of this world is vanity and perishable.
2. H. Friedmann, *The Symbolic Goldfinch*, Washington [1947], 27.
3. Seneca (= pseudo-Seneca) appears in works by Jacques de Gheyn and David Bailly, who may both have influenced Luttichuys. See also B. Strandman, "The Pseudo-Seneca Problem," *Konsthistorisk tidskrift* (Stockholm) 19 (1950), 53–93.
4. Bergström 1947, 272, fig. 223; Bergström 1956, 270, fig. 223; Grisebach 1974, 95, cat. 68, fig. 70.
5. Bukowskis, Stockholm Spring 1981 (Sale 416), cat. 657 (canvas 39¾ x 32½ inches, 100 x 82.5 cm, signed).
6. See E. de Jongh, *Zinne- en minnebeelden in de schilderkunst van de zeventiende eeuw*, 1967, 81–89 and Ingvar Bergström, "De Gheyn as a *Vanitas* Painter," *Oud-Holland* 85 (1970), 150–152.
7. Segal in Amsterdam 1982, 17, quotes the Dutch translation by Pers (1644) of Ripa, *Iconologia* (Rome, 1603): ". . . and how is our life like glass, / our hope a shadow, dust and ash, / they teach us our frailty."

Cerstiaen Luyckx

(1623–before 1670)

Cerstiaen Luyckx was baptized in Antwerp on 17 August 1623. He was a pupil of Philip de Marlier between 1639 and March 1642, and after that worked at Frans Francken III's workshop. He left for Lille in 1644 but returned soon to his native town, where he married in 1645 and became a master that same year. In a document dated 18 September 1646 he is mentioned as "in the service of His Majesty the King of Spain." His wife died, he remarried in Antwerp in 1648, and his son was baptized in 1653. After this date his name is not mentioned in archives, and by 1670 he was dead.[1] From old inventories we learn that Luyckx painted different kinds of still lifes: vanitas, *banquets, flowerpots, garlands of flowers, still lifes with fruit.*

1. Greindl 1983, 122.

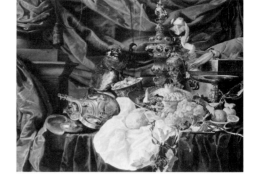

24

Banquet with Monkey

canvas 32⅝ x 41¼ inches (83.5 x 105 cm)

There is no doubt that Cerstiaen Luyckx is among the greatest Flemish still-life painters of the seventeenth century. At the same time he is the least known. Few lines are devoted to him in the literature, and his works have often passed under the names of other painters.

This banquet picture is monumental, magnificent, and abundant. Disorder prevails among the multitude of objects on the table, as if a strong wave had carried them away and left them there. The red velvet draperies in heavy folds add to the splendor. Nevertheless some stability is achieved by the horizontal and vertical elements including the flute glass, gilt cup, and the gilt *bekerschroef* with the rummer of white wine.

As a painter Cerstiaen Luyckx was a sensualist. With his magic brush he caressed objects and an occasional animal into being. With the greatest sensitivity and refinement he rendered the nautilus shell, the pieces of silver, the monkey, and the pale bluish color of the white grapes. A picture like this one, probably painted in the 1650s, has roots in the monumental banquets created by Jan Davidsz. de Heem in Antwerp from 1640 onward. But Luyckx transformed the influences he received in a more personal way than any of his contemporaries. In the great freedom of his compositions Jan Fyt was another source of inspiration.[1]

Works by Cerstiaen Luyckx have frequently been attributed to others. That was the case of the present picture, which has a long provenance as a work by Jan Davidsz. de Heem. A work comparable in conception and execution signed by Luyckx (fig. 1) makes the attribution of the exhibited work to Luyckx inescapable.

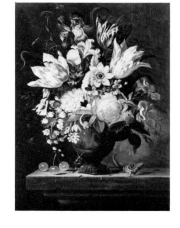

Cerstiaen Luyckx also painted a few extremely fine flower paintings and some smaller, quite intimate compositions. The picture in this exhibition is to be regarded as his masterpiece.

provenance Duc de Berry, Paris; Duchess de Berry, Paris (sale 1834?); M. Hume, London; purchased in 1836 from M. Hume by George Lucy Esq., London; Sir Montgomery Fairfax-Lucy, Bart, Charlcote Park, Warwick, England; Mr. J. Perez de Cuellar, Peru; Newhouse Galleries, New York, 1971; Private collection, USA, at all occasions as a work by Jan Davidsz. de Heem

1. A fine study on Luyckx is Greindl 1983, 120–122, cats. 1–29, who rightly emphasizes Jan Fyt's influence on his artistic development.

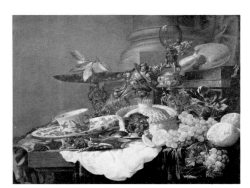

Jacob Marrel

(1614–1681)

The flower and still-life painter and engraver Jacob Marrel was born in 1614 in Frankenthal. While in Frankfurt he was a pupil of Georg Flegel.[1] Joachim von Sandrart described him as Flegel's eager disciple who soon surpassed his master.[2] Marrel moved to Utrecht around 1630, where he trained further with De Heem (cat. 19) and possibly with Ambrosius Bosschaert the Younger.[3] He also studied with Nicolaes Veerendael in Antwerp before returning to Utrecht where he married Catharina Eliot in 1641.[4] In Utrecht during the tulipomania he made series of watercolors on parchment of varieties of tulips.[5] The inventory made after his wife died in 1649 lists paintings of different subjects: fruit, flower garlands, watercolors, birds and copies after Poelenborch, Steenwijck, and De Heem. He may have worked with Poelenborch, since they purchased ultramarine pigment together. From the inventory it can be concluded that he was also an art dealer, for eighty paintings that he had sold are listed.[6] In 1651 he lived again in Frankfurt and married the widow of the engraver Mattheus Merian. His stepdaughter Maria Sybilla Merian was his pupil, as well as Abraham Mignon (cats. 27, 28). Marrel returned with Mignon to Utrecht in 1659[7] where he probably stayed until 1664.[8] In 1671 and 1675 Marrel worked in Frankfurt again, and died there in 1681.[9]

1. Bol 1969, 320.
2. Sandrart 1765/1925, 220.
3. Bergström 1956, 83.
4. Bredius 1915, 1:119.
5. Bol 1969, 320.
6. A. D. de Kruyff, "Iets over den schilder Jacob Marrell," *Oud-Holland* 10 (1892), 57–60, 189. The inventory was published by Bredius 1915, 1:112–119.
7. Bol 1969, 320.
8. Notes from Bredius and Zulch in Thieme-Becker 1930, 24:137.
9. Bol 1969, 320.

25

Flowers in a Vase

copper 15 x 11½ inches (38 x 28.5 cm)
signed *JM* [interlaced] *f 1647*

Jacob Marrel was a painter, draftsman, and engraver as well as a dealer in pictures by other masters and also in the then-precious tulip bulbs. During the early years of Marrel's Utrecht period he worked in the tradition of Ambrosius Bosschaert the Elder, and he belongs to the second generation of artists working in Bosschaert's style. The artistic heirs of Ambrosius the Elder, who included his relatives and Roelant Savery, dominated the field of fruit and flower painting in the city. Included in this group were the two Bosschaert sons, Ambrosius the Younger and Abraham. Until 1632 their uncle Balthasar van der Ast was also active there, and his influence remained alive in the city because of the number of his pictures in local collections.

The flower painting in the exhibition is dated 1647. Its general type is in the tradition of Ambrosius Bosschaert the Elder and Balthasar van der Ast. Evidence of that is the great variety of bright-colored flowers and the massiveness of the bouquet. It nevertheless belongs to the second generation because the arrangement of the flowers is less stiff and they are rendered with softness. The ceramic vase, probably an invention, strikes a manneristic note.

Marrel was more than anyone else in his time obsessed by the beauty and variety of the numerous species of red-striped white tulips. They dominate his tulip books (fig. 1) with drawings, mostly on vellum,[1] and form an important element in his flower pictures. In the bouquet of 1647 there are two tulips of this kind. The one above to the right is similar to those in other flower pieces by the mas-

ter. These tulips appear for the first time in a painting signed and dated 1637 (fig. 2), and, to the best of my knowledge, for the last time in another one, signed and dated 1650 (Newhouse Galleries, New York 1982).

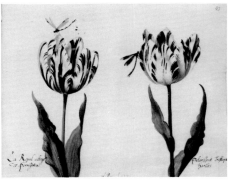

fig. 1. Jacob Marrel, *Tulips,* watercolor on vellum, signed and dated 1645. Rijksprentenkabinet, Amsterdam

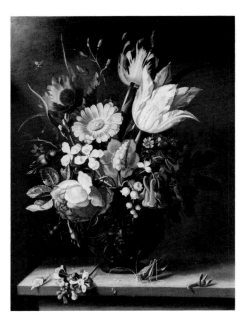

fig. 2. Jacob Marrel, *Flower Painting with Tulips,* signed and dated 1637. Photo courtesy Brod Gallery, London

Marrel varied his signatures and especially his monograms.[2] The one used in the present case, and also in the Rijksprentenkabinet drawing of 1645 (fig. 1), is Marrel's most complicated one, meaning that it has several times been read incorrectly, despite the fact that it contains his initial and all the letters of his family name. When in 1949 this picture belonged to the dealer M. Bernard in London, the monogram had been misread as that of Ambrosius Brueghel, to whom paintings like this are frequently attributed, because so much uncertainty surrounds this painter's genuine oeuvre.

provenance M. Bernard, London, 1949 (as by Ambrosius Brueghel); Private collection

literature *The Sphere*, 17 November 1949 (as by Ambrosius Brueghel; reproduced full page in color)

1. Bergström 1984.
2. Bergström 1984, fig. 30, with reproductions of signatures and monograms by Marrel.

Wouter Mertens

(active 1650s)

Very little is known about the Antwerp painter Wouter Mertens. Only three signed paintings by him are known: a fruit garland and two still lifes with a lobster and fruit,[1] one of which is the painting included in the exhibition. His work suggests the influence of Jan Davidsz. de Heem (cat. 19). He should not be confused with the Wouter Mertens who became a master in the Antwerp guild in 1641 as an embroiderer.[2]

1. Greindl 1983, 370.
2. Greindl 1983, 138.

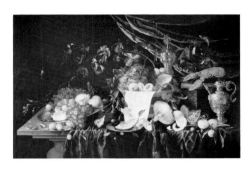

26

Tabletop Still Life

canvas 46¾ x 71½ inches (119 x 181 cm)
signed on edge of table *W. MERTENS*

The works by Wouter Mertens testify to
his being active in Flanders in the middle
of the seventeenth century. Mertens'
models are the splendid *abundantia* com-
positions that Jan Davidsz. de Heem cre-
ated in Antwerp from 1640 onward. What
Mertens learned from that great master
he put into practice with such skill and
feeling that he is to be regarded as one of
the most gifted and important followers
of Jan Davidsz. de Heem. The picture in
the exhibition is a real tour de force and
is his masterpiece. It is probably to be
dated in the 1650s. Typical of Mertens'
work is that it at several occasions has
been considered a work of De Heem.

provenance Prieuré de Rouge-Cloitre, near Brussels;
Sale Couvents supprimés de Belgique, Brussels, 12
September 1758, lot 499; Prince P. Galitzin Collec-
tion, 1875; F. Bischoffsheim Collection; Galerie Se-
delmeyer, Paris, 1895, cat. 14; Sir Joseph Robinson
Collection (1840–1929, as by Jan Davidsz. de Heem);
Princess Labia Collection (as by Jan Davidsz. de
Heem)

exhibitions *Sammlung Sir Joseph Robinson*, Kunsthaus
Zürich, 1923, cat. 23 (as by Jan Davidsz. de Heem);
The Robinson Collection, Royal Academy of Arts, Lon-
don, 1958, cat. 64 (as by Jan Davidsz. de Heem); *The
Robinson Collection*, National Gallery of South Africa,
Cape Town, 1959, cat. 35 (as by Jan Davidsz. de
Heem)

Abraham Mignon

(1640–1679)

*The German flower, fruit, and still-life
painter Abraham Mignon was born in 1640
in Frankfurt am Main and died in Utrecht in
1679. At the age of nine he became a pupil of
Jacob Marrel (cat. 25), who took him to
Utrecht in 1659. In Utrecht he studied with
De Heem (cat.19), whose influence can be no-
ticed in Mignon's work. He was a member of
Saint Luke's Guild in Utrecht in 1669,[1] and
spent most of his life in that city. He married
Maria, the cousin of the marine painter Adam
Willaerts.[2] According to Houbraken, Mignon's
realistic depictions of flowers and fruit were
held in high esteem by all art lovers during
his life and even more after his death.[3]*

1. Thieme-Becker 1930, 24:548.
2. Bol 1969, 321.
3. Houbraken 1753/1976, 3:82–83.

27

Cavern Scene

canvas 26¾ x 32¼ inches (68 x 82 cm)
signed *AB Mignon f*

Despite his relatively short life, Abraham
Mignon left an extensive oeuvre. He
painted quite a number of subjects: bou-
quets of flowers, a few cut flowers on a
ledge, garlands and suspended bunches of
flowers and/or fruit, tabletops laden with
food, and outdoor scenes such as this
one, which contain rich varieties of plant
and animal life.

During Mignon's Utrecht years, Jan
Davidsz. de Heem returned from Antwerp
to the city and stayed there between
1669 and 1672. It is generally assumed
that Mignon worked in De Heem's studio
then. His flower pieces especially testify
that De Heem's influence greatly out-
weighed that of his master Marrel. Their
drawing displays great assurance, even
virtuosity and elegance, and the colors
are bright.

The subject of the picture exhibited is a
forest undergrowth. The background is
formed by a rock with a vaultlike open-
ing that provides a view into a sunny
landscape. The rock and some stone
blocks have a peculiar shape, typical of
Mignon, which consist of a number of
joined plain or slightly curved surfaces.
Mignon rendered all the strange forma-
tions that developed during the largest
tree's long growth. At its foot grows an
abundantly flowering apple tree bearing a
bird's nest with eggs. Close to it are two
birds seated on twigs, one of which is a
kingfisher. The rest of the vegetation con-
sists of such things as bullrushes, honey-
suckle, poppies, and irises. Besides the
two birds, there are frogs near a puddle
of water, a small snake, and snails and
insects.

Such scenes by Mignon reflect the in-
fluence of Otto Marseus van Schrieck

(cat. 34). These depictions, however, do not reflect the actual appearance of nature. Flowers such as the forget-me-not in this painting would not grow in nature in the puddle between two yellow water lilies. The composition is thus a pure construction.

Despite the influence of Van Schrieck, the mood in the picture by Mignon is quite different. The vegetation of the former is dark and moist, full of threat, evil, and drama, depicting what may take place within a human soul. Mignon painted the contrary. The scenery is sunlit and idyllic with no evil portents even from the little snake. There is no mystery and magic. The plants and flowers appear in their clear, strong colors masterfully drawn and painted.

provenance Private collection, Bad Hennef/Sieg, Germany

literature Gerhard Bott, "Ein Vanitas Naturstück von Abraham Mignon als Neuerwerb im Hessischen Landesmuseum," *Kunst in Hessen und am Mittelrhein* 10 (1970), 57, fig. 1; M. Kraemer-Noble, *Abraham Mignon 1640–1679* (Leigh-on-Sea, 1973), cat. 37, pl. 40

28

Still Life with Fruit, Fish, and a Nest

oil on canvas 36.7 x 28.7 inches (94 x 73.5 cm)

The celebration of the richness and fertility of the land is a theme that reappears in different forms throughout the seventeenth century, whether in still life, landscape, or mythological scenes. This work, painted in the mid-1670s, is an evocative image of abundance in which the fruits of the sea are depicted along with the fruits of the land. The catch of the day, still hanging from hooks attached to lines that drape over the edge of the bait box, glistens in the subdued light of this cavernous scene. The fishing pole and its case can be seen resting on the fruit piled in the wicker basket. A nest with four eggs, which lies in the branches of the hibiscus, is watched over by a European goldfinch and a great tit perched on branches of a craggy, moss-covered tree and by a goldfinch standing on the handle of the basket.[1] Frogs by a pool of water in the lower left, snails, caterpillars, lizards, one of which is dead and has attracted a horde of ants, further enliven this woodland scene.

The components of this painting, while belonging to the allegorical tradition of abundance, seem also to represent various stages in the cycle of life. Mignon has included eggs, which stand for birth, as well as birds, who communicate with each other in a flirtatious way. Ripe fruit and blossoming flowers indicate maturity, while old age is included in the guise of the gnarled tree. The lizard and fish represent death. These dual aspects of abundance and the life cycle were components of De Heem's style that Mignon clearly knew. Religious concepts that reflect upon the broader theme of the cycle of life are perhaps interwoven into this painting also. The wheat and grapes so prominently displayed in the still life traditionally represent the Eucharist. These varied symbolic associations are fused together in ways that make a clear reading of the artist's intent uncertain, but in all probability Mignon thus sought to enrich the significance of his composition.

Mignon derived his flowing compositional organization, in which elements are subtly drawn together by the rhythms of the vine tendrils and stalks of wheat, from De Heem's work. This quality, as well as the luminous colors he used, gives Mignon's paintings a decorative, almost mannered character that made his work particularly valued in the late seventeenth and eighteenth centuries. To help satisfy the demand for these works he frequently reused motifs from one painting to the next. The same frog, for example, appears in cat. 27. He also painted variants and multiple versions of his most successful compositions. At least three other versions of this painting exist: a signed version in the Bayerische Staatsgemäldesammlungen, Munich (inv. 53.260); an example in the State Hermitage Museum, Leningrad (inv. 1358); and one that was recently sold on the art market (Sotheby's, New York, 12 January 1989, no. 187). A similar composition, featuring flowers rather than fruit, is in the Museum of Fine Arts, Budapest (inv. no. 3539).

A.K.W.

provenance Private collection, Germany

1. Dr. Storrs L. Olson, curator at the National Museum of Natural History, Smithsonian Institution, has kindly identified the birds and the fish (perch, pike, and roach) in this painting.

Hubert van Ravesteyn

(1638–before 1691)

The Dutch painter Hubert van Ravesteyn was baptized in 1638 in Dordrecht.[1] He married Catharina van Meurs in 1669 in Papendrecht, and they lived in the Hofstraat in Dordrecht. In 1691 a bier was ordered for the son of the widow van Ravesteyn, so the artist must have died between 1683 and 1691. Hubert van Ravesteyn was probably related to Gryphonius van Ravesteyn, the vicar of Dordrecht, and to other members of the distinguished family of that name.[2] Houbraken (1753) mentioned that Hubert van Ravesteyn painted genre scenes of working people on the farm.[3] He originally painted interiors of farmhouses, like many painters around Dordrecht. He also made a number of still lifes with smokers' requisites in the early monochrome style. His tobacco still lifes are similar to those of Jan Fris, Edwaert Collier (cat. 11), and P. Janssens Elinga.[4]

1. Gerson in Thieme-Becker 1934, 28:53.
2. G.H. Veth, "Aanteekeningen omtrent eenige Dordrechtse schilders XXIX," *Oud Holland* 9 (1891), 37–38.
3. Houbraken 1753/1976, 3:215.
4. Vroom 1980, 1:200.

29

Tobacco Still Life

panel 15 x 11½ inches (38 x 29 cm)

Hubert van Ravesteyn painted a few insignificant interiors with figures, and also some rare still lifes that are of high quality. The majority of these have as a subject smoking requisites and beer, a genre invented in the Netherlands. The first works of this type were probably painted in the 1630s by Pieter Claesz., an outstanding example of which is a still life of 1636 (fig. 1). A deck of cards has been added to the representation of the simple stimulants of life, tobacco and beer.

The exhibited work by Hubert van Ravesteyn displays a pottery bowl for glowing coals, a pewter plate with two Gouda clay pipes and a paper packet of tobacco, a measuring glass, and a bundle of pipe lighters. Beer has been exchanged for red wine from a gray stoneware jug decorated in blue and red.[1] The previously undraped table is now partly covered by a reddish, gold-fringed velvet cloth, and the picture is vertical in composition. A closely related work by Van Ravesteyn (fig. 2) is signed and dated 1664, and comparison with it suggests that the one in the exhibition may be dated c. 1664.

Van Ravesteyn was a provincial master living in Dordrecht, as far as we know. His paintings with smoking requisites and beer or wine indicate that he must have had contact with the genre created in Amsterdam by Jan Jansz. Van de Velde, especially with the work by Jan Fris. In 1650, when Van Ravesteyn was still a young boy, Fris had painted a large still life with a tall stoneware jug and smok-

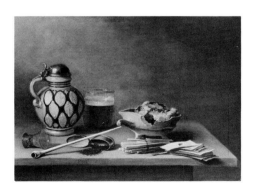

fig. 1. Pieter Claesz., *Still Life,* signed and dated 1636. Whereabouts unknown, photo courtesy Ingvar Bergström

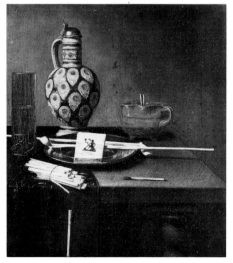

fig. 2. Hubert van Ravesteyn, *Still Life with Smoking Supplies,* signed and dated 1664. Formerly on loan to the Rijksmuseum, Amsterdam

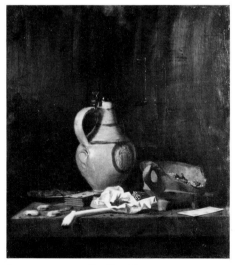

fig. 3. Jan Fris, *Still Life with Pipe,* signed and dated 1665. Private collection, photo courtesy David H. Koetser Gallery, Zurich

ing requisites (Vroom 1980, fig. 217, cat. 249). Fris' picture of 1665 (fig. 3) is close to the exhibited one by Van Ravesteyn. A stoneware jug, a measuring glass of red wine, and smoking requisites form part of the composition, which is enriched with a pewter plate of shrimp and, as in the work by Pieter Claesz. (fig.1), with playing cards.

Van Ravesteyn thus worked within an Amsterdam tradition of still life. There is no documentary evidence of his presence in that city, but judging by his pictures it is highly likely that he stayed there for some time, and that he had some sort of relation to Jan Fris. Hubert van Ravesteyn's work is characterized by firmness and a refined, highly accurate manner of execution, and by clear lighting. The underlying abstract pattern of the composition is strongly felt in a most stimulating and appealing way.

provenance Private collection

1. According to Bol 1980, 277, this type of jug, which Van Ravesteyn has painted on several occasions, is a Nassau stoneware piece except for the decoration, which is an invention by the painter.

Coenraet Roepel
(1678–1748)

The flower and still-life painter Coenraet Roepel was born in The Hague in 1678, the son of an innkeeper.[1] In 1724 he entered the Confrérie Pictura, the professional organization of painters, in The Hague.[2] When he was young he had poor health. He had a talent for painting and became pupil of Constantijn Netscher, but because of his weakness he did not make much progress. He learned about gardening in his father's garden and started painting flowers in the style of Jan van Huysum and Rachel Ruysch. These paintings met with great success. Members of the Flora, an equivalent of today's garden clubs, commissioned him to paint their best flowers. He became known to the count of Schaesbergen, who took him in 1716 to Johan Willem, the prince elector of Pfaltz in Düsseldorf. The prince bought the picture he had with him, gave him a gold chain, and commissioned more paintings. Declining health kept him from painting during the last years of his life.[3]

1. Weyerman 1769, 4:121–122.
2. Thieme-Becker 1934, 28:495–496.
3. Van Gool 1750/1971, 426–433.

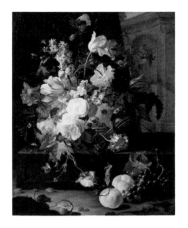

30

Flowers and Fruit

canvas 28 x 22½ inches (71 x 57 cm)
signed *Coenraet Roepel fecit 1726*

This basket with flowers by Coenraet Roepel is typical of the eighteenth century, and is one of the latest paintings in the exhibition. The scene is outdoors with architectural elements. The flower painting has the elegance and the refined warm and cool colors of the rococo. Roepel was influenced by Rachel Ruysch (cat. 31) and Jan van Huysum, who not only dominated flower painting in the Netherlands but in the rest of Europe.

Flowers, and especially the rose—Horatius spoke about *rosa brevis*—were regarded as an image of the brevity of human life. The same is true of fruit, of which Roepel included two peaches, a bunch of grapes, and a fig. To the left is a mouse, a delicate symbol of destruction.

provenance Private collection

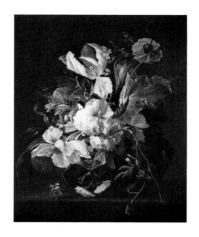

Rachel Ruysch

(1664–1750)

*Rachel Ruysch, daughter of the famous anat-
omy and botany professor Frederick Ruysch,
was born in Amsterdam. Her father noticed
her talent for painting and drawing when she
was still a child and sent her to Willem van
Aelst who became her teacher. Otto Marseus
van Schrieck also may have influenced her. In
1693 she married the portrait painter Juriaen
Pool with whom she had ten children. She
and her husband became members of the Con-
frérie Pictura in The Hague in 1701. Rachel's
paintings were represented in famous collec-
tions all over Europe. Johan Willem, the
prince elector of the Pfaltz, who held court in
Düsseldorf, was one of her greatest admirers.
In 1708 he appointed her as court painter, al-
though she worked in The Hague. Her mae-
cenas died suddenly in 1716. Rachel painted
until she was 84 years old,[1] and died in Am-
sterdam on 12 August 1750.[2]*

*Rachel Ruysch's main subject was flowers in
a vase, with fruit, insects, and reptiles. Hof-
stede de Groot published a list of ninety-one of
her paintings, many of which are signed and
dated from 1682 to 1747.[3] She did not have a
large production, but she was highly esteemed
and well paid during her lifetime. According
to Sip, Ruysch painted everything **in statu ri-
goris mortis**, dead, preserved, and not as if
from real life, perhaps because in her child-
hood she had seen dead specimens in her
father's cabinet.[4] Anna Elisabeth Ruysch,
Rachel's elder sister, also painted flowers,
fruit, and reptiles. Rachel's followers included
Elias van den Broeck, Ernst Stuven, and Wil-
lem Grasdorp.[5]*

1. Van Gool 1750/1971, 210–217.
2. Stechow in Thieme-Becker 1935, 29:243–244.
3. Hofstede de Groot 1928, 10:307–330.
4. Jaromir Sip, "Notities bij het stilleven van Rachel
Ruysch," *Nederlands Kunsthistorisch Jaarboek* 19
(1968), 160, 167–168.
5. Hofstede de Groot, 10:332.

31

Vase of Flowers on a Table

canvas 23 x 19 inches (58.5 x 48 cm)

In the years around 1650 Willem van
Aelst and Otto Marseus van Schrieck
(cat. 34) were staying in Italy. Together
they created the new type of Dutch
flower piece. Instead of the symmetry
and balance of the bouquet reigning till
then, they arranged the flowers asym-
metrically and with an S-curve, which
was to become typical of the rococo.
They had numerous followers.

Rachel Ruysch's picture in the exhibi-
tion is asymmetrical. The flowers are ar-
ranged in a soft curve. The grouping to-
gether of them is still massive, the
drawing energetic as was that of her
teacher Van Aelst. This would speak for
an early date of c. 1690. In their time
Rachel Ruysch and Jan van Huysum en-
joyed fame all over Europe.

provenance Private collection

Floris Gerritsz. van Schooten

(active 1612–1655)

*The still-life painter Floris Gerritsz. van
Schooten, son of Gerrit Jacobsz. van Schooten,
probably worked in Haarlem all his life. He is
often mentioned between 1612 and 1655. In
1612 he married Ryckloet Willems, daughter
of Willem Gerritsz. Bol. They must have been
well-to-do, for his father gave him 1,000
guilders, and her father gave her 1,200. He
became deacon of the Haarlem guild in 1639,[1]
and in 1640 he was nominated to be treas-
urer.[2] At least a hundred of his works are
known. He preferred such subjects as market
and kitchen scenes, and still lifes with kitchen
utensils, breakfast pieces, and fruit. The
breakfast pieces, similar to those by Nicolaes
Gillis and Floris van Dijck (cat. 13), date from
his early period, 1617 being the earliest. He is
best known for his tabletop compositions from
the 1640s that represent bowls with fruit or
plates with cheese, tarts, or bread on a table,
covered by olive green drapery and a white
cloth.[3]*

1. Bredius in Thieme-Becker 1936, 30:258.
2. Miedema 1980, 2:485.
3. Poul Gammelbo, "Floris Gerritsz. van Schooten,"
Nederlands Kunsthistorisch Jaarboek 17 (1966), 105–
107.

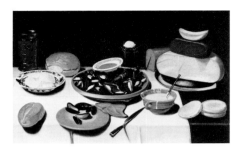

32

Breakfast of Mussels, Cheese, Bread, and Porridge

panel 22 x 34¼ inches (56 x 87 cm)

Haarlem, where Floris van Schooten was active from 1612 onward, became the important center of the Dutch breakfast piece. Floris, Pieter Claesz., and Willem Claesz. Heda were the leading masters. Van Schooten's *Breakfast of Mussels, Cheese, Bread, and Porridge*, with its simple and powerful forms and strong and saturated colors, is one of the very earliest of its kind.

Of special interest is the pewter dish with the pile of three cheeses: a big cream-colored Gouda, a dark colored one with a green rind, and a yellow chunk. Two or three cheeses upon each other is a frequent element in the many breakfast pictures by Van Schooten.[1] He painted them in such a way that their different substances, degrees of moisture or dryness, and colors can be tangibly felt.

In his early years Floris van Schooten experimented a great deal. His homely meal of mussels, bread, butter, and cheese contrasts greatly to the abundant buffet signed and dated 1617 (fig. 1) in which a lavish arrangement of fruits, and

berries, butter and bread is arrayed in costly Chinese porcelain vessels and precious gilt cups. The latter painting is signed and dated 1617. That these two still lifes are of the same early period is shown by the high viewpoint in each of them. Because it is somewhat higher in the rustic breakfast-piece exhibited, a likely date for it would be slightly earlier than the dated work, around 1615.

provenance Private collection
1. See Vroom 1980, figs. 98–101, 106–108.

33

Kitchen Scene

canvas 35¾ x 47½ inches (91 x 120 cm)
signed *F V S*

The oeuvre of Floris van Schooten is comprehensive. Some compositions are monumental, such as *Kitchen Scene*, and others are intimate. His varied repertory includes breakfast pieces, fruit, and still lifes with figures, especially market scenes and kitchens. Van Schooten and other Dutch seventeenth-century masters in the two latter categories were more or less active within the tradition created by Pieter Aertsen and Joachim Beuckelaer. Theirs were usually huge compositions, often with many figures and a subordinated religious scene, like Aertsen's *Christ in the House of Martha and Mary* of 1553 (fig. 1). Aertsen's kitchen occupies the foreground and is filled with a gorgeous display of foodstuffs of many kinds, a vase with flowers, and a number of big figures. The biblical scene is banished to an adjacent room in the background, with figures of a much reduced size. This inversion of values is a true manneristic feature.

In contrast to Aertsen's kitchen, where furniture, food, and the elongated figures are haphazardly spread out in the room,

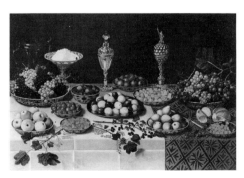

fig. 1. Floris van Schooten, *Buffet,* signed and dated 1617. Private collection

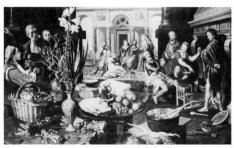

fig. 1. Pieter Aertsen, *Christ in the House of Martha and Mary,* signed and dated 1553. Museum Boymans-van Beuningen, Rotterdam

order reigns in the exhibited work by Van Schooten. Part of a bench, below to the left, the table, the shelf above, all in massive wood, are parallel to the picture surface. On the table and under it occur a panoply of vessels and foodstuffs that are subjugated to an orderly arrangement of circles and repeating diagonals. On the right stands a woman busy cutting fish and looking down at a little boy, who is holding out a ball to her. In its quietness and emotional restraint, this scene has a purely Dutch character.

In the extensive oeuvre of Van Schooten, only half a dozen or so paintings bear dates. These vary from 1617 to 1644. Most closely related to the kitchen scene exhibited is the earliest of the artist's dated works, a still life of a splendid buffet dated 1617 (cat. 32, fig. 1). What unite this other major work by the master with the picture exhibited are the strong local colors and the tangible shadows cast from objects by the clear daylight. A difference is that the viewpoint is higher in the picture of 1617, which makes the tabletop rise more steeply. This viewpoint speaks for a somewhat later date for *Kitchen Scene*, in likelihood the first half of the 1620s. After this period Floris's local colors became less strong. He then emphasized the tonal relationships and turned to a monochromatic palette as did other Haarlem masters.

Aertsen's and Beuckelaer's device, the combination of a kitchen scene with a subordinated religious representation, although not evident in this painting, was occasionally used by Van Schooten. In his kitchen picture at Uppsala University (fig. 2) he suggested a thematic connection be-

tween the woman gutting fish and the biblical narrative of Tobit and the angel carrying the fish in the background.

provenance The Hague 1925; Galerie van Diemen; Amsterdam 1929, Galerie van Diemen; Sale Van Diemen, Graupe, Berlin, 26 April 1935, lot 86; Christie's London, 25 March 1977, lot 92

exhibitions The Hague 1926, cat. 4, fig. on page 5; *La nature-morte hollandaise . . .* , Palais des Beaux-Arts, Brussels, 1929, cat. 86, fig. 21; *Het stilleven*, Kunsthandel J. Goudstikker, Amsterdam, 1933, cat. 278, fig. 7

literature E. Zarnowska 1929, XI, 26; Vorenkamp 1933, 14; Van Gelder n.d., 7; W. Martin, *De Hollandsche schilderkunst in de zeventiende eeuw, Frans Hals en zijn tijd* 2, Amsterdam, 1942, 284 and the following, fig. on page 284; Vroom 1945, 10, figs. 1, 85; Gammelbo 1966, cat. 5, fig. 4; Vroom 1980, 13, cat. 563, fig. 1; Sullivan 1984, 14, fig. 19

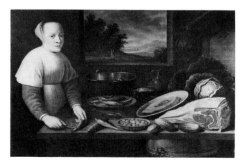

fig. 2. Floris van Schooten, *Kitchen Still Life*, signed. Uppsala University, Sweden

Otto Marseus van Schrieck
(1619/1620–1678)

Otto Marseus (Marcellis) van Schrieck was born in 1619 or 1620 in Nymegen and died in 1678 in Amsterdam. He painted in England and in France (for the queen mother), was in the service of the grand duke of Florence for a long time, and visited Naples and Rome. Willem van Aelst was his pupil in Florence. The Bentvogels in Rome gave him his nickname "de Snuffelaer" becaue he searched for colorful snakes, lizards, caterpillars, spiders, butterflies, and rare plants and herbs to use in his paintings. In 1657 he returned to the Netherlands with Van Aelst, and married Margrita Gijsels in 1664.[1] Besides a house called Waterÿk in Diemen, he had a cottage outside the city gate of Amsterdam where he could sleep and work. There he kept a rowboat and fishing gear that he used for his biological observations.[2] The French traveler De Monconys visited and described Waterÿk in 1663. Marseus bred here the reptiles that he used for his paintings. After he died in 1678, his widow told Houbraken that her late husband kept animals near his house outside Amsterdam; he fed them daily and had a house for the snakes, and after a while some snakes were so tame that when he positioned them with his maulstick they remained in that position until he was finished.[3] His paintings are dated from 1660 to 1677, and a few drawings are known. He mostly painted butterflies surrounded by water plants, and reptiles in dark woodland scenes. He also painted some pictures of flowers and fruit still lifes.[4] His brother, Evert Marseus van Schrieck, was also a painter.

1. A.D. de Vries Az., "Otto Marseus," *Oud Holland* 1 (1883), 167–168.
2. Bol 1969, 335.
3. Houbraken 1753/1976, 1:357–358; Weyerman 1729, 2:102.
4. Stechow in Thieme-Becker 1930, 24:140.

34

Nature Study

canvas 23¼ x 18½ inches (59 x 47 cm)
signed and dated 1671

This suggestive canvas by Otto Marseus van Schrieck is one of a pair. The two works represent nocturnal scenes in a dark, mysterious wood in the undergrowth beneath high trees. In the picture exhibited are ivy and two exotic plants, one silvery green and the other multicolored, while in the companion piece (fig. 1) appear a dew-cup, a dominating thistle, a cyclamen plant, and a climbing ivy. Around and on the plants are a number of pale butterflies. Below the plants are a lizard and a snake threatening the butterflies, and a creeping snail. Another snake is wriggling in the thistle. The unsteady light and the fluorescent ef-

fect, especially of the plants and the whitish butterflies, add to the magic of the two pictures.

Such scenes in the dark, moist undergrowth of a wood are pure constructions by Van Schrieck. The low viewpoint brings the spectator close to the horrible drama taking place, in which snakes and lizards threaten to catch an imprudent butterfly. In other pictures by Van Schrieck there may be warty toads catching other butterflies with their sticky long tongues (fig. 2). Van Schrieck thus painted on one hand happy-go-lucky creatures who love to visit the flowers and drink their nectar, and on the other aggressive, evil, and voracious ones. Even if the world of the drama depicted by Van Schrieck is small, it is doubtless meant to reflect the condition of humanity, the butterfly being a symbol of the human soul, while the snake, the lizard, and the toad are symbols of evil and death. The scenes painted by Van

Schrieck are representations of the human soul fighting against the forces of evil.[1]

This very special genre of the undergrowth is an invention by Otto Marseus van Schrieck. He practiced it early in his career during his Italian stay, for there are pictures in the Uffizi in Florence whose provenance extends back to the grand duke of Tuscany for whom he worked. He had many followers in the Netherlands, including Willem van Aelst, Matthias Withoos, Abraham Mignon (cats. 27, 28), Elias van den Broeck, and Rachel Ruysch (cat. 31), and in Italy Paolo Porpora. A number of pictures have been wrongly attributed to Van Schrieck, which has to some extent obscured what a great and refined master he is.

provenance Private collection

1. For a more extensive discussion see Ingvar Bergström, "Marseus, peintre de fleurs, papillons, et serpents," *L'Oeil* 233 (December 1974), 24–29, 65.

fig. 1. Otto Marseus van Schrieck, *Nature Scene,* signed and dated 1671. Heinz Family Collection

fig. 2. Otto Marseus van Schrieck, *Blue Flowers, Toad, and Insects* (detail), signed and dated 1638. Staatliches Museum, Schwerin

Daniel Seghers

(1590–1661)

Biographical details about Daniel Seghers are known because the artist himself wrote a full page in the noviatiate album in 1614 when entering the Jesuit order: "I, Daniel Seghers, of the City of Antwerp, born in the year 1590, on the third of December, of a legitimate marriage: my father Pierre Seghers, deceased, my mother Marguerite van Gheel, deceased; my father was a silk merchant; I began studying the art of painting ten years ago.[1] Seghers' father died some time after 1601, and his mother, a Roman Catholic, converted to Calvinism while she was a widow. She then left for the northern Netherlands and raised Daniel in the reformed faith. He must have started painting there, which is confirmed by the superior of the order who wrote that he began to paint around 1605. In 1610 he returned to Antwerp and looked for a teacher, and became the pupil of Jan Brueghel the Elder (cat. 8) until 1611. Later he is mentioned as a master in the guild of Saint Luke. He was mentioned as "Daniel Seghers, pictor" in the personnel registers of the Jesuits in 1617, 1620, and 1621. Immediately after taking his vows in 1625 he went to the Netherlands before traveling to Rome the same year. He returned to Antwerp in 1627 and left the city only for short trips after 1628. He kept a catalogue of all the flower pieces (239 in total) he had made, as well as his drawings from nature and from "the master's own arrangement"; it ends with three paintings which were completed in 1661, the year of his death.[2]

According to his biographer, Thomas Dekens, he worked constantly (awoke at 4 o'clock in the morning) and did not put down his palette for visitors unless they were princes. He was very famous and his paintings were owned by kings all over Europe. When he offered a painting to Frederik Hendrik, the prince of Orange, in 1646 he was given a gold cross in return. Seghers' paintings were generally used as gifts or as ornaments for Jesuit churches and were not for sale. He was highly esteemed by men of letters, for example Constantijn Huygens, as well as painters such as Jan Brueghel the Elder, Rubens, and Jordaens.[3] Seghers painted flowers in bouquets and in cartouches that often surrounded Madonna statues, saints, or portraits, and sometimes flowers in a glass by other artists. He collaborated with Hendrik van Balen, Thomas Willeboirts Bosschaert, Erasmus Quellinus, and Jan van Hoecke, as well as Cornelis Schut.[4]

1. Hairs 1985, 117.
2. An eighteenth-century copy of the catalogue was discovered by W. Couvreur in 1967. See Couvreur 1967 and Hairs 1985, 120.
3. Hairs 1985, 117–124.
4. Hairs 1985, 490–493.

Cornelis Schut the Elder

(1597–1665)

The Flemish painter and engraver Cornelis Schut the Elder was born in Antwerp in 1597 and died there in 1665. By 1618/1619 he was a master in Saint Luke's Guild, in 1620/1621 he became a member of the "Violier," and had several pupils in the 1630s. He took part in the decorations that were designed by Peter Paul Rubens for the state visit of Stadtholder Cardinal-Infant Ferdinand to Antwerp in 1635. He spent some time in Spain, where he visited his brother Pieter (engineer in Philip IV's service) and painted a large painting of Saint Francis Xavier baptizing Indians (now in Santa Cruz de Mudela) for the stairwell of the Colegio Imperial. He painted a large number of altarpieces as well as allegorical scenes that demonstrate the overpowering influence of Rubens. He often painted the centers of flower garlands by Daniel Seghers.[1] His portrait was included in Van Dyck's Iconographie.[2]

1. Zoege von Manteuffel in Thieme-Becker 1936, 30:346–347.
2. Houbraken 1753/1976, 1:77.

35

Garland of Flowers with the Annunciation

copper 39¼ x 27 inches (100 x 68 cm)
signed *D Seghers*

In the center of this painting is an *Annunciation* by Cornelis Schut that is suspended from blue ribbons. Attached to the ribbons is a shield-shaped garland of many kinds of flowers by Daniel Seghers.

Seghers is one of the greatest of all flower painters in seventeenth-century Europe. In this picture tulips, roses, irises, narcissi, a fritillaria, and other species are rendered with a high degree of perfection, great accuracy, and sensitivity. The flowers tucked in a festoon of ivy and forming the long, framing garland are arranged close to one another with few leaves between. Such a tight grouping of flowers speaks for an early date within Seghers' oeuvre, as does the fact that the background is formed by a flat wall. Seghers stayed in Rome between 1625 and 1627, and among the paintings he executed there is a Saint Ignatius surrounded by a garland of flowers (the Vatican Gallery, inv. 418), composed according to the same principles as the picture of the exhibition. Thus a likely date of the latter would be c. 1630.

In these two pictures, the arrangement of the garland against a neutral background and the flowers close together with very few leaves between is reminiscent of the wreaths by Jan Brueghel the Elder, who was Seghers' teacher. Brueghel rendered flowers with more brittle delicacy and with brushwork that

is more blurred than evident in the firm accuracy of Seghers' forms (cat. 8). Later on, Seghers developed a device of his own for which he became known. In those compositions he replaced the neutral background with richly carved stone cartouche frames. Flowers, which appear in bunches or in festoons, are attached to the frame.

It may be possible to discover the patron for this work. Seghers' inventory in many cases also notes the names of the work's owners. Three pictures on the list are relevant in this connection, because they are the only ones that have the *Annunciation* painted by Cornelis Schut as the motif of the center. Because the list in principle is in chronological order, the earliest of the three has a great likelihood of being the painting exhibited. It is no. 39, *een aen den Markies de Agitoni een caertelle daer in was een Anonciaetje van Sr Schut, daer naer bij den Baron D'Enkes.* Couvreur[1] has identified the first owner as Francisco de Moncada, marques of Aytona and duke of Ossona (1586–1635). He arrived in 1629 in Flanders and became in 1632 commander-in-chief of the Spanish military forces there. Baron D'Enkes has not been identified.

provenance First owner was probably Francisco de Moncada, Marques of Aytona, Duke of Ossona (1586–1635), acquired by him from Daniel Seghers

1. Couvreur 1967, 87–158, especially 96 and 97.

Frans Snyders

(1579–1657)

The Flemish animal and still-life painter Frans Snyders was born in Antwerp. His father was the keeper of a well-known inn that was frequented by many artists. In 1593 Snyders became a pupil of Pieter Brueghel the Younger and later probably also of Hendrik van Balen the Elder. He became a master in Antwerp in 1602. At the recommendation of Jan Brueghel the Elder (cat. 8) he left his native city for Rome in 1608, and later that year he went to Milan, where he was introduced to Cardinal Borromeo by a letter from Jan the Elder. Snyders returned to Antwerp in 1609. In 1611 he married Marguerite de Vos, sister of Cornelis and Paul de Vos. In 1619 he became a member and in 1628 a deacon of the Romanist Society. He was at the center of artistic life in Antwerp and frequently collaborated with Peter Paul Rubens, painting animals, fruit, flowers, and landscapes in that master's compositions. He was a very wealthy man, but much to his chagrin he had no children. He left the enormous amount of 8,500 florins to Adriaen, Cornelis, and Paul de Vos.[1] During his career he formed an important collection of old and contemporary paintings, which after his death were acquired by the art dealer Matthijs Musson (in 1659) for 13,645 florins.[2]

The concept of his still-life paintings, which have a decorative character, was new in Flanders. His main subject was game combined with baskets of fruit, vegetables, lobsters, oysters, and sometimes a bouquet of flowers and a figure, and he also painted fruit garlands.

1. Greindl 1983, 84–85.
2. Greindl 1983, 85.

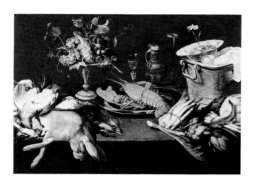

36

Game, Shellfish, Fruit, and Vegetables

panel 36 x 48 inches (91.5 x 122 cm)

This still life is an excellent example of the spirit of Flemish seventeenth-century painting. The forms are powerfully rendered, the colors bright, strong, and saturated with oil. It is a work created in Antwerp in the era of Rubens (1577–1640), with whom Snyders collaborated as well as with Jacob Jordaens.

The Four Elements have contributed to the content of this painting. There are fruits, berries, and vegetables of the fertile earth of Flanders, birds of the air, and in the center a magnificent dark-red lobster of the sea. The gilt silver *tazza*, the shining pewter dish, the drinking glasses, the stoneware jug and the huge copper vessel are of materials born in fire.

It is a picture painted with a broad touch. Nevertheless, even with such strong, shining local colors, the big copper bucket has been rendered with the utmost coloristic delicacy. The viewpoint is comparatively high and the composition simple and straightforward, and the objects are organized in a pattern of intersecting diagonals. The physical quality of the objects is what Snyders emphasized, a characteristic that reminds one

that the artistic forebear of this work is the Netherlandish kitchen picture of the sixteenth century as practiced by masters such as Pieter Aertsen (see cat. 33, fig. 1) and Joachim Beuckelaer.

This composition by Frans Snyders was obviously in demand with the contemporary public. Three more versions of it are known. One of them belongs to the Alte Pinakothek, Munich (inv. 6007) and is attributed to Joris van Son, and another one appeared in a Brussels sale room (Palais des Beaux-Arts, 12 June 1979, lot 636). Both display weaknesses indicating that they are studio work. The remaining fourth one, previously in the Del Monte Collection, Brussels, is of approximately the same size as the picture in the exhibition and seems to be an original version by Snyders.

The oeuvre of Frans Snyders is extensive, but only a few among the many pictures are dated. The exhibited work seems to be an early one and may have been painted c. 1610–1615.

provenance Private collection

Joris van Son

(1623–1667)

The Flemish flower and fruit painter Joris van Son was born in Antwerp in 1623. He became a master in Saint Luke's Guild in 1643/1644 and had five pupils between 1652 and 1665: Abraham Herderwyn, Cornelis van Huynen, Frans van Everbroeck, Norbert Montali, and Jan Pauwel Gillemans the Younger. Working in the style of Jan Davidsz. de Heem and Jan Pauwel Gillemans the Elder, Van Son specialized in painting garlands with fruit, flowers, and vegetables. He signed as "J. van Son," as did his son Jan Frans van Son, which has caused confusion between them.[1]

1. Greindl 1983, 131–133, 381–382.

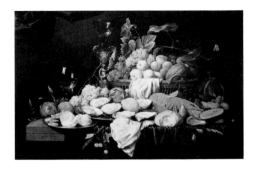

37

Melon, Oysters, Lobster, and Fruit

canvas 32¼ x 46½ inches (82 x 118 cm)
signed on the edge of the table *J. VAN. SON. F 1658*

The composition is based on a right trian-
gle. Its illuminated side ascends from the
left foreground to the basket with fruit,
crowned by the vine. Its leaves form a
decorative outline. Despite this firm foun-
dation, the composition is like a water-
fall. It starts with the fruits of the basket,
continues through the bunch of grapes,
the pomegranate, and the lemon on the
larger pewter plate, and ends up at the
lower pewter plate with the lemon. This
effective, strongly emphasized movement
is accompanied by the streaming down of
the napkin, starting in the basket and,
like the sprig of cherries, falling over the
front edge of the table. The total effect is
that of an emptied cornucopia. This
movement within the composition is
counteracted by two firm verticals, the
rummer of white wine and the silver *bek-
erschroef*, or beaker holder, which is a
typical Netherlandish showpiece for the
tables of wealthy people. This one has a
sculptured putto as its stem. Van Son
painted this piece of the goldsmith's art
several times, for instance in a still life in
the Staatliche Kunsthalle, Karlsruhe.

Joris van Son was one of the foremost
of the many Flemish painters inspired by
the De Heem style, which was a blending
of Dutch and Flemish ideals in still-life
painting (cat. 19). That this picture fol-
lows a De Heem device is evident from a
comparison with the latter's work (fig. 1).
When Joris van Son put into practice
what he learned from De Heem, he did it
in a personal way. His paintings have an
appealing softness and, in many of his
still lifes, one finds a predilection for pale
yellow colors that gives them a golden
shimmer. The still life by Joris van Son
exhibited is one of his major works.

provenance Private collection, Boston
literature Greindl 1983, 132, fig. 220, cat. 18

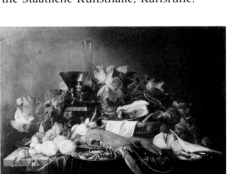

fig. 1. Jan Davidsz. de Heem, *Still Life,* signed.
H. M. the King of Sweden

Isaac Soreau

(1604–after 1638)

*The father of Isaac Soreau, the painter Daniel
Soreau, was of Flemish descent, but had
moved to Frankfurt to avoid religious persecu-
tion in the late 1580s. In 1599 he was instru-
mental in the founding of a new town not far
from Frankfurt called Hanau, where Isaac
was born in 1604.[1] Isaac was probably
trained by his father, but he must have had
another teacher after his father's death in
1619. His brother Jan (born 1591) was a
painter as well. According to public records
Isaac was in Hanau until 1626, but whether
he stayed there throughout his life is not
known. He painted still lifes with baskets and
bowls of fruit and vases of flowers in the style
of Jacob van Hulsdonck (cat. 20) and Osias
Beert (cats 3, 4).[2]*

1. Bol 1982, 35.
2. Greindl 1983, 64–67, 383.

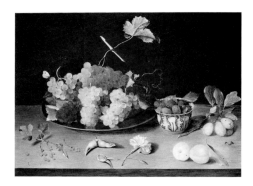

38

Tabletop with Plate of Fruit

panel 19½ x 25½ inches (49.5 x 65 cm)

Many fruit paintings by Isaac Soreau have been preserved. A painting related to this work is one signed and dated in 1638 in Schwerin (fig. 1). The only difference between the two is found in the lower right corner of the panels, where the rose sprig in the Schwerin painting has been replaced by the two fruits and a leaf. A third version of the composition, also by Soreau, belongs to the Ambrosiana, Milan.

Typical of Isaac Soreau is that he often repeated himself. He used a limited choice of objects, which he moved into different positions like chessmen on the chessboard. One of these objects is the Chinese bowl with mulberries, which can be found in a number of other pictures by Soreau.

All his life Isaac Soreau worked under Flemish influence, especially that of Jacob van Hulsdonck (cat. 20). Many pictures by Soreau have been thought the work of Hulsdonck. That was the case also when the present picture appeared in London in the 1961 Hallsborough exhibition.

Isaac Soreau may be dependent on Hulsdonck, but at the same time he has his own artistic personality of much attraction. Characteristic of his composition is a graceful lightness with much space around the objects and thin application of paint, which Bott characterized as "an enamel-like, shimmering effect."

provenance Private collection, London

exhibition William Hallsborough Gallery, London, summer exhibition 1961, cat. 26 (as by Jacob van Hulsdonck)

literature Gerhard Bott, "Stillebenmaler des 17. Jahrhunderts, Isaak Soreau–Peter Binoit," *Kunst in Hessen und am Mittelrhein* 1–2 (1961–1962), 42, 58, fig. 2; Pavière 1962, 57, plate 64b (as by Jan Peter Soreau); Greindl 1983, 65, cat. 13

Harmen van Steenwyck

(1612–after 1664)

Harmen van Steenwyck was born in Delft in 1612. He was a pupil of his uncle David Bailly in Leiden for five years.[1] In 1644 he was in Delft, in 1654 he left for the East Indies, and in 1656 he was back in Holland again.

He painted fruit, vegetables, fish, birds, and pottery in a predominant light gray tone, with accents in local colors. Some vanitas pictures by him are known.[2] His fish paintings also have a light gray tonality.[3]

1. Bol 1969, 89.
2. Bergström 1956, 166.
3. Bergström 1956, 237.

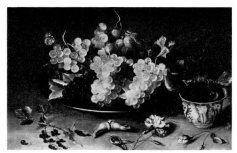

fig. 1. Isaak Soreau, *Fruit Still Life*, signed and dated 1638. Staatliches Museum, Schwerin

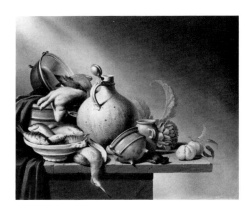

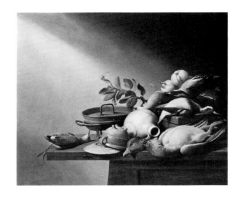

39

Stoneware Jug, Game, and Fish

panel 15¾ x 18⅛ inches (40 x 46.5 cm)
signed *H Steenwijck 1646*

This pair of kitchen still lifes depicts the upper part of rustic tables on which pots and pans, a cask, a stoneware tankard, a rabbit, dead birds, fish, an artichoke and some fruits have been assembled. The objects may give the impression of having been haphazardly heaped, but each has been organized in a triangular arrangement that mirrors the other painting. In both pictures light falls from the upper left, enveloping the objects in a fine silvery light. The light tempers local colors such as red, blue, black, yellow, brown, and green, and creates a chilly silvery gray unity. The backgrounds also are painted in that shade. Steenwyck has represented the objects in the pair considerably smaller than natural size, with fine sensitivity and a wealth of delicately rendered details.

40

Skillet and Game

panel 15¾ x 18¼ inches (40 x 46.5 cm)
signed *H Steenwijk 1646*

Steenwyck conceived the two kitchen still lifes entirely in the spirit of the Leiden *fijnschilderij*, which he had come to know in the studio of David Bailly, and which has been perpetuated by that city's most famous master, Gerrit Dou. Dou painted motifs much smaller than their natural size and rendered the many different objects he included in his genre scenes in minute details. A group of them, isolated, would have the character of a miniature still life.

Even though Harmen Steenwyck in all likelihood painted this pair of kitchen still lifes in Delft, they stand out as a high point within the *fijnschilderij* traditions of Leiden and also within the master's oeuvre.

Jan Jansz. Treck

(1606–1652)

Treck was born in Amsterdam and lived there until his death in 1652. His brother-in-law, Jan Jansz. den Uyl, was his teacher in 1623. Documents confirm close contact with the family of Den Uyl, and Treck's works show the influence of his teacher, especially in his expressive and tangible rendering of metal and the firm modeling of a draped napkin.[1] Den Uyl and Treck worked closely together in at least one painting in a private collection in Paris that shows their double signature. The work was perhaps started by Den Uyl and finished by Treck after Den Uyl's death in 1640.[2]

Treck painted still lifes with smoker's requisites, stoneware jugs, pewter ware, Chinese porcelain bowls, and some glassware and, late in his career, seems to have tried his hand at fruit still lifes. His earliest known signed and dated work, of 1635, is now in Antwerp.[3]

1. Bergström 1956, 151–152.
2. Vroom 1980, 1:213.
3. Vroom 1980, 2:125.

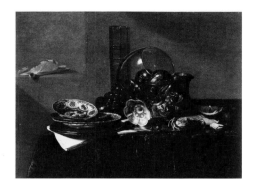

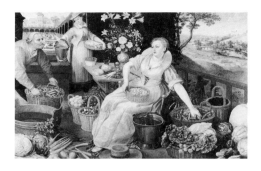

41

Tabletop with Saltcellar, Dishes, and Glasses

panel 19¾ x 26⅜ inches (50.5 x 66.5 cm)
signed and dated 1644

Jan Jansz. Treck dated and signed this painting on the neatly folded white napkin lying on the red velvet tablecloth. The instability of the objects on the table is counteracted by the verticals of the edge of the niche, the measuring glass, and the saltcellar. The room is defined by the niche with a clay pipe and a cabbage leaf.

Treck was strongly influenced by his brother-in-law, the fascinating still-life master Jan Jansz. den Uyl. From him he learned to render pewter, silver, Chinese porcelain, and glass powerfully and in full plasticity. The motifs of these two great Amsterdam painters are similar to those of the contemporary still-life painters in Haarlem such as Heda and Claesz., but in the latter city the painting style was softer. A comparison of the picture exhibited with cat. 10 by Pieter Claesz., dated two years later than Jan Jansz. Treck's still life, reveals a great difference in temperament.

provenance Private collection, Paris
literature Vroom 1980, 213, cat. 643, fig. 289

Lucas van Valckenborch

(1535–1597)

Lucas van Valckenborch the Elder is the best-known artist of the Valckenborch family of painters.[1] Although born in Louvain, Lucas moved to Mechelin by 1560, the year he registered in the Mechelin guild. After 1566 Lucas traveled for a number of years in France and Germany. He was in Aachen by 1570 but was back in Flanders by 1575. Lucas worked for Archduke Matthias of Austria, governor of the Netherlands, from 1579 until 1593. In 1582 he followed the archduke from Brussels to Linz on the Danube, and from there Lucas went to Upper Austria. The majority of his paintings (landscapes, portraits) from this period are now in the Kunsthistorisches Museum in Vienna. By 1593 he was in poor health, and the archduke arranged for permission for Lucas to live in Frankfurt with his brother Martin (1534/1535–1612).[2] Georg Flegel (cat. 15) was his only pupil.

1. Van Mander 1604/1979, 259–260. See also W. K. Zülch, "Die Künstlerfamilie Van Valckenborch nach den Urkunden im Frankfurter Stadtarchiv," *Oud Holland* 49 (1932), 221–228.
2. Alexander Wied, "Lucas van Valckenborch," *Jahrbuch der kunsthistorischen Sammlungen in Wien*, 67 (1971), 119–134.

42

Allegory of Summer

canvas 47 x 73 inches (120 x 185 cm)
signed in monogram by Van Valckenborch *L V V*
still-life elements by Georg Flegel
dated 1595

Until 1987 the whereabouts of *Allegory of Summer* had been unknown since the Leipzig exhibition in 1929. Two more paintings of the series The Four Seasons, *Spring* (fig. 1) and *Winter* (fig. 2), were sold at Christie's, London, on 29 November 1974 to the Swedish collector Tomas Fischer. All three pictures are signed by Van Valckenborch and dated 1595. Of the series *Autumn* is still missing. In the sale of 1974 *Spring* and *Winter* were listed without mention of Flegel. The attribution of the still-life parts of all three known compositions to Georg Flegel had earlier been made by Müller. He knew the paintings from reproductions and descriptions of them in the inventory of 1823 of the collection of pictures in the Altenburg Palace in Saxony.[1]

Despite Lucas van Valckenborch's ill health during the last four years of his life, he painted a number of sizable pictures with large figures in the foreground and with rich still-life elements by Flegel that are reminiscent of earlier sixteenth-

fig. 1. Lucas van Valckenborch and Georg Flegel, *Allegory of Spring*, signed by Van Valckenborch and dated 1595. Private collection, Sweden

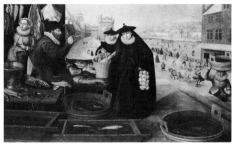

fig. 2. Lucas van Valckenborch and Georg Flegel, *Allegory of Winter*, signed by Van Valckenborch and dated 1595. Private collection, Sweden

century market scenes by Pieter Aertsen and Joachim Beuckelaer. Up to that time he had mainly devoted himself to modest-size landscapes with small figures. These final years of Van Valckenborch's life show a remarkable reorientation and regeneration. The artistic climate of Frankfurt, which attracted many religious and political refugees from the southern Netherlands, and Van Valckenborch's excellent collaborator Georg Flegel may have been sources of inspiration and stimulus to the older master.[2]

The emphasis on linear perspective in *Allegory of Summer* is typical of Lucas. The contrast in size between what is represented in the foreground and the background is violent, because a real transition in the middle ground is missing. That is also typical of the master.

The large figures in the foreground have a certain late-manneristic stiffness and provide a strong contrast to the tiny ones in the garden and especially in the landscape to the right, which are depicted more naturally, and are rendered with a spirited, feathery brush. The two young women of the foreground are idealized types more than individuals. The conception of the old man with the basket of peas is rather naturalistic and reminds us of boorish figures in the oeuvre of Pieter Bruegel the Elder.

The still-life components in *Allegory of Summer* are all by Georg Flegel. They include the abundance of vegetables and fruit, the light meal on the table, and a silver vase with a huge bouquet. It is arranged flatly with no overlapping elements and according to the principle of radial composition.[3] The leaves are few, allowing the splendor of the flowers to

dominate, which is typical of a number of flower pictures painted in the years around 1600. The individual characterization of the various materials, such as fruits and vegetables, flowers, wood, metals, straw, and water, betrays Flegel's artistry.

Spring, Summer, and *Winter,* the three paintings now known from Lucas van Valckenborch and Georg Flegel's series of the Four Seasons, stand out in the art created in Germany on the threshold of the seventeenth century. The pictures are works by two masters from abroad. For the Fleming Van Valckenborch, who was to die two years later, they represent the peak of his artistic activity. As to Flegel from Moravia, whose activity was to last forty-three more years, they belong to the promising beginning of a creative career that was to make him one of the greatest European painters of flowers and still lifes (see also cat. 15).

provenance Duke of Altenburg, Saxony, before 1823, assuming that he originally owned the entire series of seasons of 1595 by Van Valckenborch and Flegel; Germany 1929, Private collection; Germany 1987, Private collection

exhibition Alte Meister aus Privatbesitz, Museum der bildenden Künste (Leipziger Kunstverein), Leipzig, 1929, cat. 116

literature Müller 1956, 86–88; Wied 1971, 175–180, cats. 61, 62; Hana Seifertová, "Tempores anni Lucas van Valckenborch," *Uméni* (Prague), 22 (1974), 328–329, fig. 3; I. Bergström, "Lucas van Valckenborch in Collaboration with Georg Flegel," *Tableau* 5 (1983), 320–327. The four works quoted discuss only *Spring* and *Winter* of 1595 by Van Valckenborch and Flegel. *Allegory of Summer* was unknown when they were published.

1. Müller 1956, 88.
2. Wied 1971, 226; Seifertová 1974, 324–325.
3. Ingvar Bergström, "Flower-Pieces of Radial Composition in European 16th and 17th Century Art," *Album Amicorum J. G. van Gelder* (The Hague 1973), 22–26, figs. 1–11.

Jan Jansz. van de Velde III

(1619/1620–1663 or later)

The Dutch still-life painter Jan van de Velde III, son of Jan van de Velde II, was born in Haarlem in 1619 or 1620. His birthdate is based on his marriage documents, in which he is mentioned as being 23 when he married Dieuwertje Willems Middeldorp in April 1643 in Amsterdam.[1] In 1644 he was the sponsor at the baptism of Esaias van de Velde, the son of the painter Esaias van de Velde II, a distant cousin of Jan. He was also the cousin of Willem van de Velde, member of the famous family of marine painters. Jan remarried Christina van Hees in 1656[2] in Amsterdam and probably died there. There is some confusion in the literature about the year of his death, but it was certainly after he dated a painting in 1663.[3]

Jan may have had his apprenticeship in Haarlem, although his teacher is not known. His early paintings resemble, both in subject and style, the work of Pieter Claesz. (cats. 9, 10) and Willem Heda (cat. 18). Later he painted still lifes with smoking requisites, wine or beer glasses, nuts, and some fruit, in the manner of the Amsterdam school of still-life painters, such as Jan Jansz. Treck, Jan Jansz. den Uyl, and Laurens Craen.[4]

1. Zoege von Manteuffel in Thieme-Becker 1940, 34:202.
2. George S. Keyes, *Esaias van de Velde 1587–1630* (Doornspijk, 1984), 18–19.
3. Vorenkamp 1933, 46.
4. Vroom 1980, 222–230.

43

Breakfast with Cards and Pipe

panel 36¾ x 29¼ inches (93 x 74 cm)
signed *I. vande. Velde. F 1644*

Jan Jansz. van de Velde III painted primarily intimate compositions, with just a few objects such as a pack of cards, a glass of foaming beer, smoking requisites, and a few hazelnuts. His pictures of this type, which seem to be modeled on the comparable works by Pieter Claesz., are rich in atmosphere. Although other Amsterdam masters also painted intimate still lifes, for instance Jan Jansz. Treck, Simon Luttichuys, Johannes Fris, and Cornelis Kick, Van de Velde is the most prominent of these artists—the court musician with a muted cello.

Van de Velde, however, also painted a few monumental works. The small size, the great simplicity, and the intimacy give way to much bigger panels and considerably enriched compositions, of which the still life exhibited is an excellent example.

When Van de Velde painted this monumental picture in 1644, Amsterdam's importance as a world trading and financial center was great and still growing. The city's wealthy patricians constructed five- to six-storied splendid houses with palatial rooms along its semi-circular canals. To those people a Van de Velde still life like the present one was more appealing and suitable than the intimate ones.

The overturned stoneware tankard displays in relief the coat of arms of Amsterdam, three crosses of Saint Andrew above the imperial crown. Tankards with that decoration are frequent in Van de Velde's oeuvre.

provenance Denant Sale, Lepke, Berlin, 27–28 October 1903, lot 97 (reproduced); Private collection, Maryland
literature Vroom 1980, 1:280, fig. 308, cat. 676; *Tableau* 4:1 (September/October 1981, reproduced in color on the cover)

Simon Pietersz. Verelst

(1644–1721)

The flower painter Simon Verelst was born in 1644 in The Hague and died in 1721 in London. It is not known who his teacher was, but it might have been his father, Pieter Verelst. Simon and his elder brother Herman became members of the Confrérie Pictura, the painters fraternity in The Hague, in 1663.[1] In 1669 Simon went to London, where the duke of Buckingham became his patron. He might have been in Paris in 1680.[2] He was highly esteemed and very well rewarded for his work. This success was his misfortune: he became arrogant, called himself "King of the Painters" and "God of Flowers." Eventually he went insane, and although he recovered he never regained his earlier artistic prominence. Weyerman visited him in London several times and was astonished by the decay he saw in his paintings at the end of his life.[3]

1. G.H. Veth, "Aanteekeningen omtrent eenige Dordrechtse schilders XXXIX," *Oud Holland* 14 (1896), 100–101. See for biographical data and family tree, Lewis 1979, 15–19.
2. Thieme-Becker 1940, 34:238.
3. Veth 1896, 110–111.

44

Vase of Flowers with Watch and Key

canvas 33 x 26½ inches (84 x 67 cm)

The mass of flowers of this picture is arranged in an inverted S curve, indicating a mature work by the master. The degree of perfection of this unusually fine painting is high, the drawing of the flowers is firm, accurate, and elegant, and the shape of the leaves is exuberant. Three more variations by Verelst of the same basic design are known, which indicates that the composition was a success.

In Netherlandish seventeenth-century art a bouquet of flowers was regarded as an image of the brevity of human life. In Verelst's picture this meaning is emphasized by the presence of the silver pocket watch, a reminder of *tempus fugit*, time is fleeting.

Verelst became an extremely successful flower painter during the more than fifty years he worked in London, living the fast life of the capital of Charles II. Among his patrons were the king, who owned six of his paintings, the duke of Buckingham, and numerous other members of the nobility.

provenance Lady Greg; Private collection
literature Frank A. Lewis, *Simon Pietersz Verelst "The God of Flowers" 1644–1721* (Leigh-on-Sea, 1979), cat. 31 (reproduced)

1. For some of the facts about the life of Simon Verelst I am indebted to P. Mitchell, "Verelst," *Gallery Notes* 19 (1971).

Selected Bibliography

Alpers 1983
Alpers, Svetlana. *The Art of Describing. Dutch Art in the Seventeenth Century.* Chicago, 1983.

Amsterdam 1982
Een bloemrijk verleden. Overzicht van de Noord en Zuidnederlandse bloemschilderkunst, 1600-heden / A Flowery Past. A Survey of Dutch and Flemish Flower Painting from 1600 until the Present. Exh. cat., Amsterdam, Gallery P. de Boer; 's-Hertogenbosch, Noordbrabants Museum. Amsterdam, 1982 (cat. by Sam Segal).

Amsterdam 1983
A Fruitful Past. A Survey of the Fruit Still Lifes of the Northern and Southern Netherlands from Brueghel till Van Gogh / Niederländische Stilleben van Brueghel bis Van Gogh. Exh. cat., Amsterdam, Gallery P. de Boer; Braunschweig, Herzog Anton Ulrich-Museum. Amsterdam, 1983 (cat. by Sam Segal).

Amsterdam 1984–1985
Masters of Middelburg. Exh. cat., Kunsthandel K. & V. Waterman. Amsterdam, 1984 (cat. by Noortje Bakker, Ingvar Bergström, Guido Jansen, Simon H. Levie, Sam Segal).

Auckland 1982
Still Life in the Age of Rembrandt. Exh. cat., Auckland City Art Gallery. Auckland, 1982 (cat. by E. de Jongh a.o.).

Benedict 1938
Benedict, Curt. "Un Peintre oublié de Natures mortes. Osias Beert." *L'Amour de l'Art* 19 (1938), 307–313.

Bergström 1955
Bergström, Ingvar. "Disguised Symbolism in 'Madonna' Pictures and Still Life." *Burlington Magazine* 97 (1955), 303–308, 342–349.

Bergström 1947/1956
Bergström, Ingvar. *Studier i Holländskt Stillevenmaleri under 1600-talet.* Göteborg, 1947. English rev. ed. *Dutch Still-Life Painting in the Seventeenth Century.* London, 1956.

Bergström 1977
Bergström, Ingvar. "Georg Flegel als Meister des Blumenstucks." *Festschrift Paul Pieper-Westfalen* 55 (1977), 135–146.

Bergström 1984
Bergström, Ingvar. "Jacob Marrel's Earliest Tulip Book—Hitherto Unknown." *Tableau* 7 (November, 1984), 32–49.

De Bie 1661/1971
Bie, Cornelis de. *Het gulden cabinet vande edele vry schilderconst . . . waer-inne begrepen is den . . . loff vande vermaerste constminnende geesten ende schilders van dese eeuw* Antwerp, 1661. Facs. Soest, 1971.

Bol 1955
Bol, Laurens J. "Een Middelburgse Brueghelgroep III". *Oud Holland* 70 (1955), 138–154.

Bol 1956
Bol, Laurens J. "Een Middelburgse Brueghelgroep IV". *Oud Holland* 71 (1956), 132–153.

Bol 1960
Bol, Laurens J. *The Bosschaert Dynasty. Painters of Flowers and Fruit.* Leigh-on-Sea, 1960.

Bol 1969
Bol, Laurens J. *Holländische Maler das 17. Jahrhundert nahe den grossen Meistern. Landschaft und Stilleben.* Braunschweig, 1969.

Bol 1982
Bol, Laurens J. *Goede Onbekenden.* Utrecht, 1982.

Bredius 1915–1922
Bredius, A. *Künstler-Inventare. Urkunden zur Geschichte der holländischen Kunst des XVIten, XVIIten, and XVIIIten Jahrhunderts.* 8 vols. The Hague, 1915–1922.

Couvreur 1967
Couvreur, W. "Daniel Seghers Inventaris van door hem geschilderde bloemstukken." *Gentse bijdragen tot de kunstgeschiedenis en de oudheidkunde* 20 (1967), 87–158.

Dordrecht 1962
Nederlandse stillevens uit de zeventiende eeuw. Exh. cat., Dordrechts Museum. Dordrecht, 1982 (cat. by Laurens J. Bol).

Dresden 1983
Das Stilleben und sein Gegenstand. Eine Geweinschaftsausstellung von Museen aus de UDSSR der ČSSR und der DDR. Albertinum. Dresden, 1983.

Duyvené de Wit 1958
Duyvené de Wit-Klinkhamer, Th. M., and M. H. Gans. *Geschiedenis van het Nederlandse zilver.* Amsterdam, 1958. English ed. *Dutch Silver.* London, 1961.

Eindhoven 1957
Het Hollandse stilleven 1550–1950. Exh. cat., Van Abbemuseum. Eindhoven, 1957.

Ertz 1979
Ertz, Klaus. *Jan Brueghel der Aeltere (1568–1625). Die Gemälde mit kritischem Oeuvrekatalog.* Cologne, 1979.

Fuchs 1978
Fuchs, R. H. *Dutch Painting.* New York and Toronto, 1978.

Gammelbo 1960
Gammelbo, Poul. *Dutch Still-Life Painting from the 16th to the 18th Centuries in Danish Collections.* Leigh-on-Sea, 1960.

Van Gelder n.d.
Gelder, H. E. van. *W. C. Heda, A. van Beyeren, W. Kalf* (Paletserie). Amsterdam, n.d. [1941].

Van Gelder 1936
Gelder, J. G. van. "Van blompot en blomglas." *Elseviers geïllustreerde maandschrift* 46 (1936).

Van Gelder 1950
Catalogue of the Collection of Dutch and Flemish Still-Life Pictures Bequeathed by Daisy Linda Ward. Ashmolean Museum. Oxford, 1950. (cat. by J. G. van Gelder).

Ghent 1986–1987
Joachim Beuckelaer. Het markt- en keukenstuk in de Nederlanden 1550–1650. Exh. cat., Museum voor Schone Kunsten. Ghent, 1986–1987.

Van Gool 1750/1971
Gool, Johan van. *De nieuwe schouwburg der Nederlantsche kunstschilders en schilderessen waer in de levens en kunstbedryven der tans levende en reets overleedene schilders, die van Houbraken, noch eenig ander schryver, zyn aangeteekend, verhaelt worden, door Johan van Gool.* The Hague, 1750. Facs. Soest, 1971.

Greindl 1956/1983
Greindl, Edith. *Les Peintres flamands de Nature Morte au XVIIe Siècle.* Brussels, 1956. 2d rev. ed. 1983.

Grisebach 1974
Grisebach, Lucius. *Willem Kalf 1619–1693.* Berlin, 1974.

Haak 1967
Haak, B. "De vergankelijkheidssymboliek in de 16de eeuwse portretten in 17de eeuwse stil-levens in Holland." *Antiek* 1 no. 7 (1967), 23–30, 2 (1967–1968), 399–411.

Haak 1984
Haak, B. *Hollandse schilders in de Gouden Eeuw.* Amsterdam, 1984. English ed. *The Golden Age. Dutch Painters of the Seventeenth Century.* New York, 1984.

The Hague 1926
Nederlandsche stillevens uit vijf eeuwen. Exh. cat., Haags Gemeentemuseum. The Hague, 1926.

Hairs 1955/1965/1985
Hairs, Marie-Louise. *Les Peintres flamands de fleurs au XVIIe siècle.* Paris & Brussels, 1955. 2d ed. 1965, 3d ed. 1985, 2 vols. English ed. *The Flemish Flower Painters in the XVIIth Century.* Brussels, 1985.

Hofstede de Groot 1907–1928
Hofstede de Groot, C. *Beschreibendes und kritisches Verzeichnis der Werke de hervorragendsten holländischen Maler des XVII. Jahrhunderts.* Vols. 1–9 Esslingen a.N. and Paris, 1907–1926. Vol. 10 Stuttgart and Paris, 1928.

Hoogstraeten 1678
Hoogstraeten, Samuel van. *Inleyding tot de hooge schoole der schilderkonst. Anders de zicht-bare werelt.* . . . Rotterdam, 1678. Facs. (microfilm) Ann Arbor, 1975.

Houbraken 1753/1976
Houbraken, Arnold. *De groote schouburgh der Nederlantsche konstschilders en schilderessen.* The Hague, 1753 (2d ed.) 3 vols. Facs. Amsterdam, 1976.

Jones 1988
Jones, Pamela M. "Federico Borromeo as a Patron of Landscapes and Still Lifes. Christian Optimism in Italy ca. 1600." *The Art Bulletin* 70 (1988), 261–272.

Ter Kuile 1985
Kuile, Onno ter. *Seventeenth-century North Netherlandish Still Lifes* (Rijksdienst Beeldende Kunst). Amsterdam and The Hague, 1985.

Kunstschrift 1987
"Flora en Pictura." *Kunstschrift. Openbaar kunstbezit* 31, no. 3 (May/June), 1987.

Lairesse 1707/1740/1969
Lairesse, Gerard de. *Het groot schilderboek.* 2 vols. Amsterdam, 1707, and Haarlem, 1740. Facs. 1969.

Lewis 1973
Lewis, Frank A. *Dictionary of Dutch & Flemish Flower, Fruit, and Still Life Painters. 15th to 19th Century.* Leigh-on-Sea, 1973.

Luttervelt 1947
Luttervelt, R. van. *Schilders van het stilleven.* Naarden, 1947.

Madrid 1936–1940
Floreros y bodegones en la pintura Española. Exh. cat., Sociedad Española de amigos del arte. Madrid, 1936 and 1940.

Van Mander 1604/1969
Mander, Karel van. *Het schilder-boeck waerin voor eerst de leerlustige Iueght den grondt der edel vry schilderconst in verscheyden deelen wort voorghedraghen. Daer nae in dry deelen t' Leuen der vermaerde doorluchtighe Schilders des ouden, en nieuwen tyds. Eyntlyck d'wtlegghinghe op den Metamorphosen.* Haarlem, 1604. Facs. Utrecht, 1969.

Miedema 1980
Miedema, Hessel. *De archiefstukken van het St. Lukasgilde te Haarlem. 1497–1798.* 2 vols. Alphen-aan-den-Rijn, 1980.

Mitchell 1973
Mitchell, Peter. *European Flower Painters.* London, 1973.

Müller 1956
Müller, Wolfgang J. *Der Maler Georg Flegel und die Anfänge des Stillebens. Schriften des Historischen Museums 8.* Frankfurt am Main, 1956.

Münster 1979
Stilleben in Europa. Exh. cat., Westfälisches Landesmuseum für Kunst und Kulturgeschichte. Münster, 1979.

New York 1983
A Selection of Dutch and Flemish Seventeenth-century Paintings. Exh. cat., Gallery Hoogsteder-Naumann Ltd. New York, 1983.

Pavière 1962
Pavière, S. H. *A Directory of Flower, Fruit, and Still Life Painters.* Leigh-on-Sea, 1962.

Robels 1969
Robels, H. "Frans Snijders' ontwikkeling als Stillebenmaler." *Wallraf-Richards Jahrbuch* 31 (1969), 43–94.

Rosenberg 1966
Rosenberg, J., S. Slive, E. H. ter Kuile. *Dutch Art and Architecture. 1600 to 1800.* Middlesex, 1966. 2d rev. ed. 1972. 3d rev. ed. 1977.

Sandrart 1675/1925
Sandrart, Joachim von. *Academie der Bau-, Bild-, und Mahlerey-Künste von 1675.* (A. R. Peltzer). Munich, 1925.

Schama 1987
Schama, Simon. *The Embarrassment of Riches. An Interpretation of Dutch Culture in the Golden Age.* New York, 1987.

Schreveli 1648
Schreveli, Theod. [Schrevelius] *Harlemias Ofte om beter te seggen De eerste stichting der Stadt Haerlem.* 6 vols. Haarlem, 1648.

Segal 1988
Segal, Sam. *A Prosperous Past. The Sumptuous Still Life in the Netherlands 1600–1700.* Exh. cat., Stedelijk Museum Het Prinsenhof, Delft. The Hague, 1988.

Sterling 1952/1959/1981
Sterling, Charles. *La nature morte de l'antiquité à nos jours.* Paris, 1952. Rev. ed. Paris, 1959. 2d rev. ed. *La nature morte de l'antiquité au XXe siècle.* Paris, 1981. English ed. *Still-Life Painting from Antiquity to the Present Time.* Paris, 1959. 2d rev. ed. *Still-Life Painting from Antiquity to the Twentieth Century.* New York & Toronto, 1981.

Sullivan 1984
Sullivan, S. A. *The Dutch Gamepiece.* Totowa & Montclair, 1984.

Thieme-Becker 1907–1950
Allgemeines Lexikon der bildenden Künstler von der Antike bis zur Gegenwart. Begrundet von Ulrich Thieme und Felix Becker. 37 vols. Leipzig, 1907–1950.

Vorenkamp 1933
Vorenkamp, Alphonsus Petrus Antonius. *Bijdrage tot de geschiedenis van het Hollandsch stilleven in de zeventiende eeuw.* Leiden, 1933.

Vroom 1945/1980
Vroom, N. R. A. *A Modest Message as Intimated by the Painters of the 'Monochrome banketje.'* 2 vols. Schiedam, 1980. (Rev. ed. of *De schilders van het monochrome banketje.* Amsterdam, 1945.)

Warner 1928
Warner, Ralph. *Dutch and Flemish Flower and Fruit Painters of the 17th and 18th Centuries.* London, 1928 (reprint ed. S. Segal, with add. Amsterdam, 1975).

Weyerman 1729–1769
Weyerman, Jacob Campo. *De levens-beschryvingen der Nederlandsche konst-schilders en konst-schilderessen, met een uytbreyding over de schilderkonst der ouden. . . .* 4 vols. Vols. 1, 2, and 3, The Hague, 1729. Vol. 4, Dordrecht, 1769.

Van der Willigen 1870/1970
Willigen, Pz. A. van der. *Les Artistes de Harlem. Notices historique avec un Précis sur la Gilde de St. Luc.* Haarlem/The Hague, 1870, reprinted Nieuwkoop, 1970.

Ydema 1988
Ydema, O. "Carpets in 17th-Century Dutch and Flemish Painting." Cat. *The European Art Fair,* 15–28. Maastricht, 1988.

Zülch 1967
Zülch, Walther Karl. *Frankfurter Künstler, 1223–1700.* Frankfurt am Main, 1967.